FRANCIS W. EDMONDS

American Master in the Dutch Tradition

H. Nichols B. Clark

PUBLISHED FOR THE AMON CARTER MUSEUM
BY THE SMITHSONIAN INSTITUTION PRESS
WASHINGTON, D.C., AND LONDON

Dates of the exhibition:

Amon Carter Museum, Fort Worth, Texas
9 January–28 February 1988

The New-York Historical Society, New York, New York
6 April–19 June 1988

LIBRARY OF CONGRESS CATALOGING-IN-PUBLICATION DATA

Clark, Henry Nichols Blake.
Francis W. Edmonds, American Master in the Dutch Tradition

Bibliography: p.
1. Edmonds, Francis William, 1806–1863—Exhibitions.
2. Genre painting, American—Exhibitions.
3. Genre painting—19th century—United States—Exhibitions.
4. Edmonds, Francis William, 1806–1863—Criticism and interpretation.
I. Amon Carter Museum of Western Art. II. Title.
ND237.E394A4 1988 759.13 87-20469
ISBN 0-87474-319-2 (alk. paper)

Cover: Francis W. Edmonds, *The Speculator*, 1852. [Plate 10, *infra.*]

The paper used in this publication meets the minimum requirements of the
American National Standard for Permanence of Paper for Printed Materials
Z39.48-1984.

Designer: Alan Carter

Typesetter: World Composition Services, Inc.

Printer: Schneidereith and Sons

Photography Credits

Photographs were supplied by the owners or lenders of the works of art.
In addition, the following photographers, galleries, and archives are gratefully
acknowledged:

Archivi Alinari, Florence, and Art Resource, New York, fig. 28.
Jörg P. Anders, Berlin, fig. 19.
Glenn Castellano, New-York Historical Society, figs. 7, 25, 48, 50, 89.
Art Evans, Williamstown, Mass., fig. 13.
Helga Photo Studio, Upper Montclair, N.J., figs. 9, 58, 68.
Kennedy Galleries, New York, figs. 10, 21, 31, 44, 54, 60, 61, 87, 88.
Linda Lorenz, Amon Carter Museum, fig. 11.
Michael Marsland, Yale Center for British Art, fig. 96.
National Gallery of Ireland, Dublin, fig. 36.
Tom Scott, Edinburgh, fig. 37.
David Stansbury, Springfield, Mass., fig. 65.
Taylor and Dull, New York, fig. 105.
Vizzavona, Paris, fig. 91.

Contents

Foreword

FRANCIS WILLIAM EDMONDS (1806–63) WAS AN AMERICAN PAINTER OF considerable repute in the first half of the nineteenth century. By profession a banker, Edmonds was also a talented artist. Like several other painters of his time, he took inspiration from seventeenth-century Dutch genre painting, echoing its meticulous renderings of the everyday world. Like the Dutch masters, he treats in his genre pieces not merely the incidental moment, but the human condition. The work is infused with a significant depth of feeling, becoming more poignant and profound in his most mature efforts. Edmonds also directs our attention to the broader social context behind these slivers of everyday life. His art probes human relationships; it places the individual within a society that commingled much of the optimism of the Jacksonian era with the harsher realities of unsettled financial times and with politically divisive issues such as racial equality.

We are grateful to H. Nichols B. Clark, director of the Lamont Gallery, Phillips Exeter Academy, for his guidance in selecting the objects for the exhibition this publication commemorates and for producing such an insightful book on Edmonds's career. Dr. Clark places Edmonds in the context of American genre painting, an area of scholarship now undergoing reevaluation. He investigates the artist's sources and the importance of a European trip in 1840–41, and he traces Edmonds's career from his formative years to his mature later works. With the recent reappearance of a number of works by Edmonds and Dr. Clark's new research, we can formulate a more complete idea of the artist's small oeuvre. This book publishes for the first time many of the preliminary oil sketches for the paintings and brings to light material that has descended in the artist's family.

This project began as an extensive examination of one painting in the Amon Carter Museum collection, *The Flute*, an intimate interior scene from late in Edmonds's career. The endeavor has proved to be a happy collaboration between the Amon Carter Museum and The New-York Historical Society, the institution with the largest holdings of work by Edmonds.

The book and exhibition were made possible through a generous

grant from the Henry Luce Foundation, Inc. The exhibition is also supported by grants from the Union Pacific Foundation on behalf of Union Pacific Corporation and its operating companies—Union Pacific Railroad Company, Union Pacific Resources Company, and Union Pacific Realty Company—and from the Texas Commission on the Arts and the National Endowment for the Arts. We would like to extend our gratitude to them and to the many lenders who are acknowledged in the Checklist of the Exhibition.

Finally, our appreciation goes to Smithsonian Institution Press and Kathy Kuhtz for producing this handsome volume.

Jan Keene Muhlert, *Director* James B. Bell, *Director*
Amon Carter Museum *The New-York Historical Society*

Acknowledgments

IN THE FALL OF 1984 I WAS INVITED TO LECTURE AT THE AMON CARTER Museum on Francis Edmonds's *The Flute*, a recent addition to their collection. Happily, those in attendance from the Museum thought Edmonds's work merited more extensive consideration in the form of an exhibition. The Museum's faith was doubly rewarded when we learned of the remarkable coincidence that the man for whom Fort Worth was named, William Jenkins Worth, was one of the artist's relatives. This boded well for the project, and I must express my deep gratitude to Jan Muhlert, Linda Ayres, Jane Myers, Matthew Abbate, and the rest of the staff at the Amon Carter Museum for their enthusiastic and unqualified support of this exhibition. That the show will be seen at The New-York Historical Society is equally appropriate, since Edmonds was a prominent figure in New York and a moving force behind the encouragement of the arts at the Historical Society. Their collection of paintings by Edmonds provided an important foundation for the exhibition. I am indebted especially to Ella Foshay and Karen Stiefel for their capable coordination of this project.

My efforts to place Edmonds in the scheme of nineteenth-century American art and culture were greatly assisted by Maybelle Mann's cornerstone research. She and her husband, Alvin, were most generous in sharing their extensive knowledge of the artist. To them I am indeed grateful.

The success of an exhibition hinges on the willingness of owners to lend, and I must thank all those lenders, both public and private, who have made possible this opportunity to see Edmonds's work in such depth. Many paintings remain unlocated, and, in a sense, this project is still an intermediate step toward providing a comprehensive assessment of the artist's work. I hope the exhibition will bring some of the unlocated works back into public view.

No undertaking of this magnitude can be borne on one person's shoulders; I wish to express my gratitude to the following people and institutions: the staffs of the Archives of American Art in Boston and Washington, D.C.; the staffs of the Library, Index of American Painting, and Pre-1877 Exhibition Index of the National Museum of

American Art, Smithsonian Institution, with special thanks to Roberta Geier and Pat Lynagh; the Day Fund of Phillips Exeter Academy for a generous summer grant to write the essay; the librarians of Phillips Exeter Academy; the many descendants of Francis Edmonds who gave so willingly of their time and knowledge; Henry Adams; Sally Bottiggi; Russell Burke; Mr. and Mrs. Thomas R. B. Campbell; Jay Cantor; Angela Carone; Lois Fink; Roger Friedman; Marcia Hart; Frederick Hill; Elizabeth Johns; Betsy Kornhauser; Cheryl Leibold; Nancy Little; Celia McGee; Melissa Medeiros; Colonel Merl Moore, Jr.; M. P. Naud; Jim Ray; Janet Shepherd; Anna M. Smyth; and Bill Truettner. A special accolade must go to my able assistant, Mary Thomas, for her untiring effort on behalf of this project, particularly the typing of numerous drafts of the essay under formidable deadlines. She carried out these tasks with her usual cheerful efficiency.

Finally, I must acknowledge the patience and resilient support of my wife, Trinkett, and daughter, Charlotte, who spent a lot of time waiting for me to come home from the library and then had to endure my ensuing distraction. They provided more support and succor than they can ever know, and to them go my love and unfathomable gratitude for their understanding and perseverance.

H. Nichols B. Clark

Chronology

1806	22 November. Francis Henry William Edmonds born in Hudson, Columbia County, New York.
1823	Accepts position as underclerk at Tradesman's Bank in New York City, where his uncle Gorham A. Worth is cashier.
1826	Enrolls in evening classes at the Antique School of National Academy of Design, New York.
1829	Exhibits first painting, *Hudibras Capturing the Fiddler* (unlocated), at National Academy of Design. Elected associate member of National Academy.
1830	Appointed cashier of Hudson River Bank in Hudson, New York. Suspends artistic pursuits. Marries Martha Norman, whom he met in Hudson.
1832	Returns to New York as cashier of Leather Manufacturers' Bank.
1835	Resumes painting; seeks advice from the emerging portrait painter William Page.
1836	Exhibits *Sammy the Tailor* (fig. 10) at National Academy of Design under pseudonym E. F. Williams.
1837	Elected associate member of National Academy of Design (not clear whether under his own name).
1838	Participates in inaugural exhibition of Apollo Association, New York.
1839	Elected cashier of Mechanics' Bank, New York. Member of Sketch Club, New York. Elected treasurer of Apollo Association.
1840	5 January. Edmonds's wife, Martha, dies. Exhibits *Sparking* (plate 3) and *The City and the Country Beaux* (plate 4) at National Academy of Design. Elected full member of National Academy. 15 November. Departs for eight-month sojourn in Europe and Great Britain.

1841	17 July. Returns to New York.
	November. Marries Dorothea Lord.
1842	Exhibits first painting completed since return from abroad, *The Bashful Cousin* (plate 5), at National Academy of Design.
	Serves as officer and manager of newly founded American Art-Union, New York.
1843	Member of Committee of Arrangements for National Academy of Design (served until 1860).
	Spends much of year in Albany lobbying on behalf of Mechanics' Bank.
	Helps reorganize New York and Erie Railroad.
1844	Founding member and officer of New-York Gallery of the Fine Arts.
	Sends Asher B. Durand an autobiographical sketch of his life.
	Exhibits in Boston for the first time: shows *The Penny Paper* (unlocated) at Boston Artists' Association.
1845	Exhibits *Commodore Trunnion and Jack Hatchway* (plate 2) at Boston Athenaeum.
	The Image Pedlar (plate 6) exhibited at Royal Academy, London.
1846	Elected recording secretary of National Academy of Design (served until 1848).
	Donates *The Image Pedlar* to New-York Gallery of the Fine Arts.
1847	Founding member of Century Association, New York.
1850	Buys first parcel of property in Bronxville, New York; commences building Crow's Nest, which will become his agrarian retreat.
1852	Dissolution of American Art-Union.
	Exhibits at Pennsylvania Academy of the Fine Arts, Philadelphia, for the first time: *Sam Weller* (unlocated) lent by Charles M. Leupp.
1853	Helps establish the New York Clearing House. Chairman of first Clearing House committee.
	November. Oldest son (by first marriage), Francis Henry Edmonds, dies.
1854	Appointed city chamberlain of New York City.
	Becomes active in Episcopal Church.
	Commences *Felix Trembled* (fig. 76).

1855 Controversy over Edmonds's role in misappropriation of bank funds. Resigns (voluntarily) from Mechanics' Bank and New York Clearing House.

Moves permanent residence to Crow's Nest in Bronxville.

1856 Forms a bank-note engraving partnership with Alfred Jones and James Smillie.

1857 Elected treasurer of National Academy of Design (served until 1859).

Helps found Artists' Fund Society, New York.

1858 Bank-note concern incorporated into American Bank Note Company.

Begins to exhibit in a series of artists' receptions in New York City.

1859 Exhibits at National Academy of Design for the last time: *The New Bonnet* (plate 15).

1861 Resigns from National Academy of Design.

1863 7 February. Francis Henry William Edmonds dies at the age of fifty-six.

Color Plates

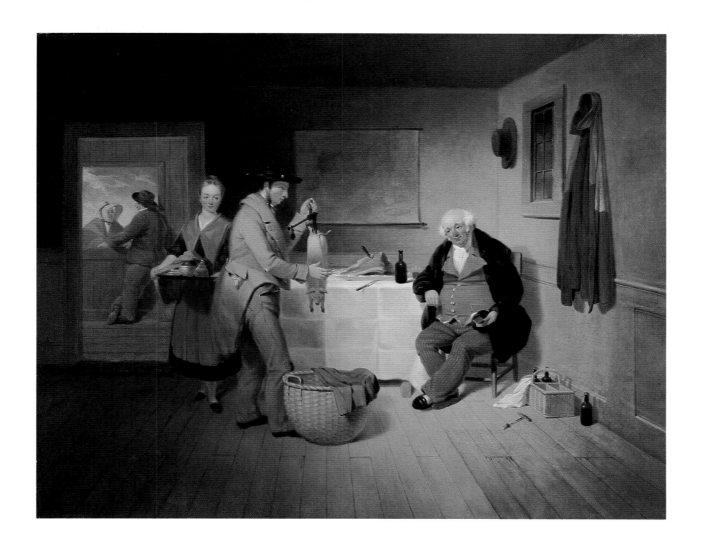

PLATE I. *The Epicure*, 1838. Oil on canvas,
26¾ × 33½ in. Wadsworth Atheneum,
Hartford, Connecticut; The Ella Gallup
Sumner and Mary Catlin Sumner Collec-
tion.

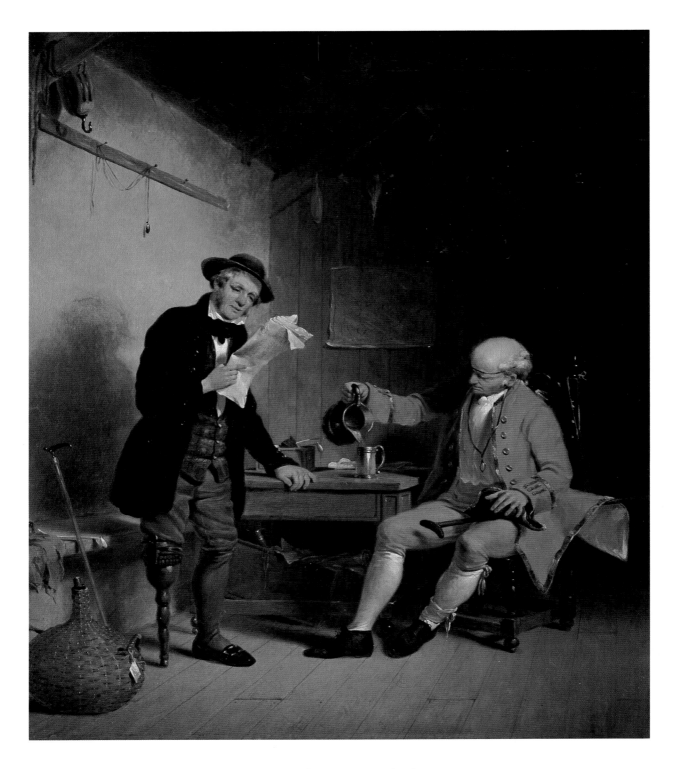

PLATE 2. *Commodore Trunnion and Jack Hatchway*, 1839. Oil on canvas, 25½ × 22 in. Vose Galleries of Boston, Inc., Boston, Massachusetts.

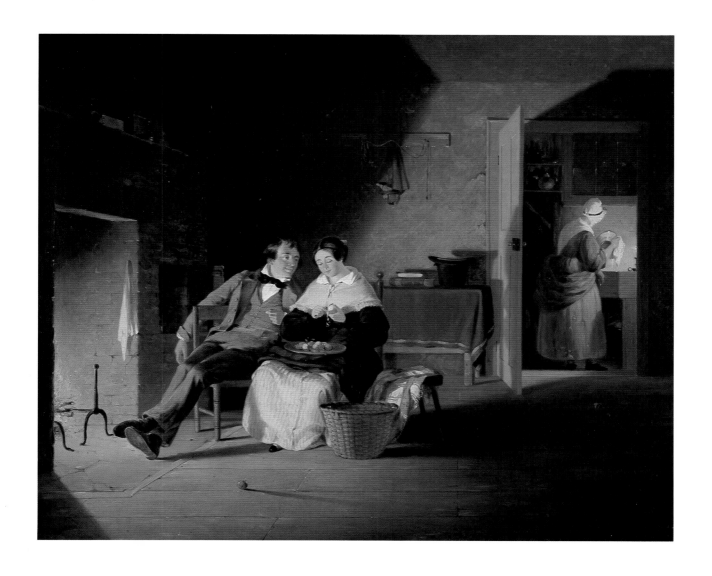

PLATE 3. *Sparking*, 1839. Oil on canvas, 20
× 24 in. Sterling and Francine Clark Art
Institute, Williamstown, Massachusetts.

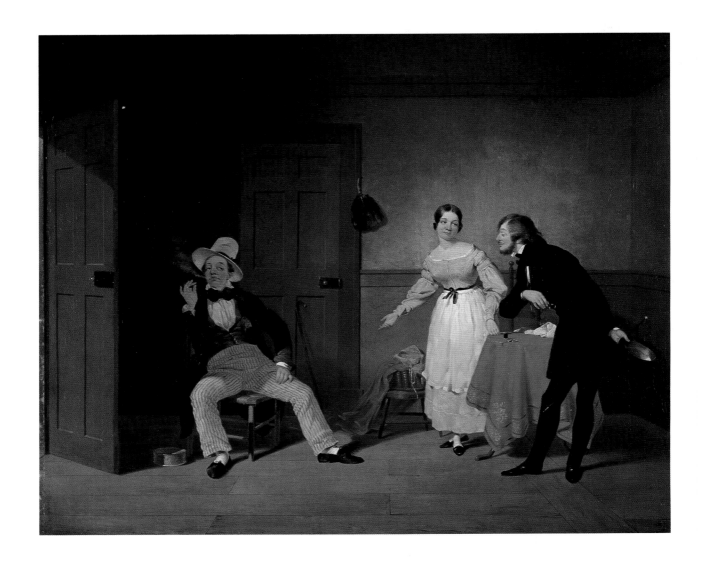

PLATE 4. *The City and the Country Beaux*,
c. 1839. Oil on canvas, 20⅛ × 24¼ in.
Sterling and Francine Clark Art Institute,
Williamstown, Massachusetts.

PLATE 5. *The Bashful Cousin*, c. 1842. Oil
on canvas, 25 × 30 in. National Gallery
of Art, Washington, D.C.; Gift of Freder-
ick Sturges, Jr.

PLATE 6. *The Image Pedlar*, c. 1844. Oil on canvas, 33¼ × 42¼ in. The New-York Historical Society; Gift of the New-York Gallery of Fine Arts.

PLATE 7. *The New Scholar*, 1845. Oil on
canvas, 27 × 34 in. Private collection.

PLATE 8. *The Organ Grinder*, c. 1848. Oil
on canvas, 31¾ × 42¼ in. Private collection.

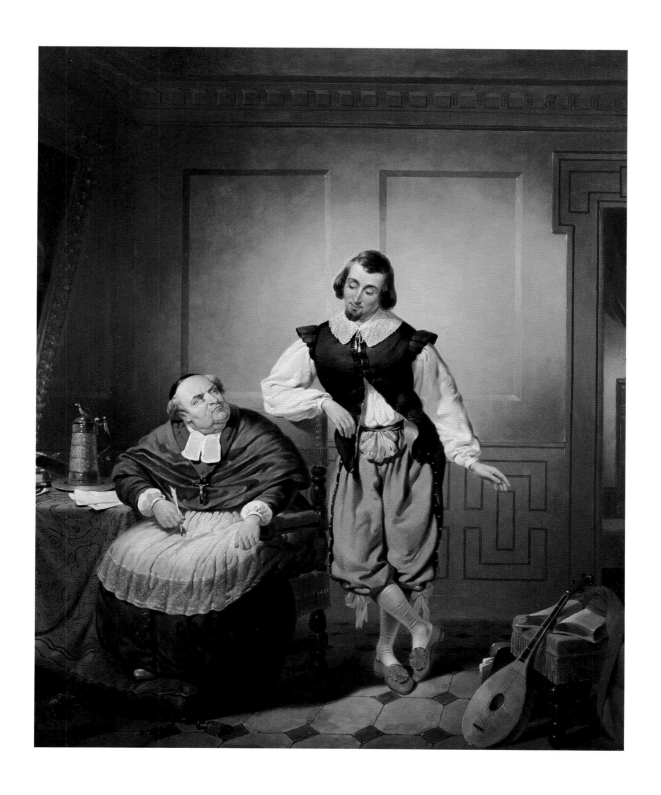

PLATE 9. *Gil Blas and the Archbishop*,
c. 1849. Oil on canvas, 29½ × 24 in.
Private collection.

PLATE 10. *The Speculator*, 1852. Oil on
canvas, 25⅛ × 30⅛ in. National Museum
of American Art, Smithsonian Institution,
Washington, D.C.; Gift of Ruth C. and
Kevin McCann in affectionate memory of
Dwight David Eisenhower, 34th Presi-
dent of the United States.

PLATE 11. *Taking the Census*, 1854. Oil on
canvas, 28 × 38 in. Private collection.

13

PLATE 12. *The Thirsty Drover*, 1856. Oil
on canvas, 27 × 36 in. The Nelson-
Atkins Museum of Art, Kansas City,
Missouri; Nelson Fund.

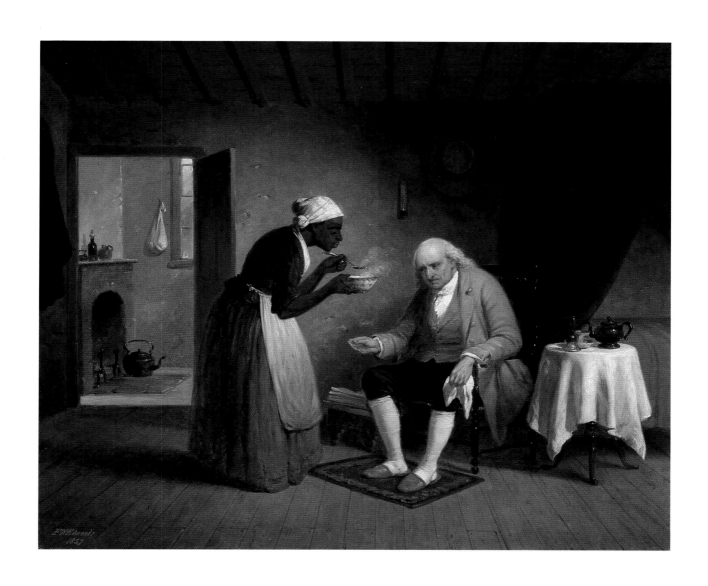

PLATE 13. *Devotion*, 1857. Oil on canvas,
20¼ × 24 in. Collection of Mr. and Mrs.
E. G. Nicholson.

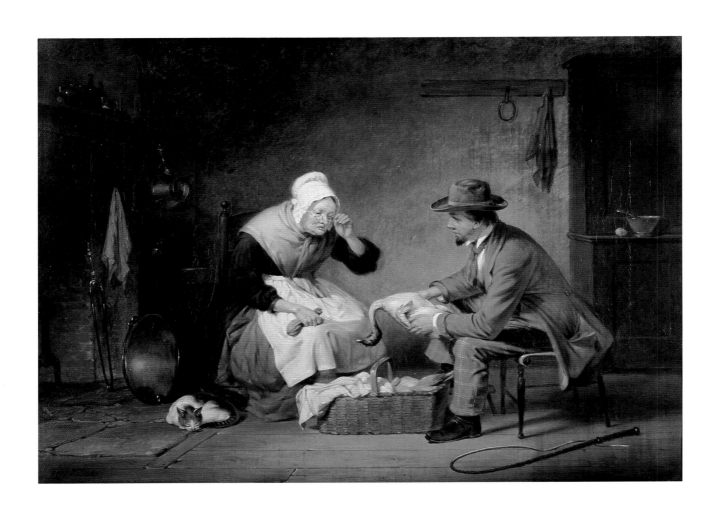

PLATE 14. *Bargaining (The Christmas Turkey)*, 1858. Oil on canvas, 16½ × 23⅜ in. The New-York Historical Society; The Robert L. Stuart Collection, on permanent loan from the New York Public Library, 1944.

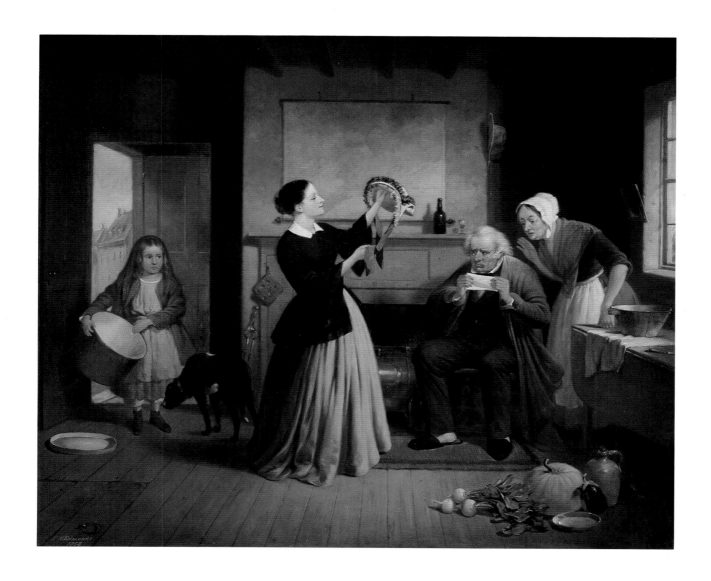

PLATE 15. *The New Bonnet*, 1858. Oil on
canvas, 25 × 30⅛ in. The Metropolitan
Museum of Art, New York; Purchase,
Erving Wolf Foundation Gift and Hanson
K. Corning Gift by exchange, 1975.

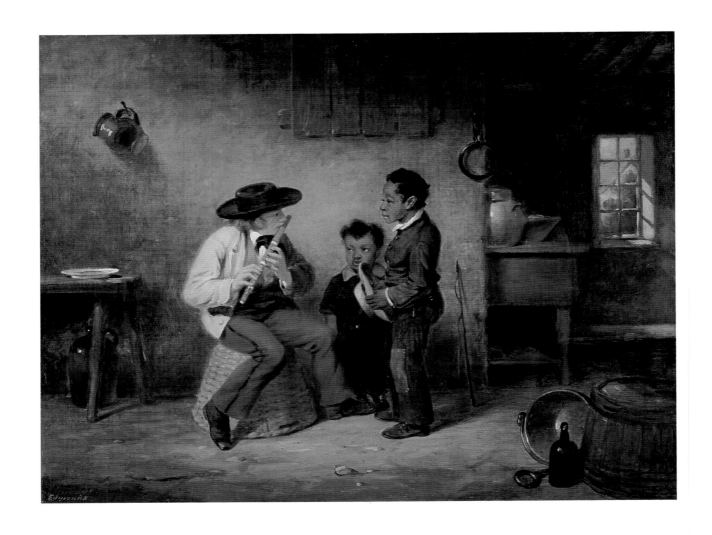

PLATE 16. *The Flute*, c. 1859. Oil on canvas, 13¼ × 17¼ in. Amon Carter Museum, Fort Worth, Texas; Gift of Mr. and Mrs. Louis J. Urdahl and Mitchell A. Wilder Memorial Fund donors.

CHAPTER I

The Milieu: Edmonds as a Public Man

FRANCIS WILLIAM EDMONDS'S REMARKABLE ABILITY TO EXCEL IN TWO professions did not fail to attract the attention of his contemporaries. In 1841 the painter John Frederick Kensett (1816–72), then residing in Paris, wrote his uncle John R. Kensett of the arrival of "a distinguished member of the Banking fraternity of New York [who] has been out here for his health. He is now Cashier of the Mechanics' Bank, one of the largest and finest institutions in the country and is a most excellent man as well as an amateur painter which gives him a rank equal to any proffessional [sic] artist that we have among us."[1]

While Edmonds undoubtedly would have appreciated this glowing assessment, he might have found "amateur" an inadequate title, since he had been elected a full member of the National Academy of Design in 1840.[2] Yet Edmonds recognized the anomaly of his situation. He was keenly aware that his commitment to the world of finance would invariably take precedence over his activities as an artist. This alone might account for his comparatively modest output as a painter; only fifty-four finished paintings are known. But considering Edmonds's active participation in the public life of his time, it is remarkable that he produced as much as he did.[3] His story is in part the story of numerous organizations, both financial and artistic, ranging from the New York Clearing House and the American Bank Note Company to the National Academy of Design, the Apollo Association (later the American Art-Union), the New-York Gallery of the Fine Arts, and the Sketch Club (whose members, including Edmonds, later helped found the Century Association). He had his finger on the pulse of the commercial and artistic capital of America. A self-portrait from the 1830s (fig. 1) suggests an affable and benevolent man. His circle of friends was diverse; the boundary between business associate and patron was often difficult to distinguish.

Edmonds was also in touch with the political concerns of his time. His most active years were the decades preceding the Civil War, years of American cultural, economic, and geographical expansion. In the political landscape of the time, Edmonds's connections were with the Democratic Party of Andrew Jackson, and more particularly with Jackson's successor in the presidency, Martin Van Buren.

Edmonds's first major advance in his banking career, his appointment in 1830 as cashier of the Hudson River Bank in Hudson, New York—an office of considerable importance in the banks of that day—had intriguing political ramifications. Van Buren, like Edmonds a native of Columbia County in upstate New York, had been a director of the Hudson River Bank in the 1810s, and he maintained connections to it. Moreover, Edmonds's uncle Gorham A. Worth, who had given Edmonds his first banking job in New York City in 1823, was one of Van Buren's best friends. Van Buren had a close relationship with the Mechanics' and Farmers' Bank in Albany, as well, which was run by Edmonds's cousin Thomas Worth Olcott. Finally, Edmonds's older brother, John Worth Edmonds, an esteemed lawyer and jurist, began his legal career around 1816 as a clerk in Van Buren's law office.[4] John Worth Edmonds earned a reputation as an ardent Democrat with radical leanings, and he unquestionably helped shape his younger brother's views at a time when the political situation was in great flux. As Democratic ideology took shape, it challenged the conservative aristocratic establishment of the eighteenth century. The

FIGURE 1. Francis W. Edmonds, *Self-Portrait*, c. 1835–40. Oil on canvas. Present location unknown; photograph courtesy of the New York Clearing House.

more radical Democrats went beyond Van Buren's conciliatory positions, embracing egalitarian principles of universal suffrage, popular election, and, in the arena of commerce and banking, the principle of laissez-faire.

These associations also influenced the pattern of Edmonds's artistic patronage when he resumed painting. His patrons were merchants, bankers, and railroad executives with primarily Democratic sympathies. The role of politics, which assumed a prominent role in genre painting during the ante-bellum decades, becomes significant to an understanding of Edmonds's art.[5]

Edmonds was clearly a skilled banker: by 1832 he was back in New York City as cashier of the Leather Manufacturers' Bank. He returned to New York at an emotionally highly charged time for the banking world. Andrew Jackson was in the process of eliminating the Bank of the United States, and this decentralizing act in connection with the recently opened Erie Canal moved the financial capital of the country from Philadelphia to New York.[6] The ensuing turmoil was compounded by the Panic of 1837, which was a product of excessive speculation, especially in the sale of government lands, and overextended credit. George Templeton Strong, the eminent New York lawyer and diarist, offered a vivid account of the financial community's desperate straits. His entry for 4 May 1837 recorded an episode that was central to Edmonds's career:

> Terrible news in Wall Street. [John] Fleming, late president of the Mechanics Bank, found dead in his bed this morning. Some say prussic acid; others (and the coroner's jury) say mental excitement and apoplexy. Anyhow there's a run on the bank—street crowded—more feeling of alarm and despondency in Wall Street than has appeared yet.[7]

Two years later, in 1839, Edmonds was elected cashier of the Mechanics' Bank in order to take charge of its recovery.[8]

The Mechanics' Bank had supported President Jackson's early challenging of the Bank of the United States, and most of its officers were Jackson sympathizers as well as Democrats. In a letter of 1843 to the poet William Cullen Bryant, Edmonds remarked on how often he was criticized "for uniting in my person that strange compound—a Bank officer and a Democrat."[9] In spite of the seeming contradiction of elitism and egalitarianism, this mixture was not altogether uncommon, yet Edmonds felt it had unusual implications. He expressed a high sense of purpose in the service of "humanity" in the same letter to Bryant:

> No one could have endeavoured to discharge the duties of life more honestly and truly than I have, and having resisted evil when sur-

rounded with temptation, I am extremely sensitive to the wholesale abuse that is poured (somewhat justly I admit) upon the heads of all those who have been so unfortunate as to have their destinies cast in the same mould with "monied Corporations."

But the good opinion of good men is a source of great consolation and enables me to [persevere] in the career I have marked out—namely—to act my part in the great drama of life honestly, and leave the result to *time* and a just *Providence* for my reward.[10]

These words take on an added poignancy in light of later events in his career.

The historian George Bancroft captured the spirit of the age in which Edmonds's career was unfolding in the introduction to the first book of his ten-volume *History of the United States*, published in 1834. Bancroft, himself a Jacksonian Democrat and an associate of Edmonds in the Century Association, praised the priority given in the United States to "the practice and defense of the equal rights of man," and proudly pointed to America's support of the sovereignty of the people, its respect for laws, and the flexibility of its Constitution. He marveled at the ingenuity fostered by the freedom of competition, reminded his readers that only hard work should be rewarded, and emphasized the importance of freedom of expression, the United States government's toleration of dissidents, and its sheltering of the oppressed. Finally, Bancroft hailed the expansion, progress, and increased wealth and population enjoyed by the country since its independence.[11]

Such passages extolling the potential for personal liberty and commercial success—which the British traveler Mrs. Frances Trollope, in her *Domestic Manners of the Americans*, rather pointedly characterized as the "universal" pursuit of money in America—sum up the aspirations of the Jacksonian democracy in which Edmonds so fervently believed.[12] He was present at the creation of a financially strong and politically active American middle class that began to chip away at the rigid social barriers that had persisted in colonial America.

During these formative years, a strong sense of national pride developed, accompanied by the desire to establish a cultural identity through literature and the arts. Nineteenth-century American writers expressed powerful nationalistic sentiments, often by celebrating the texture and detail of their society. In his Phi Beta Kappa address, "The American Scholar," delivered at Harvard College in 1837, Ralph Waldo Emerson (whom Edmonds met at a Sketch Club evening)[13] identified the familiar elements of everyday life as those most suitably and characteristically American:

The literature of the poor, the feelings of the child, the philosophy of the street, the meaning of household life, are the topics of the

time. It is a great stride. It is a sign—is it not?—of new vigor. . . . I ask not for the great, the remote, the romantic . . . I embrace the common, I explore and sit at the feet of the familiar, the low.[14]

Oliver Wendell Holmes called this oration America's intellectual Declaration of Independence.[15] Nathaniel Hawthorne, who applied Emerson's ideas to his own writing, offered similar advice in a letter to his friend Horatio Bridge: "Think nothing too trifling to write down, so it be in the smallest degree characteristic. You will be surprised to find on reperusing your journal what an importance and graphic power these little particulars assume."[16] Edmonds's artistic goals ran in the same general vein, expressed by the painter in genre scenes that chronicled the straightforward activities of the schoolroom, the barnyard, and the kitchen.

Edmonds's frequent use of literary subjects in his art reflected his involvement in the literary affairs of the day. His early association with the confederation of writers, artists, and "amateurs" known as the Sketch Club bears this out. The Sketch Club, in existence by 6 February 1829, was founded to promote fraternity among authors, artists, and patrons.[17] Counted among its members were some of the most respected figures in their fields—the artists Thomas Cole (1801–48), Asher B. Durand (1796–1886), Samuel F. B. Morse (1791–1877), and George W. Hatch (1805–67), with whom Edmonds had once roomed; the writers William Cullen Bryant, John Inman, John Howard Payne, and Gulian Verplanck; and such distinguished patrons as Luman Reed, Jonathan Sturges, Abraham M. Cozzens, and Charles M. Leupp. The club's stated objectives were conviviality and productivity (the proposal to produce a literary annual was, however, never realized); the liveliness of the meetings was further sparked by the presence of distinguished guests, who included Washington Irving, James Fenimore Cooper, James Kirke Paulding, William Sidney Mount, Horatio Greenough, Ralph Waldo Emerson, Oliver Wendell Holmes, and former president Martin Van Buren.

In his autobiography Edmonds wrote about being part of this group, also known as the "XXI." His participation dates at least to early 1839, when he wrote Durand apologizing for having missed a gathering because of an unavoidable business conflict and expressing the hope that Durand would be able to attend the meeting Edmonds was hosting. This letter points to the dilemma Edmonds often faced when it came to juggling art and commerce. To his credit, his attendance was regular enough that he was not asked to resign. (A resolution passed in 1844 stipulated this penalty for excessive absences.) His attendance became more sporadic, however, when he left New York City in the early 1850s.[18]

In addition to lively conversation, Sketch Club meetings often

entailed exercises in impromptu written or visual expression. At a gathering Edmonds attended at Thomas Cole's home, the assigned topic for the evening was "The Trying Hour." Some of the resultant drawings that have survived (figs. 2, 3) demonstrate the variety the group could bring to the interpretation of a single theme. In *Perseverance* (fig. 4), another drawing deriving from his attendance at these soirees, Edmonds's handling is assured, revealing his mastery of the medium. Edmonds found the discipline beneficial.[19]

The critical and theoretical interchange that evolved from these sessions must have been quite important for the participants. However, by 1844 the proceedings had lost their artistic focus, and a core group of the artists, including Edmonds, Cole, Durand, Charles Cromwell Ingham (1796–1863), and John Gadsby Chapman (1808–89), decided to found the more exclusive Artists' Sketch Club. At the meeting of 12 January 1844, held at Edmonds's residence, articles were voted on, including the proviso that the host was to provide materials for drawing and that he was entitled to keep the sketches.[20]

Although the Artists' Sketch Club ranked as one of the vital organizations of its time, it had its drawbacks. Historian Allan Nevins has pointed to the inconvenience of entertaining at home, the desire for centrally situated rooms, and the demand for a club of less limited membership as factors contributing to the founding of the Century Association. This new organization expanded the membership of the artistically oriented Sketch Club and, according to its constitution, was "composed of authors, artists, and amateurs of letters and the Fine Arts, residents of New York City and its vicinity; its objects, the cultivation of a taste for letters and the arts and social enjoyment." Forty-two persons accepted the constitution of the association in 1847 and became founding members; of these, twenty-three were members of the extant Sketch Club. Edmonds was a member of both organizations.[21]

The founding of the Century Association served to broaden the cultural scene in New York, bringing to it a less restrictive atmosphere. Nor did the fledgling institution compromise the vigor of the Sketch Club. A symbiotic relationship seems to have evolved; Edmonds, for instance, hosted a Sketch Club gathering in rooms at the Century in 1858.[22]

The Century provided a milieu of good fellowship and gaiety and offered a host of special programs. Occasionally these events were intended to be charitable, as was the case in January 1854 with a dinner in honor of the poet Fitz-Greene Halleck, who was living on a modest annuity left to him by John Jacob Astor. Edmonds was among the organizers of the affair, deemed "one of the most pleasant and elegant ever given in the city." Edmonds's connection to Halleck

FIGURE 2. Francis W. Edmonds, *The Trying Hour*, c. 1841. Brown wash over graphite touched with white on light blue paper, 10¾ × 15⅝ in. Museum of Fine Arts, Boston; Gift of Maxim Karolik.

FIGURE 3. Asher B. Durand, *The Trying Hour*, c. 1841. Brown and white wash over graphite on gray paper, 10⅛ × 15⅛ in. Museum of Fine Arts, Boston; Gift of Maxim Karolik.

dated back to at least 1847, when he provided an illustration (fig. 5) for a collection of Halleck's poems.[23]

This kind of involvement indicates Edmonds's integral role in the cultural life of New York and hints at his unflagging efforts on behalf of the fine arts, which were still looked upon with suspicion in the 1830s when he embarked on his career. As late as 1855, Samuel Osgood, a clergyman and author, was to admit in a letter to the editor of the art journal *Crayon* that enthusiasm for painting and

sculpture was not widespread in the United States; he offered the following, somewhat exaggerated explanation:

> It is unreasonable to expect our countrymen to feel like Italians for Italian art, to shout or weep over a Madonna or St. Cecilia, like the crowd of devotees who look upon the painting of the saint's face as the presence of the saint's intercession. Nor can we be expected to admire the court scenes or battle-pieces of France or England, as if they answered to our own home affections, and their heroes were household words with us. We are shaping our own form of domestic and national life in much strength, which in the end, must bloom out into not a little beauty.[24]

Edmonds was much concerned for the welfare of the fine arts in his country and worked diligently for more than a few art organizations. He was regarded as almost a savior by some people. John F. Kensett, anxious about the disposition of some of his paintings in 1843, contended that their favorable reception "rests allmost [sic] wholly upon the good offices of a friend Mr. F. W. Edmonds . . . for I know of no others who have any influence or taste in the arts on whom I could depend with even the slightest degree of certainty." (In spite of Edmonds's efforts, the paintings remained unsold nearly a year later.)[25]

Edmonds was inevitably called upon for his financial expertise. He served as the first treasurer of the Apollo Association for the Promotion of the Fine Arts in the United States, which was founded in 1838 to make art more available to a broader spectrum of the

populace.[26] The organization was not launched at the most propitious of times, since the Panic of 1837 had severely compromised disposable income. Securing art suitable for the association's purpose proved difficult as well. There were myriad other problems and the venture languished, but by the fall of 1842 circumstances had improved. Edmonds's role was considerable. In a letter soliciting work from Thomas Cole, he articulated how problems were being dealt with:

> We consider this association *under its present management*, as just in its infancy—Heretofore it has been managed by men who *knew little* about the arts and *cared less*. The gentlemen who now compose the committee I think are such as will give the concern an entire new feature—and I hope the artists will lend them a hand in Endeavoring to build it up into some magnitude—and one of the best methods for them to adopt, is to furnish the society, now while it is struggling for a new reputation, with pictures at the lowest possible prices.[27]

Edmonds applied himself with great determination to reorganizing the Apollo Association, even though it was only one of his many duties—he apologized in a subsequent letter for closing abruptly due to pressing bank matters.[28] His concerns extended beyond the purely commercial; he reassured Cole that a painting of Cole's that the association had acquired would fall into worthy hands and would even receive notice in Bryant's *Evening Post*.

The reorganization of the Apollo Association was handled intelligently and with good marketing sense. A new beginning was marked in 1842 with a change of name to the American Art-Union, ironically based on European models. The works of art owned by the Art-Union were exhibited continuously, with free admission, in a gallery in New York while awaiting their distribution by lottery at the end of the year. Participation in the lottery required membership in the Art-Union. This cost five dollars and entitled the member to one ticket and a number of publications, including an illustrated *Bulletin*, the annual *Transactions*, and, perhaps most important, an engraving after a painting selected by the Art-Union. Through distribution of these engravings and by creating the opportunity for individuals all over the country to acquire works of art through its lottery system, the Art-Union was able to appeal to a broad segment of the population. The institution also advocated readily comprehensible subject matter deemed illustrative of the national character, a formula that met with great success.[29]

In addition to his involvement as a member of the Art-Union's Executive Committee, Edmonds exhibited there frequently. His paintings purchased for distribution were *The New Scholar* (plate 7), *The Organ Grinder* (plate 8), and *Gil Blas and the Archbishop* (plate 9).

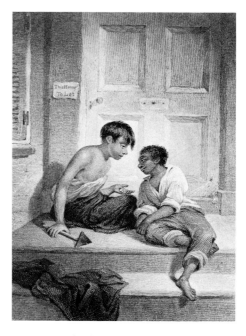

FIGURE 5. Charles Burt, after Francis W. Edmonds, "*This House to Let*," c. 1847. Engraving. From *The Poetical Works of Fitz-Greene Halleck* (New York: D. Appleton and Co., 1847), opposite p. 202.

They went to lucky recipients in New York City, Washington, D.C., and Coxsackie, New York. Edmonds gained even greater exposure when two of his works, *Sparking* (fig. 6) and *The New Scholar* (fig. 7), were engraved for distribution in 1844 and 1850 respectively. Another of his efforts, *"What Can a Young Lassie Do wi' an Auld Man"* (unlocated) was reproduced as a wood engraving (fig. 8) in the December 1851 issue of the *Bulletin of the American Art-Union*.[30]

Like many of his fellow artists, Edmonds was affected by the Art-Union's downfall. After ten years the organization's meteoric ascendancy may have been its undoing: overexpansion led to financial problems, and a politically motivated suit challenged the legality of lotteries. In December 1852 a final sale was held. Among the sale items were Edmonds's *"What Can a Young Lassie Do wi' an Auld Man"* and *Preparing for Christmas* (unlocated), along with copies of the two engravings and the wood engraving created for the Art-Union and even the copperplate and woodblock for the prints. The auction at least enabled the institution to close its doors with more of a bang than a whimper. One account reported that "the Art-Union sale went off with unexpected animation and success, and from the decided prestige it has given to American art, may, amidst the difficulties of the Institution be considered a final act of triumph."[31] The Art-Union, moreover, survived in a certain sense through the transfer of its remaining funds and works of art to the New-York Gallery of the Fine Arts.

Founded in 1844, this institution was conceived as a means of transforming the late Luman Reed's collection into a permanent and public gallery of American art.[32] Reed's business partner in the wholesale grocery business, Jonathan Sturges, was committed to perpetuating Reed's goals regarding the encouragement of the fine arts, and it was he who ensured that Reed's collection would remain intact. Not only did Sturges generate the impetus for founding the New-York Gallery of the Fine Arts, he also provided substantial financial support, which helped keep the struggling institution afloat during the fourteen years of its shaky existence. In addition to his activities in connection with the New-York Gallery, Sturges was an early member of the Sketch Club and made his fiscal expertise available to the American Art-Union, serving as an officer and manager from 1842 to 1846. Consequently, he also collaborated closely with Edmonds on behalf of the New-York Gallery; they were president and vice president. They were backed by a large group of influential New Yorkers.[33] Among the trustees with especially close associations with Edmonds were Thomas S. Cummings (1804–94), the only other artist; William Cullen Bryant; Charles M. Leupp; Joseph N. Lord

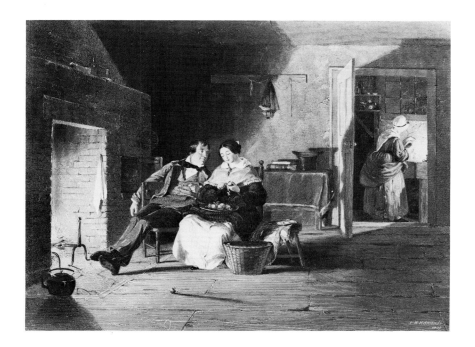

FIGURE 6. Alfred Jones, after Francis W. Edmonds, *Sparking*, 1844. Engraving (hand colored), 12¾ × 16¹³⁄₁₆ in. (image). Amon Carter Museum, Fort Worth, Texas.

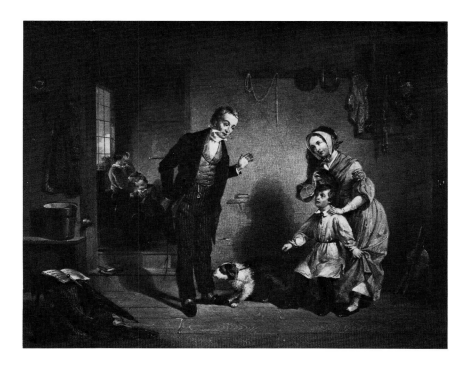

FIGURE 7. Alfred Jones, after Francis W. Edmonds, *The New Scholar*, 1850. Engraving, 7⅜ × 9⅜ in. (image). Private collection.

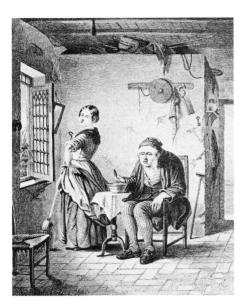

FIGURE 8. After Francis W. Edmonds, "*What Can a Young Lassie Do wi' an Auld Man,*" 1851. Wood engraving. From *Bulletin of the American Art-Union*, December 1851, p. 141.

(Edmonds's father-in-law); and Shepherd Knapp, president of the Mechanics' Bank.

From the outset, Edmonds immersed himself in a variety of activities, beginning with the hanging of the gallery's inaugural exhibition late in 1844. He apparently worked alone, Cummings being out of town, although he sought Durand's advice by correspondence and kept the latter abreast of the hanging's progress and of financial developments.[34]

The core of this first exhibition was the Reed collection. One critic felt this created an imbalance, especially with regard to the many examples of George W. Flagg's (1816–97) work, eleven in all. Also criticized were the admission fee and the inclusion of copies after Old Masters. Sturges responded to these objections, no doubt in consultation with Edmonds.[35]

Edmonds exhibited regularly in New-York Gallery exhibitions. In the first show he was represented by three paintings: *Mischief in the Pantry* (unlocated) and *The Bashful Cousin* (plate 5), both of which were lent by Jonathan Sturges, and *An American Boy's Inheritance* (unlocated), which was lent by Joseph N. Lord. Edmonds attempted to show a variety of his works, and occasionally he prevailed upon collectors from afar to lend paintings. In 1853 he asked his cousin Thomas Worth Olcott of Albany to lend *Commodore Trunnion and Jack Hatchway* (plate 2).[36] But he remained ever sensitive to the needs of the permanent collection as well and donated his own *The Image Pedlar* (plate 6), first exhibited there in 1846, to the gallery's collection. Years later, in 1857, he attempted to secure Samuel F. B. Morse's *House of Representatives* for the New-York Gallery, without success. This must have been one of Edmonds's final acts on behalf of the gallery, since by the end of the year the *Crayon* reported that its collection of paintings and statuary had "found a home under the protective wing of The New-York Historical Society," where they still reside. The reason for the gallery's demise can be inferred from the *Crayon*'s contrasting description of the success of this new arrangement: "The city now possesses *a free public gallery of works of Art*, accessible at suitable hours, and established so permanently as to attract donations, and justify the hope of future enlargement."[37]

Sturges, Edmonds, and others who had tasted a double draft of disappointment regarding the failure of the American Art-Union and the New-York Gallery of the Fine Arts could take some solace in the establishment of a legitimate offspring under the caring administration of the New-York Historical Society.

In addition to his support of what today might be termed "alternative spaces," Edmonds was involved with the most prestigious "establishment" art institution of the day, the National Academy of

Design. Having gravitated there to take classes at the outset of his career, he was by 1840 a full-fledged academician. He exhibited there regularly, no mean feat given his other duties. At times the decision of what to show overwhelmed him. He wrote to Durand in September of 1849, seeking counsel: "You know all the pictures I have painted of late years are out of my hands. I want your opinion as to which of my pictures you would advise me to send. You know I do not paint enough pictures to give me any great choice."[38] It is clear from this letter that Edmonds, an inordinately busy man, also sold what he painted.

The National Academy recognized Edmonds's administrative abilities, and from 1843 on he served in a number of official capacities, ranging from member of the Committee of Arrangements (1843–60) to recording secretary (1846–48) and treasurer (1857–59). These activities overlapped with his officerships in other organizations, a situation paralleled by several other cultural leaders.[39] The limited pool of people with both an expertise in and commitment to the arts made this kind of interlocking inevitable, and it underscores the existence of a close-knit group pursuing the common goal of cultural enrichment for their country.

A prime example of this collaborative spirit was a joint effort to mount a memorial exhibition of Thomas Cole's works in February 1848, with the proceeds to benefit his family. The organizing committee, comprised of officers from the National Academy, the New-York Gallery, and the American Art-Union, consisted of Asher B. Durand, Jonathan Sturges, Daniel Huntington (1816–1906), Charles M. Leupp, Edmonds, Thomas S. Cummings, A. M. Cozzens, P. M. Wetmore, and W. J. Hoppin. Although the author of a newspaper item announcing the exhibition associated Edmonds with the New-York Gallery, he could just as appropriately have associated him—and others—with the other two organizations.[40]

The only documented friction between Edmonds and a fellow artist was in connection with his role as treasurer and later trustee of the National Academy of Design. His antagonist was fellow trustee Thomas S. Cummings. The issue centered on the ongoing search for a permanent site for the National Academy, which was not realized until 1865. Through the decade of the 1850s Cummings kept trying to push ahead with a building plan, while Edmonds could be counted on for a gloomy financial prognosis. In 1861 their conflict came to a head when Edmonds, now a trustee, expressed concern about the National Academy's precarious financial situation. He tried to call a meeting of Durand, Sturges, and himself, thus constituting a quorum of the trustees that would be able to vote on a resolution releasing the academy from an obligation to build on the Twenty-

third Street property owned by the institution. Edmonds kept the meeting secret from his opponent, and it is not known if it was actually held. He did not win in the end, and he incurred Cummings's enmity. Such internal divisions eventually led both Durand and Edmonds to resign from their official capacities at the institution.[41]

The last art organization Edmonds was involved with was the Artists' Fund Society, founded in 1857 under the direction of Durand, Edmonds, and Cummings, before their differences had become irreconcilable.[42] The purpose of the society was to aid artists' widows and children through the sale of works donated by their surviving fellow artists. The first beneficiary was the family of William T. Ranney (1813–57). Edmonds contributed by offering paintings and sound financial advice. After he withdrew from the National Academy, the Artists' Fund Society exhibitions became an important venue for his work, where his financial observations occasionally addressed broad issues concerning the American economy. In a letter of 10 December 1860 to John Kensett regarding the disposal of pictures at auction for the society, for instance, Edmonds advised placing a conservative lower limit at which the works could be sold:

> I mean these remarks to apply to the *present time*. Ordinarily I would let them [the pictures] take their course. But these are times which we have not seen in our day. It is not a mere money panic, but a panic of a much graver and more important character, and one which should cause the Committee to examine the ground well before they advance.[43]

Contained in this assessment is a chillingly prophetic view of the effect of the imminent Civil War.

To round out the picture of Edmonds's contributions to the developing nation in the decades prior to the war, it is instructive to return briefly to his role as a banker, for the last decade of his life encompassed both the zenith and nadir of his financial career.

In 1850 Edmonds, at forty-four years old, had been in the banking profession for over twenty-five years. He was in the prime of life and had achieved a position of great respect and influence in financial circles. In 1853 he played a part in the founding of the New York Clearing House, set up to facilitate the transfer of funds among banks by replacing much of the cumbersome and redundant exchange of hard currency with paper certificates drawn on money deposited in a common vault. Edmonds was a moving force behind this concept, a lasting contribution to the New York banking community; in the spring of 1853 he provided an exhaustive plan detailing the proposed procedure.[44] By the summer of 1853, cashiers of the city's major banks were meeting regularly. The minutes show Edmonds

assuming a leading role; not surprisingly, he was chairman of the first Clearing House Committee.[45] According to an early history of the Clearing House, it was an "especial honor to serve on the committee much less chair it."[46]

The minutes also refer to the less happy side of Edmonds's career on Wall Street, however. For the meeting of 6 August 1855, they reported: "Mr. Punnett was elected Chairman of the Committee to fill the vacancy created by the resignation of F. W. Edmonds, Esq. as the Cashier of the Mechanics' Bank and as such Chairman of the Clearing House Committee."[47]

Edmonds had tendered his resignation amidst a heated controversy over the misappropriation of funds at the Mechanics' Bank. George Templeton Strong offered a rather sensational account:

> July 31 Report in the street of a defalcation. Edmonds of the Mechanics' Bank is reported to have left town and to have left accounts behind him that don't balance; very bad if true.

> August 2 The trouble in the Mechanics' Bank proves to be some hitch between Edmonds and Burke, the clerk of the City Chamberlain's department. Edmonds resigned and his resignation is accepted. It grows out of payments by some one to somebody, in the nature of secret service money to secure the Bank the funds in court.[48]

Strong's second entry indicates the complexity of the issue. Subsequent to the Democratic victories in 1853,[49] Edmonds had been appointed city chamberlain in January 1854, an unabashedly political appointment entailing control of the city's funds. The chamberlain had the advantage of being allowed to deposit the monies in his own bank without having to pay interest on them, and with the right to use such funds for income-producing loans. This position was vulnerable to such underhanded but accepted methods of persuasion as under-the-table contributions to bank officers for political purposes.

Paradoxically, as chairman of the Clearing House Committee Edmonds belonged to an organization that advocated extremely strict controls and well-regulated procedures. The year before Edmonds had noted in his diary that he was being loudly criticized for being instrumental in breaking banks because of the Clearing House's no-nonsense demand that banks pay their balances promptly.[50] Yet he was, as chamberlain, accused of apparently questionable arrangements regarding deposits. Edmonds's predecessor as chamberlain was Shepherd Knapp, the president of the Mechanics' Bank and a Whig; it is entirely possible that he was equally guilty of the practice of accepting questionable contributions and that Edmonds was the victim of a whistle blower. But Knapp capitalized on his rival's situation

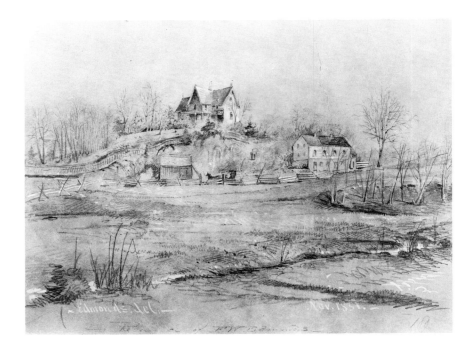

to discredit his honesty, even though it was at the cost of his bank's reputation.[51]

In the face of allegations of misappropriation of funds leveled at him by Knapp and the Mechanics' Bank, Edmonds quickly produced a lengthy and spirited defense. But whether culprit or scapegoat, the damage was done. Edmonds withdrew from all active roles in the banking profession (though he was allowed to complete his term as a director of the bank). Yet to say that he retired from the world of business would be misleading; nor was he ostracized from it. He continued as a director of the Harlem Railroad and had the unwavering support and concern of his friends.[52]

He also formed a bank-note engraving partnership, first with Alfred Jones and subsequently with James Smillie. Edmonds's expertise and connections stood the business in good stead. The designs he provided for the notes led *Harper's* to comment in a lengthy article on the company that "the walls are covered with original drawings by Darley, Casilear, Edmonds, Herrick and others. Portfolios filled with such drawings are opened for our inspection. A connoisseur in art could nowhere spend a more pleasant day than here."[53] The partnership was incorporated under favorable terms into the American Bank Note Company in 1858, and Edmonds eventually became a director and secretary of the expanded company.

In this venture, Edmonds achieved perhaps the ultimate synthesis of art and commerce. Yet it was his painting that seems to have furnished the greatest comfort after the banking debacle. The closing

words of his "Defence" declared his intention to leave the bank and devote "the rest of my days to a pursuit far more congenial to me—the pursuit of the fine arts."[54]

Edmonds retreated to Crow's Nest (fig. 9), his home in suburban Bronxville, New York, and continued to live an active life until his untimely death in 1863 at the age of fifty-six. Fitting testimony to his public standing was the running of a special train by the Harlem Railroad to carry New Yorkers to Bronxville for his funeral. Even the acerbic Thomas S. Cummings acknowledged Edmonds's importance in his preface to the remembrance prepared for the National Academy of Design by John Worth Edmonds.[55] Francis Edmonds's life was a richly tiled mosaic, offering insight into many aspects of both the financial and cultural life of New York in the decades leading up to the Civil War. Yet the most enduring interest of this extraordinary individual's career is to be found in his overriding passion: his art.

CHAPTER II

The Early Years, 1806–41

THE OUTSET OF EDMONDS'S CAREER INVOLVED YEARS OF STRUGGLE FOR artistic competence, twice suspended for extended periods due to his obligations as a banker. His work during this time anticipates much of what would constitute his mature vision. The content of his early work relied heavily on a wide range of literary subjects, and he emulated seventeenth-century Dutch painting for many of the formal and technical aspects of his development. But it was a trip to Europe in 1840–41 and the resulting exposure to the Old Masters that finally crystallized his vision and climaxed his artistic education.

Francis Henry William Edmonds was born on 22 November 1806, in Hudson, Columbia County, New York, the son of Samuel and Lydia Worth Edmonds. His parents' union was an unusual one; Samuel was a highly respected military officer who attained the rank of general in the War of 1812, and Lydia was raised as a Quaker and presumably a pacifist. The premium placed on tolerance by the Society of Friends was to benefit young Francis. Although the Society frowned on the practice of art, when he demonstrated a greater enthusiasm for drawing than for sums and spelling, his Quaker schoolmaster wisely encouraged him to follow his true talents.[1] (Judging from his later abilities with balance sheets and his predilection for literary themes in his art, Edmonds could not have been completely oblivious to classroom proceedings.) By the age of thirteen he was buying and grinding paints, attempting to prepare canvas, copying engravings, and even trying to work directly from nature.

By the time he was fifteen Edmonds had decided that he wanted to become an engraver, but his hopes of entering this field of popular art were squelched by prohibitive apprenticeship fees.[2] At this time, in the 1820s, engraving constituted one of the primary vehicles for gaining entry into the art profession. Though he was unable to apprentice himself for formal study, part of Edmonds's early independent training was to create designs for wood engravers. The precision and penchant for detail this entailed had a decided effect on his mature artistic output. In a preliminary draft of his autobiography, Edmonds recounted that the older artist William Dunlap (1766–1839) praised his abilities and took him along on a sketching trip in the Catskills.[3]

This encouragement was undoubtedly reassuring and helped foster Edmonds's tenacious commitment to painting.

In 1823 Edmonds's uncle Gorham A. Worth offered him a position as an underclerk at the Tradesman's Bank in New York City, where he was cashier. Edmonds later recalled that when he was summoned to New York to enter the banking profession, "I was obliged to abandon the idea of studying as an artist . . . it was with great reluctance I laid aside the pencil—and only sheer necessity caused me to do it."[4] By 1826 he had made up for this sacrifice and begun to fuse his two worlds. He took rooms with the engraver George W. Hatch, a pupil of Asher B. Durand; at Hatch's urging he enrolled in evening classes at the Antique School of the newly founded National Academy of Design. Edmonds welcomed this opportunity to renew his involvement with the arts. At the National Academy, he wrote, he met William Sidney Mount (1807–68), the wood engraver Joseph A. Adams (c. 1803–80), William Page (1811–85), and Raphael Hoyle (1804–38).[5]

Despite a paucity of documentary evidence, we can extrapolate Mount's significance for Edmonds's development from Edmonds's works. Page and Hoyle, on the other hand, were to supplement Edmonds's enthusiasm with sound technical advice, which has recently been discovered in a notebook Edmonds kept. Although only two years older than Edmonds, Hoyle appears to have assumed the role of mentor. Edmonds devoted nearly two pages of his notebook to "Hints received from Raphael Hoyle," which included suggestions, among others, about composing a palette, using color, and selecting brushes and canvas. Other memoranda included diagrams and discussions of the palettes of Thomas Sully (1783–1872), Gilbert Stuart (1755–1828), and Sir Henry Raeburn (1756–1823), a brief commentary on the working method of Sir Thomas Lawrence (1769–1830), and an extract from John Burnet's *Treatise on Painting* (the latter publication was to be especially important to Edmonds).[6]

For the most part, Edmonds's notations centered around questions of color, shadow, glazing, and scumbling, his most persistent concern being the effective rendering of shadows. Interestingly, he discussed most of the information in the context of portrait painting, which was to be little more than a sideline for him. The young artist's models were those painters with an especial affinity for color, a predilection that was to be an essential ingredient in his own mature work.

It is frustrating that so much of Edmonds's early work remains unlocated, since it would be instructive to be able to compare theory and practice. A case in point is the still unlocated painting Edmonds exhibited at the National Academy of Design in 1829, *Hudibras Cap-*

turing the Fiddler. In his autobiography, the artist recalled that this was the first painting he had ever carefully finished and was his first rendering of an original subject.[7]

Taken from Samuel Butler's satirical epic *Hudibras*, the picture, according to its title, shows an episode in part 1, canto 2, in which the English knight Hudibras rather unceremoniously subdues his already crippled adversary, Crowdero.[8] Why Edmonds selected this particular subject remains a mystery. But the farcical nature of the poem reflects Edmonds's delight in humorous authors (some others were Tobias Smollett, Washington Irving, and James Kirke Paulding) and anticipates a number of the artist's droller works. While Edmonds's interest in literary subjects may be some indication that he aspired to the more lofty intellectual heights of artistic expression, there remains an undercurrent of warmth and humor that keeps most of this work human and accessible.

Hudibras Capturing the Fiddler was well received by Edmonds's peers, and William Dunlap, then vice-president of the National Academy, praised it extravagantly—albeit mistakenly as a work by a different artist. The painting had sufficient merit to bring about Edmonds's election as an associate member of the National Academy.[9]

Edmonds's first experience as a practicing artist was short-lived. In 1830, when he was appointed cashier of the Hudson River Bank in his native Hudson, the pressures of his new position forced him to suspend his artistic activities. Another factor may have been his marriage to Martha Norman, whom he met in Hudson.[10] Edmonds wrote that the two-year interlude upstate caused him to lose the knack of painting entirely, and what efforts he did make to resume painting were unsatisfactory. Not until 1835 did he undertake to rectify this situation, by way of a portrait-sitting-cum-tutorial with his old friend William Page. Edmonds particularly admired Page's proficiency in coloring, which he perceived as his own area of weakness. He recalled:

> I employed him to paint my portrait, upon condition that he would place a looking glass behind him by which I could observe his process of commencing and finishing a head. He willingly assented to this and very kindly gave me many hints as he progressed with the work which as soon as I returned home I committed to paper.[11]

Edmonds was assiduous in the task he had set himself, filling his technical notebook with eleven pages of notes in addition to a page taken while his wife had her portrait painted.[12] This experience was profoundly beneficial in reacquainting him with the craft of painting. Thus fortified, he resumed picture-making, producing a work for exhibition at the National Academy in 1836. Not, however,

confident enough to show it under his own name, he used a pseudonym. Visitors to the exhibition were led to believe that the charming little picture *Sammy the Tailor* (fig. 10) was by the heretofore unknown E. F. Williams. The painting was praiseworthy, the critic for the *Knickerbocker* observed: "Good again; very good. Sammy is clearly in the full tide of inspiration, and the gentleman who took his portrait has done him ample justice."[13]

Again Edmonds relied on a literary source, a passage from Thomas Moore's *Irish Melodies*:

> Says Sammy the Tailor to me
> As he sat with his spindles cross-ways
> 'Tis bekase I'm a poet you see,
> That I kiver my head with breen baize.[14]

Given the serious nature of much of Moore's poetry, it is interesting that Edmonds selected a humorous passage. He was not yet ready to utilize subject matter from the everyday world, yet he chose literature that had a broad popular appeal.

Edmonds worked hard on the picture. "To be sure to get it right," he recalled, "I moddled [*sic*] the figure in clay, draped it, and placed it in a box to get just the right light I wanted." In 1829 the sharp-tongued critic John Neal had discussed this method of preparing a composition, originated, he said, by Sir David Wilkie (1785–1841); but he suggested that it was a technique unworthy of the greatest talents. Exactly from whom Edmonds derived this working method is not known—there is no reference to it in his technical jottings—but Neal indicated that painting from a preliminary clay model enjoyed widespread use. Crediting its origins to Wilkie would have assured its popularity, since his work constituted such an important model for budding American genre painters of the time.[15]

Sammy the Tailor is small, measuring only 9¼ by 11¼ inches; thus everything about it is compact. Edmonds placed Sammy in an uncluttered, neutral setting. It is a somewhat ambiguous space that takes on the character of a bas-relief. The artist focused his attention on Sammy's cross-legged pose, creating a lively dynamic between Sammy's pyramidal head and torso and the interlocking diagonals of his legs. The paint is handled with facility and with a remarkable sensitivity to texture. The notices tacked to the wall on the right in the picture and the shears, ink bottle, quill, and sheaf of papers on the lower left are painted with great dexterity, anticipating Edmonds's later fondness for still-life elements. The colors, too, are deft. They are bold and clear; the red of Sammy's apron was to become a recurrent feature in Edmonds's oeuvre.

Edmonds was surprised by *Sammy the Tailor*'s warm reception

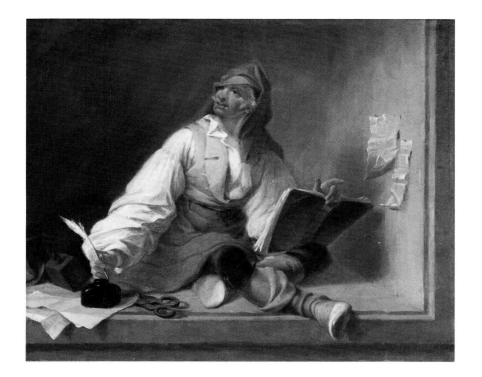

FIGURE 10. Francis W. Edmonds, *Sammy the Tailor*, 1836. Oil on canvas, 9¾ × 11¾ in. The Art Institute of Chicago; Charles H. and Mary F. S. Worcester Collection.

and encouraged by its success to continue to paint. He was still not ready to discard his pseudonym, however, and once again relied upon "E. F. Williams" to author the two paintings he exhibited at the National Academy in 1837. These works, listed in the catalog as *The Skinner* (fig. 11) and *Dominie Sampson Reading the King's Commission to the Laird of Ellangowan* (unlocated), indicate Edmonds's continued use of literary subjects.

The Skinner depicts an unsavory type of Revolutionary War figure. Skinners had been members of marauding gangs who pledged allegiance to the American cause and usually roamed the territory between the British and American lines in Westchester County, New York. (In his laudatory comments on Edmonds's paintings, the critic for the *New-York Mirror* observed that skinners were nothing more than "scoundrel vagabonds" and "cow-thief[s] and robber[s] of the defenceless.")[16] This territory was the setting for James Fenimore Cooper's *The Spy*, in which skinners played a considerable role. Cooper was disdainful of their activities, but grudgingly recognized their service to the Revolutionary cause through their disruption of the British.[17] The protagonist of the painting, presumably surprised by the soldier entering at the rear, wears a costume later than the Revolutionary period in style, one that does not accord with the scruffiness normally ascribed to these misfits. The artist challenged

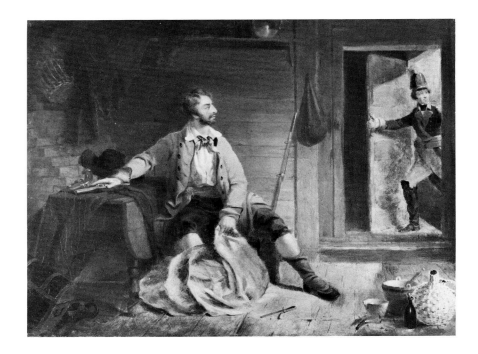

himself in attempting this rather complex composition. He set the skinner in a stablelike interior containing an elaborate composite of still-life elements: a straw-covered flagon, a bucket, a bowl, and a knife lying on the floor. Edmonds captured the sense of urgency as the skinner reaches for his pistol. His musket stands nearby, behind his left leg. The soldier, wearing a tall military hat with feather plume, cuts an equally histrionic figure, looking over his shoulder out the door behind him as he enters with purposeful stride. His costume, too, is a romantic fabrication, though with allusions to the British dragoons of the Revolutionary era.[18]

Why Edmonds chose this subject remains a matter of speculation, but the composition he used was more complicated than anything he had done before. Indeed, he may have begun to rely on print sources for compositional guidance, since *The Skinner*, even in its rudimentary style, demonstrates an affinity to Sir David Wilkie's *Alfred in the Neatherd's Cottage* (1807), which was published as an engraving (fig. 12) in 1828.[19]

Dominie Sampson Reading the King's Commission to the Laird of Ellangowan was based on a specific episode in chapter 6 of Sir Walter Scott's *Guy Mannering; or, The Astrologer* (1820), one of the author's highly popular Waverly novels.[20] Given the painting's extensive title, Edmonds must have been true in many details to the episode, which involved the Laird of Ellangowan's appointment as a justice in the county and his subsequent request for his resident scholar and preacher,

Dominie Sampson, to read the commission aloud. Sampson complies, and the laird, the quintessential country squire of dubious intellect, responds naively to the standard line about the king's pleasure by taking the salutation personally. Scott intended this to be a humorous moment; typically, Edmonds selected a passage that permitted him to paint subject matter in a light vein. And it was no accident that the artist derived his literary inspiration from one of the most popular authors of his day.

This painting, too, garnered Edmonds positive notice.[21] He must have been especially pleased with a favorable comparison to the highly regarded, recently deceased Gilbert Stuart Newton (1794–1835), who had achieved considerable stature as an interpreter of literary subjects in his brief and ill-starred career. A further boost to Edmonds's confidence was his election for the second time as an associate member of the National Academy of Design.[22] It is unclear whether he was elected under his real name, which was becoming known among academicians, or his pseudonym, since the following year he persisted in exhibiting incognito.

Edmonds had apparently found a successful working rhythm. He submitted three canvases to the National Academy in 1838: *The Epicure* (plate 1 and fig. 13), *Comforts of Old Age*, and *Ichabod Crane Teaching Katrina Van Tassel Psalmody* (the latter two unlocated). Much to his disappointment, none of these paintings received favorable comments. In reviewing the exhibition, a critic for the *New-York Mirror* urged Edmonds—and all other young American artists—to concentrate more on painting from nature, arguing that because they

FIGURE 12. James Mitchell, after Sir David Wilkie, *Alfred in the Neatherd's Cottage*, 1828. Engraving, 30 × 23¾ in. (sheet). Print Collection, Miriam and Ira D. Wallach Division of Art, Prints and Photographs, The New York Public Library; Astor, Lenox and Tilden Foundations.

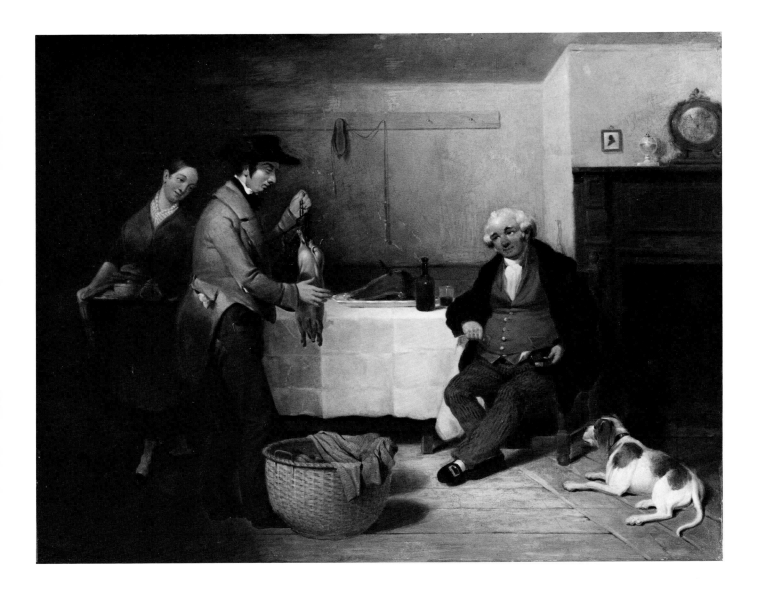

FIGURE 13. Francis W. Edmonds, *The Epicure*, c. 1838. Oil on canvas, 29¼ × 36⅛ in. Private collection.

had no Old Masters to study, they should "form a school for themselves, and that school must be built upon nature—nature carefully studied, analyzed, and understood."[23] By emphasizing painting from nature, the critic was urging artists to depict the indigenous subjects of their young nation. Edmonds's reliance on literary themes, even from American sources, was apparently not sufficiently natural. Yet in his formative years, he needed outside inspiration both thematically and compositionally; as he found the former in literature, he often turned for the latter to seventeenth-century Dutch models.

Seventeenth-century Netherlandish art enjoyed considerable popularity in the United States prior to the Civil War. There were many striking similarities between the two societies, most obviously

manifested in the rise of a strong mercantile class following closely on newly won independence. In both republics there emerged a powerful sense of national pride, and the quest for a national character, it was thought, could be supported by literature and art.[24] It was the financially strong and politically influential middle class that dominated the patronage of art in both societies, although the encouragement of the arts in America took longer to flower. Many American collectors and painters recognized the Dutch achievements and modeled their efforts on their European counterparts. As early as 1814, the *Portfolio*'s reviewer of the fourth annual exhibition of the Pennsylvania Academy of the Fine Arts exhorted America's wealthy citizens to support their artists in much the same way the Dutch burghers had supported theirs:

> The Dutch and Flemish schools, for faithful representations of nature, have never been excelled. Who were here the connoisseurs? Who the patrons of the artists?—Merchants and other wealthy citizens—men of plain and simple manners, possessing taste without affectation. The burgomaster, instead of giving expensive routes [*sic*], amused his guests with his collection of pictures, which consisted (instead of the mutilated and uncertain works of foreign masters) generally of the meritorious productions of his fellow-citizens. The fine arts in Holland and Flanders were fashionable, and artists of merit sought after and rewarded. The number and excellence of their works are sufficient proofs of the fact. The pictures of Dutch and Flemish artists were generally of a small size, and well calculated to ornament rooms. We are not without hopes that some of our wealthy citizens will soon set the laudable example of furnishing their houses with the productions of our own artists. We may then hope to see works of art of the American school equal, perhaps superior, to any that have preceded them.[25]

Dutch and Flemish painting, then, contributed substantially to the developing American artistic consciousness in the decades prior to the Civil War. National chauvinists could not begrudge this foreign influence, because it so well supported their artistic goals of recording the activities of daily life. Americans were attracted to the good-natured, matter-of-fact view of the world they saw in the paintings of the earlier northern tradition, and they noted that a clear sense of the Dutch national character could be drawn from these pictures. In embracing the Dutch mode of artistic expression, citizens of the young republic hoped that they, too, could bring into focus exactly who and what they were.

American painters could see Dutch and Flemish works under a number of different circumstances: in public exhibitions, in private collections, at auctions, in engravings, and in art publications.[26]

Edmonds's art is particularly strong evidence of this welcome exposure. No less a figure than William Sidney Mount recognized Edmonds's debt to Dutch painting when he noted in his diary around 1846, "Edmunds [*sic*] generally introduces a door or window in his pictures to let in the sky or reflected light, as often seen in the dutch masters."[27] Much of the rest of Edmonds's career reflects this influence.

It is instructive, for instance, to dwell on *The Epicure*, the painting Edmonds exhibited to such disappointing notices at the National Academy in 1838. Not only is this the only work of the three on view in 1838 known to us today, but it survives in two versions—one in the Wadsworth Atheneum in Hartford, Connecticut (plate 1), and another still in the possession of the artist's descendants (fig. 13).

Both versions of *The Epicure* have the same central motif, a dining room in which a portly gentleman is taking a pinch of snuff while inspecting a suckling pig that has been presented for his delectation. The scene has a staged quality; literature, possibly the writings of Tobias Smollett or Sir Walter Scott, seems to have inspired the artist.[28] Beyond this, the paintings differ radically, especially in their backgrounds. In the Wadsworth Atheneum version, Edmonds turned directly to a Dutch source for compositional guidance; in the alterations he made in the other version, he demonstrated an increased concern for originality.

The existence of two versions of *The Epicure* is the only known instance of duplication in Edmonds's oeuvre. Although precise documentation regarding chronology does not survive, comparison with a print after a seventeenth-century Dutch painting makes a strong case for judging the Wadsworth Atheneum *Epicure* the earlier of the two. It has striking similarities to a drinking scene by Pieter de Hooch (1629–84; fig. 14) reproduced by the Scotsman John Burnet in his *Treatise on Painting* (1827). Edmonds was definitely aware of the de Hooch reproduction in Burnet since, when he saw the original painting (fig. 15) in the Hope Collection in London in 1841, he noted in his travel diary that the work was "in Burnet."[29] The composition of the de Hooch was reversed in the reproduction process for the *Treatise*, and it was this mirror image that Edmonds used as his source.

Burnet represents an important influence on Edmonds. His writings were well known in America by the 1830s; Edmonds's technical notebook indicates that he knew about them from an early point in his career.[30] Burnet's views were highly respected among American artists at this time, and one of his pamphlets, "Practical Hints on Composition," which made up part of the *Treatise on Painting*, was given as a premium for the antique class at the National Academy of Design in 1832.[31] He placed great importance on the study of

nature, in which he found "a truth and precision, a variety and beauty, that objects drawn from memory, or those images under the guidance of the mind only, have no pretension to."[32] Not surprisingly, he was particularly fond of paintings from the Low Countries.

Burnet was to continue to prove a sympathetic source for Edmonds, and surely their shared affinity for Netherlandish art played a central role in this. Many of the Dutch paintings Burnet reproduced in his *Treatise* were genre scenes. Among the most pertinent were two by Adriaen van Ostade (1610–84; figs. 16, 17) and two by Pieter de Hooch (figs. 14, 18), one of the latter being the one that inspired *The Epicure*. Burnet was keen on de Hooch's art, arguing that he "carried the highest principle of the art into the humblest walks . . . stamping the whole with the firmness and truth of nature."[33] This was a sentiment that would have been very persuasive in crystallizing Edmonds's own predilections. Burnet had been a fellow student of David Wilkie at the Trustees' Academy in Edinburgh and subsequently followed him to London.[34] Burnet pursued the art of engraving rather than painting, however, and, in addition to his treatises, established a reputation for reproducing Wilkie's work. His admiration for Wilkie and for Dutch and Flemish art was most important for American painters, Edmonds in particular.

In both versions of *The Epicure*, the single-corner interior with

FIGURE 14. John Burnet, after Pieter de Hooch, *A Girl Drinking with Two Soldiers*, 1827. Etching. From John Burnet, *A Practical Treatise on Painting* (London: James Carpenter and Son, 1827), part 3, plate 8, fig. 1. Henry Francis du Pont Winterthur Museum Library, Winterthur, Delaware; Collection of Printed Books.

FIGURE 15. Pieter de Hooch, *A Girl Drinking with Two Soldiers*, 1658. Oil on canvas, 27⅛ × 23⅝ in. Musée du Louvre, Paris.

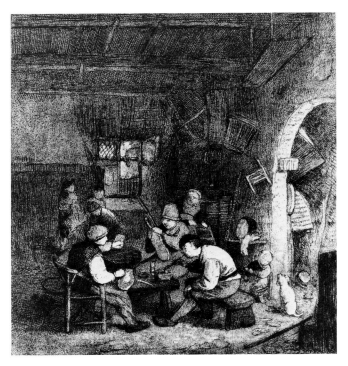

the back wall parallel to the picture plane, the recession into space through two upright rectangular doors, and the map hanging on the wall behind the seated figures provide a rigid geometric format. In addition, the placement of the window along the wall at the right and the way the wooden floor recedes are common elements; Edmonds changed the direction of the planking from parallel to the picture plane in the first *Epicure* to perpendicular in the second, thereby distinguishing it from the arrangement in the print of the Dutch painting. Finally, Edmonds appears to have borrowed even the print's color scheme: the relationship between the gourmand's red vest and black jacket echoes de Hooch's juxtaposition of the seated girl's red skirt and the black suit of the gallant pouring her wine. Since the color scheme of both versions of *The Epicure* is nearly identical, Edmonds must have been familiar with the de Hooch print from the outset.

In the second version of the painting Edmonds moved cautiously toward an original composition. The figures in the center of this version are placed much closer to the front of the picture plane. The tables are laid virtually identically in both paintings, with the exception of the knife projecting from the edge in the Wadsworth Atheneum painting. (This addition, an extra flourish on the part of the artist, reflects his first modest attempt to alter the original source.)

On the back wall parallel to the picture plane in the later painting, Edmonds substituted a row of wooden pegs for the map in the first version and the de Hooch print. The left background no longer has a pair of receding doorways with a couple conversing beyond. On the right, the fireplace, recumbent dog, framed silhouette, and oil lamp and clock on the mantel in the second *Epicure* replace the oblique wall pierced by a window, pegs with hanging hat and cloaks, and basket with wine bottles and corkscrew on the floor. (In the initial version a fireplace set along the oblique wall, with a hooked rug and a dog or a cat curled up in front of it, was painted out.)[35] Perhaps most important, the figures in the second version are infused with greater animation; they are not as stiff and wooden as those in the first attempt.

Adverse criticism notwithstanding, Edmonds was not ashamed of *The Epicure*, since he exhibited it at the Fourth Annual Exhibition of the Brooklyn Institute. He went on to submit two new works to the National Academy exhibition in 1839, *The Penny Paper* (unlocated) and *Commodore Trunnion and Jack Hatchway* (plate 2).[36]

Charles Lanman (1819–95) has given us a description of *The Penny Paper*, which he referred to as *Newspaper Boy*, noting that it represented "a large room thronged with men, women, and children, into the midst of whom a ragged boy has entered to sell his Sunday morning papers."[37] Edmonds's own reminiscence indicated that it had been his most ambitious effort to date:

> The former consist[ed] of many figures and an interior was considered for its grouping. Effect and finish superior to all my other works. It cost me a deal of labour as there were so many figures and objects brought into the picture all of which were painted from life, that it took me the whole of the summer of 1838 to finish it. Whole groups in it were painted in and painted out several times.[38]

The reference to painting from life reflects Edmonds's willingness to take criticism to heart. As well as aspiring to a sense of immediacy by working from live models, Edmonds selected an episode from contemporary life, since penny papers catering to the masses were a recent phenomenon.[39] Although these tabloids initially established their market share through sensationalism, they gradually developed a social conscience and purported to champion the causes of their less fortunate readers. Consequently, the penny press's politics were more Democratic than Whig, which would not have been lost on Edmonds the Democrat.

The painter could take great satisfaction in being singled out as one of the promising amateurs by the critic for the *Commercial Advertiser*:

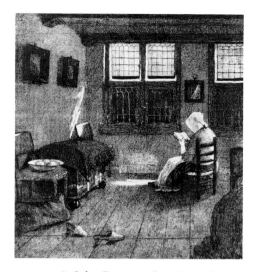

FIGURE 18. John Burnet, after Pieter de Hooch (attributed to), *Woman Reading*, 1827. Etching. From John Burnet, *A Practical Treatise on Painting* (London: James Carpenter and Son, 1827), part 3, plate 8, fig. 2. Henry Francis du Pont Winterthur Museum Library, Winterthur, Delaware; Collection of Printed Books.

A still more remarkable feature of [the exhibition] is the striking improvement evinced by many of the younger artists, some, whose names appear for the first time in the catalogue, having contributed works of art which in point of excellence tread closely on the productions exhibited by gentlemen who have long been known and honored in the profession. Another noticeable fact is the high degree of talent and skill evinced by some of the amateur exhibitors. . . . No. 241—"The penny paper" . . . is one of the pictures by amateurs to which we had reference in the first paragraph of this article.[40]

Edmonds thought highly enough of *The Penny Paper* to exhibit it in 1844 at the Boston Artists' Association.[41] This was his earliest known exposure in that city.

In his other 1839 submission, *Commodore Trunnion and Jack Hatchway* (plate 2), Edmonds reverted to his fondness for literary themes, in this instance an early episode from Tobias Smollett's *The Adventures of Peregrine Pickle*.[42] Again he embraced the comic mode, although he simplified and somewhat refined the book's description of the rather boisterous tavern scene in which Commodore Trunnion responds explosively to information garnered from the newspaper by Jack that a rival, Admiral Bower, is being created a peer of the realm. Edmonds opted for the less emotionally fraught moment when Jack is scanning the newspaper and the commodore pouring himself a drink. Perhaps Edmonds was still intimidated by the prospect of depicting extreme emotions and the convincing facial expressions that this entailed.

Edmonds chose to forego the rich possibilities of the novel's tavern setting for what seems, judging from the plethora of nautical paraphernalia, to be the commodore's workroom. Edmonds evidently delighted in rendering these objects, which range from block and tackle, harpoons and sinkers hanging from the rafters and wall, to a chart and pictures of a naval engagement and an anchor (a reminder of good fortune). The large flagon covered by woven straw at the left and the box full of charts and papers under the table are further testimony to the artist's considerable ability in realizing still-life elements.

Edmonds employs the familiar single-corner interior format but demonstrates a growing sophistication in spatial configuration that is more complex than those of his earlier works. The composition is fluid, and a unity of character and setting conveys a vivid immediacy not fully realized heretofore.

Commodore Trunnion and Jack Hatchway reflects considerable artistic maturity and fully deserved the praise it received from the press. Among its admirers was no less a personage and art lover than the noted diarist and former Whig mayor of New York, Philip Hone:

The School of Mount, the American Wilkie, appears to have attracted many aspirants after the honours of that class of subjects in which he excells, and they have produced several capital things. Foremost in the number stands two pictures by Mr. Edmonds, an amateur painter—one representing the reading of a penny paper, the other "Commodore Trunnion and Tom Pipes" [*sic*]—both admirable; indeed, I prefer the latter to a new picture of Mount's, "The Rabbit Trapper's," which he has painted for Mr. Charles A. Davis. I am puzzled to know how Mr. Edmonds finds time, in the midst of his laborious occupation as cashier of the Leather Manufacturers' Bank, to devote himself to an art so foreign to his ordinary pursuits, and how under so great a disadvantage, he should have arrived at such proficiency.[43]

To be associated with Mount would have brought Edmonds satisfaction enough; to be compared favorably must have been cause for celebration. This was not the only time the two artists' names were linked and not the sole instance that Edmonds received accolades for a superior performance.

Commodore Trunnion and Jack Hatchway also merits attention because it was one of the first paintings Edmonds is known to have parted with. The nature of the transaction illustrates the interconnectedness of Edmonds's two spheres of activity, art and banking. When Edmonds was being considered for the cashiership of the Mechanics' Bank, it was stipulated that he increase the size of the bond that he had to put up for personal security. In order not to jeopardize his position at the Whiggish Leather Manufacturers' Bank by burning his bridges behind him, Edmonds turned to his cousin Thomas Worth Olcott, who had recently assumed the presidency of the Mechanics' and Farmers' Bank in Albany. Olcott obliged, but Edmonds cautioned further discretion, since he had recently been disqualified for several positions because he was, in his own words, "such an infernal *Loco Foco* [i.e., radical Democrat]."[44] Olcott, with his close ties to Martin Van Buren, shared Edmonds's political views and would have been sensitive to his cousin's predicament.

In the same letter Edmonds discussed his longstanding promise of a painting to Olcott. In the closing paragraph Edmonds assured him that his right of selection would not be affected by the outcome of the Mechanics' Bank affair. He offered him a choice of either *Ichabod Crane Teaching Katrina Van Tassel Psalmody* or "an original picture," as he put it, "from a couple of characters in Smollett's *Roderick Random* [*sic*], to wit, 'Commodore Trunnion and Jack Hardcastle [*sic*].' "[45]

The artist further requested that if Olcott selected *Commodore Trunnion and Jack Hatchway*, he permit it to be exhibited at the annual exhibition at the National Academy. Olcott obliged, and Edmonds

was able to report its favorable reception. He informed his cousin that Philip Hone especially admired the picture and "expressed a great deal [of] what I term 'soft soup' respecting my works. This from him who never spoke to me before, I thought queer of."[46] The Whig diarist certainly set his politics aside in his warm response to the work of such staunch Democrats as Mount and Edmonds. As for Hone's prior taciturnity, Edmonds seems to have forgotten that he had until then been exhibiting under a pseudonym.

When Olcott took delivery of the painting in July of 1839, Edmonds wrote reassuring him that *Commodore Trunnion and Jack Hatchway* was generally considered the best picture he had executed so far, an opinion, he added, that was the consensus of his fellow artists, the only good judges in this regard. Edmonds closed by expressing the hope that Olcott would not regret the "bargain" they had made, the genesis of which remains somewhat murky.[47]

Olcott was very sympathetic to his cousin's artistic aspirations. In at least one instance he tried to act as a dealer for his work, and he provided exposure for Edmonds by his willingness to lend *Commodore Trunnion and Jack Hatchway* to a variety of exhibitions over the years. In his capacity as broker, Olcott tried to secure *Comforts of Old Age* (1838; unlocated) for a friend, but Edmonds declined the overture because his wife was so strongly attached to the picture.[48] Indeed, Edmonds could be quite fussy about who owned one of his paintings. Very possibly it was the guaranteed income from his career as a banker that enabled him to be so selective. On the other hand, the artist's nagging insecurity about his work may well have prompted him to place it only where he was confident it would receive a sympathetic reception.

The year 1839 also marked Edmonds's earliest participation in an Apollo Association exhibition. He lent *Afternoon in the Country— A Rustic Interior* (unlocated) to the October show, feeling no doubt compelled to exhibit since he had been elected treasurer of the organization in January of that year.[49] Since Philip Hone was on the Apollo Association's Committee of Management at the same time, he may well have had occasion to communicate his admiration for *The Penny Paper* and *Commodore Trunnion and Jack Hatchway* to Edmonds personally.

It was a good year for Edmonds, as an artist and a banker. But his good fortune was shattered when his wife Martha died on January 5 of the new year. The grief of this loss resulted in a lingering malaise, which Edmonds attempted to remedy by an eight-month sojourn in Europe, beginning in November 1840.

Before he left, he submitted two paintings to the National Academy, *Sparking* (plate 3) and *The City and the Country Beaux* (plate 4).

Their subject matter, which centered around themes of courtship, must have held special poignancy for the recently bereaved artist. It is tantalizing to speculate that these paintings were conceived as a pair. Their virtually identical size and horizontal format would corroborate this, but, unfortunately, little is known about their early histories.[50]

Sparking, which was painted before Edmonds's wife died, is the more tender of the two pictures. While not painted under the specter of profound grief, the picture is moving nonetheless, since Edmonds must have known the prognosis for his wife's consumption was not good.[51] Family history has it that the woman in the kitchen in the background is Edmonds's mother, Lydia Worth Edmonds, and that the girl being courted is Martha Norman herself.[52] A comparison of the young swain in the picture with a portrait of the artist, however, reveals little resemblance, so it appears that Edmonds was not being completely autobiographical.

The term "sparking," commonly used at the time to signify courting, enjoyed popular exposure in literature as early as 1807, in Washington Irving's "Legend of Sleepy Hollow."[53] In Abram Dayton's *Last Days of Knickerbocker Life in New York* (1882), there is a description that echoes the painting, in a discussion of life in the parlor during wintertime:

> At such a time the stiff high chairs were not amiss when drawn cosily about the spacious fire-place, and the family convened for social chat. Nuts and apples, cider and doughnuts, with grandfathers Santa Cruz toddy, comprised the entertainment. On such festive occasions the bashful sweetheart not unfrequently managed to slip in, and while paring apples for the *old folks* would snatch the opportunity to glance the story of his love, and find himself assured by a crimson blush that would shed a halo about the prim old parlor.[54]

Despite the reversed roles of apple peeler in the literary and pictorial "sparking," the scenes are quite similar. Another difference is the proximity, in the painting, of the young man's hat to some books on the table, which seems to signify this Lothario's intellectual aspirations and to recommend his respectability and eligibility.

Formally, the painting reflects growing sophistication on the part of the artist. Edmonds reiterated his familiar single-corner interior format, expressing his admiration for seventeenth-century Dutch compositions by including a room beyond seen through an open door. The foreshortening of the door presented a new challenge for him. Edmonds deftly offset the rectilinear structure with an enlivening system of diagonals, many of which were created by cast shadows.

These shadows and the illumination by fire and candlelight were

central to the artist's objectives in composing the picture:

> I was impressed with the idea that all the fire or lamplight pictures that I had seen, seemed to me painted altogether too red—I had observed none of the pictures under this light had ever attempted to preserve the cool greys that are seen by day light and which I thought were not lost by candle or fire light. I therefore endeavoured to preserve as far as possible these peculiar tints so indispenible [*sic*] to a fine picture.[55]

Edmonds had paid close attention to the rendering of shadows in his "Technical Notebook," especially in the works of Stuart and Page, and with great success: the shadows in *Sparking* have a wonderfully convincing transparency, and Edmonds received high praise from the critic of the *Knickerbocker* for his masterful handling of shadow and light.[56] Particularly clever was the way he used the partially hidden light sources of the fire at the left and the candle (obscured by the doorframe) at the right as virtual parentheses for the composition.

The tenderness of the painting's mood manages to avoid any mawkish sentimentality. The scene's more prosaic aspects evince the influence of Wilkie (which the *Knickerbocker*'s reviewer did not fail to point out) as well as various seventeenth-century Dutch models; the depiction of peeling apples is especially reminiscent of kitchen scenes by Nicolaes Maes (1634–93), such as *The Apple Peeler* (c. 1650; fig. 19), though Edmonds is unlikely to have seen this particular painting.

If *Sparking* is a discreet statement about courting, then *The City and the Country Beaux* (plate 4), with its use of histrionic gesture to comment on the growing rivalry between rusticity and urbanity, offers hyperbolic bravado. Once again, the theme had currency in contemporary literature, James Kirke Paulding's *The Dutchman's Fireside* (1831) being but one example.[57] Artists had also interpreted the idea, including William Sidney Mount in *The Sportsman's Last Visit* (1835; fig. 20). In light of the shared ideals of Mount and Edmonds, a comparison of these two works is of interest.

Both tackled the same theme: the suave city slicker competing with the earnest bumpkin for a girl's affections. Both artists recognized that the obligatory sartorial color for a dandy's clothing was black.[58] But while Mount's country lad comes off as reasonably well-heeled, and somewhat retiring in his actions, Edmonds's borders on being a blustering buffoon. In his tan and ocher striped pants, butterfly bow tie, and wide-brimmed straw hat, he prepares to flick the ash of his cheroot in a still-confident display of braggadocio. The women in both pictures are appropriately demure, although Mount's seems

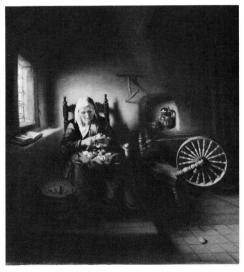

FIGURE 19. Nicolaes Maes, *The Apple Peeler*, c. 1650. Oil on canvas, 21¾ × 19¾ in. Gemäldegalerie, Staatliche Museen Preussischer Kulturbesitz, West Berlin.

wooden and rather detached; Edmonds uses his young lady to connect the opponents by means of gesture and glance. Edmonds has permitted himself a few forays into the realm of still life with the spittoon, the feather duster, and the scissors and spool of thread on the table. Mount's composition, too, is enhanced by a meticulous rendering of mundane objects—the sewing basket, rifle, book, and candlestick, and various objects hanging on the back wall. Where Edmonds outshines his worthy rival, however, is in the disposition of his figures within their setting, which is relatively spare, the severe rectilinearity offset by the undulating poses of the figures. Edmonds achieves a harmonious sense of scale, while Mount's figures appear engulfed by their surroundings.

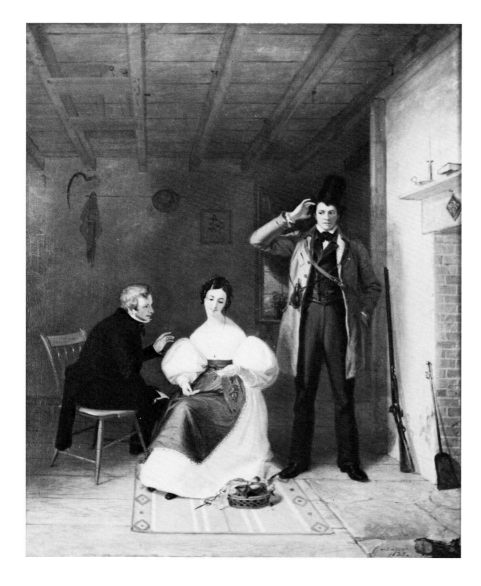

FIGURE 20. William Sidney Mount, *The Sportsman's Last Visit*, 1835. Oil on canvas, 21¼ × 17¼ in. The Museums at Stony Brook, Stony Brook, New York; Gift of Mr. and Mrs. Ward Melville, 1958.

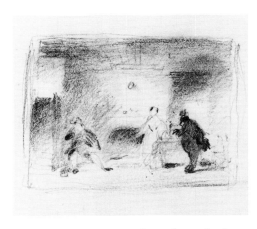

FIGURE 21. Francis W. Edmonds, study for *The City and the Country Beaux*, c. 1839. Graphite on paper, 6⅝ × 8¼ in. The Metropolitan Museum of Art, New York; Sheila and Richard J. Schwartz Fund, 1987.

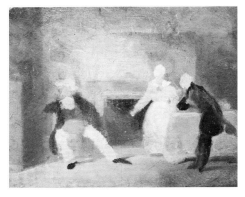

FIGURE 22. Francis W. Edmonds, study for *The City and the Country Beaux*, c. 1839. Oil on composition board, 4¼ × 5¼ in. Courtesy of Kennedy Galleries, New York.

A recently discovered preliminary drawing (fig. 21) and a small oil sketch (fig. 22) show how Edmonds refined his ideas for *The City and the Country Beaux*. The drawing illustrates the eventual placement of the figures in the painting, although the city slicker's pose is more rigid and he is on the portly side. The room, too, is much larger, overwhelming the figures, and it contains a fireplace as well as a big window behind the fellow to the right. There is only one door, which opens into the room from the back wall at the far left of the composition.

In the oil sketch Edmonds has begun the process of distillation, which seems to have been relatively straightforward. The final positioning and posturing of the figures is anticipated, and the room has been scaled down so that the relation of figure to architecture is on a more human scale. Although the fireplace survives in this version, the window has been eliminated, and the artist is nearing his solution of having the door open in from the oblique wall at the left. The struggle of painting and repainting *The Penny Paper* may have brought Edmonds this system of preliminary sketches as a modus operandi. Sporadic sketches for finished paintings exist from as late in his career as 1857.

In *The City and the Country Beaux* Edmonds took the comic tack. Although a precise date for its completion eludes us, he must have been working on the painting around the time of his wife's death. Perhaps it offered a release from his mourning. It also made reference, however indirect, to his own circumstances. In the course of his career, Edmonds had grown from a country boy into a highly respected member of New York's banking and artistic fraternity. Yet with the death of his wife, who left him with two small children, he had been placed, once again, in the role of suitor. Thus both *Sparking* and *The City and the Country Beaux* must have had great personal meaning for the artist; he unquestionably applied an extra measure of effort to their creation. He outdid himself in the process, and his reward was not only election as a full member of the National Academy,[59] but laudatory reviews that began to recognize his rightful place in the art world of his time. *Sparking* was later selected for engraving and distribution by the American Art-Union.

The review of the two works in the *American Repository of Art, Science, and Manufacturing*, while noting the painter's amateur status, asserted that Edmonds "does high honor to himself and country."[60] More significant was an extensive and thoughtful critique in the *Knickerbocker*, worth citing in full:

> We commend these pictures to the attentive study of young artists. They are *finished* pictures; finished in "the scope and in the detail." The whole story is told. No part is omitted, or slurred over. And it

is here that so many of our artists fail. They become impatient and spurn those severe requirements of detail, and finish, without proper attention to which, no painter can become great. The drawing, coloring, arrangement, etc., of these pictures are in excellent keeping. The management of light and shadow, in Number 234, is masterly. Mr. Edmonds, we have remarked, has been frequently compared to Wilkie. If by this be meant that he *copies* Wilkie's pictures, it is certainly no compliment, and very far from the truth. He can be compared to Wilkie in no other particular, (except perhaps in choosing his subjects from the same class of society that Wilkie chooses his,) than in his attention to design, composition, and light and shade. In these respects, he may be said to resemble Wilkie, and it is in these respects that Wilkie resembles the old masters. The great Scottish artist is one of the few who have carried all the principles of the *grand style* into the commonest subjects; and herein lies the eminent merit of his works. Mr. Edmonds paintings exhibit the same attention to the correct rules of taste; and we certainly hope he will not be induced, by such comparisons, to depart from them. A departure may please for a while, by reason of its novelty; but sooner or later will be discarded, as fictitious and false. The artist who paints for reputation, must seek a surer foundation for its basis than *novelty*.[61]

The comparison of Edmonds to the highly esteemed Wilkie made him, along with William Sidney Mount, one of the accomplished few to earn such recognition. This author, too, recognized Wilkie's formal affinities to the Old Masters, especially his important links to the seventeenth-century Dutch and Flemish art he favored early in his career,[62] thus suggesting a connection between Edmonds's two major sources.

Such a favorable review must have provided a tonic for the shattered Edmonds, but it was not enough. His extreme grief, coupled with escalating pressures in his new job at the Mechanics' Bank, which was still recovering from the Panic of 1837, brought on a mysterious ailment that today would be considered a nervous breakdown. A European trip was prescribed, and in the fall of 1840 Edmonds took a leave from his banking duties to travel abroad, with the added incentive of the opportunity to immerse himself in the great works of the Old Masters.[63] In many ways the journey was an artistic awakening for Edmonds, testing and confirming his admiration for Wilkie and seventeenth-century Dutch and Flemish art and sharpening all his faculties as he viewed for the first time the great art collections of the Old World.

Edmonds left New York on 15 November 1840, arriving in London on 18 December after a long and wearying sea voyage. Within two days of his arrival he had visited the National Gallery. His initial

reaction was disappointment, particularly in regard to the Old Masters, which he thought inferior. In his autobiography he explained that "they seemed to me too dark and too low in tone to please the eye." He did admire certain English paintings and judged two by Wilkie to be very fine, *The Blind Fiddler* (fig. 23) and *The Village Festival* (fig. 24). He commended their careful finish, fine effect, and harmonious coloring; later, after more experience, he compared *The Village Festival* to the Dutch painters in this regard.[64]

One of the most important results of Edmonds's sojourn abroad was that it reinforced his reverence for the recently deceased Scotsman. Though he spent part of a "disagreeable Sunday" in taking stock of contemporary British art, Wilkie remained his *sine qua non.* Noting the Continental penchant for the intellect and the contrasting British concern for the perceptual, he felt that the ideal should be a synthesis of the elevated and the commonplace. "Wilkie," he wrote in his diary, "was one who combined both of these qualities in his works. He addressed the eye in the most attractive manner and retained the mind with equal force." He admitted that Wilkie's later genre scenes and portraits did not merit the same praise, and noted, interestingly, that this falling off was due to a mental affliction. It is regrettable that Edmonds never met Wilkie; the Scotsman was known for his approachability, and Asher B. Durand reported a pleasant and instructive visit with him.[65]

In Paris, his second stop, Edmonds sought out his old friend and colleague John F. Kensett, who had been eagerly anticipating his

FIGURE 23. Sir David Wilkie, *The Blind Fiddler*, 1806. Oil on panel, 23 × 31 in. The Tate Gallery, London.

FIGURE 24. Sir David Wilkie, *The Village Festival*, 1811. Oil on canvas, 37 × 50 in. The Tate Gallery, London.

arrival. At the Louvre, to which the two men made repeated visits, Edmonds rapidly established a preference for the Dutch and Flemish schools, indicating that he "particularly admired Gabriel Metzu [*sic*], Correggio, Guido, Rembrandt, Reubens [*sic*], Teniers, Wouwermans [*sic*], Ostade, etc."[66] Kensett offered a more detailed account of Edmonds's reactions in his own journal:

> We [Kensett and painter Thomas P. Rossiter] walked along beside him and enjoyed his remarks on the various productions of the Old Masters—He is much delighted with Metzu's [*sic*] works—and all the Dutch school—the colouring of Rubens—says he cannot feel Titian—and very few of the Italian school—of the Spanish he prefers Murillo with whom he is much delighted.[67]

Edmonds's main destination, however, was southern Europe, following his doctor's recommendation of its climate. He departed for Rome on 16 January 1841, accompanied by John W. Casilear (1811–93), an American artist whom he had met through Kensett. In Rome as in Paris his arrival was impatiently awaited by a close friend; Asher B. Durand wrote his wife that Edmonds's presence would be "the most welcome sight in Rome."[68] Once settled there, Edmonds augmented his tourist activities with a regimen of painting and drawing; *Head of a Man* (fig. 25) may be one of the results of his working from the live model at this time. But seeing works by the great masters remained his main goal.

The newcomer soon realized that Rome was more suited to sculptors or painters working in the "Grand Style" than to artists of

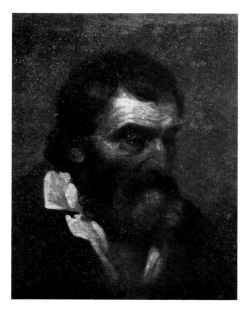

FIGURE 25. Francis W. Edmonds, *Head of a Man*, c. 1841. Oil on canvas, 18⅛ × 14⅛ in. Private collection.

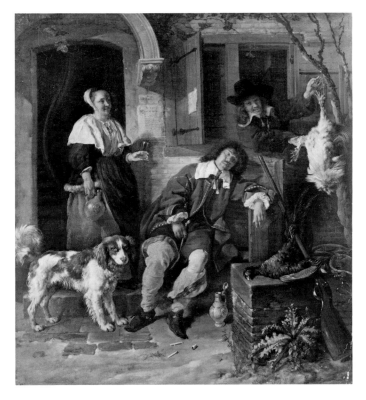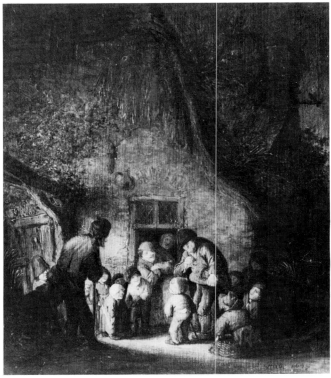

FIGURE 26. Gabriel Metsu, *The Sleeping Sportsman*, 1650s. Oil on canvas, 16⅝ × 14⅝ in. The Wallace Collection, London.

FIGURE 27. Adriaen van Ostade, *The Hurdy Gurdy Player in Front of a Cottage*, 1637. Oil on panel, 12 × 10 in. Present location unknown; photograph courtesy of Rijksbureau voor Kunsthistorische Documentatie, The Hague, Netherlands.

his more prosaic bent. Fortunately, Edmonds was able to see, in Cardinal Fesch's famous collection, more congenial works that pertained to his own interests. The cardinal's Dutch paintings were thought to be the best in Europe; Edmonds noted seeing "two or three admirable Teniers—one beautiful Metzu [*sic*]—besides several excellent Wouwermans [*sic*], Ostade, etc."[69] The painting by Gabriel Metsu (1629–67) that Edmonds admired was probably *The Sleeping Sportsman* (fig. 26), which the cataloger of the collection placed at the highest pinnacle of artistic achievement: "One will not attempt to describe its perfections [*The Sleeping Sportsman*], for the eyes that contemplate them seem to fear that it is only an illusion."[70] If Edmonds knew of this opinion, it would only have reinforced his admiration for Metsu's work. He also singled out Adriaen van Ostade, who was to have a decided impact on him. A painting that may have struck a particular chord was *The Hurdy Gurdy Player in Front of a Cottage* (fig. 27).

In addition to listing favorite artists in his diary, Edmonds commented on technique:

Style of painting by the ~~Flemish~~ [*sic*] Dutch school—butiful touch—transparent shaddows—luminous effects—very little positive

color—but when used, of the greatest value—seem first painted up with great care and softened down so that when the last touches were applied, they told excellingly well.[71]

He also made a sketch in his travel diary of one of the paintings he saw in Rome, accompanied by an extensive technical notation. The painting was *Tavern Scene* (fig. 28), by David Ryckaert III (1616–61), which Edmonds saw in the Palazzo Doria-Pamphili. His drawing (fig. 29), at the back of the first volume of the diary, depicts a man

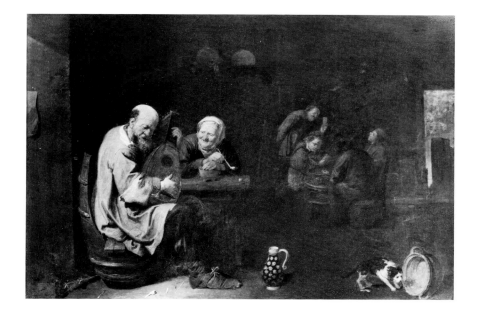

FIGURE 28. David Ryckaert III, *Tavern Scene*, c. 1645. Oil on panel, 20½ × 28¾ in. Palazzo Doria-Pamphili, Rome.

FIGURE 29. Francis W. Edmonds, after David Ryckaert III, *Tavern Scene*, 1841. Watercolor on paper, 4⅛ × 6⅛ in. The Columbia County Historical Society, Kinderhook, New York.

FIGURE 30. Francis W. Edmonds, *Monastery*, 1841. Watercolor on paper, 10½ × 7⅜ in. Courtesy of Kennedy Galleries, New York.

FIGURE 31. Francis W. Edmonds, *Street in Amalfi*, 1841. Watercolor on paper, 9½ × 6¼ in. Collection of Paul Bigelow, Trustee for Cecil Bigelow.

playing a lute as a woman looks on, while a group of boorish-looking types carouse in the background. Although Edmonds never mentioned the painting (thought at the time to be a work by David Teniers [1582–1649]), in the entries recounting his visits, the lengthy memorandum framing the drawing itself again reveals the painter's close scrutiny of the art of the Low Countries. Such technical commentaries supersede any he had made in earlier years, since they were based on firsthand study of his most pertinent sources of inspiration.

As Edmonds settled into a routine of sightseeing and sketching in Rome, his physical condition began to improve, and he felt compelled to see as many of Italy's important sights as possible. In the company of Durand, Casilear, and a young painter named Kennedy, Edmonds traveled south, visiting Naples, Pompeii, Herculaneum, and Paestum, and sketching the countryside along the way. A few of Edmonds's sketches have come to light, including one of an unidentified monastery town (fig. 30) and another of a street scene in Amalfi (fig. 31). In April he turned back toward London with Durand, stopping at some of the major cities on the way.

Edmonds immediately fell in love with Florence, their first stop; his travel diary is full of superlatives.[72] Here, too, he produced sketches, including a view of the Arno with the Palazzo del Vecchio and the Duomo, later exhibited at the National Academy of Design (fig. 44). The scene teems with activity. Not only did the physical beauty of such sights as the Boboli Gardens and the Cascina enthrall him, but the architecture, painting, and sculpture there also made a deep impression. He enjoyed the full range of artistic treasures that the Pitti Palace and Uffizi Gallery offered. After spending two very full days taking in all the major monuments, Edmonds focused his attention on the Uffizi's collection, making copies of and taking notes on the paintings. Some of the copies, executed in watercolor in a small sketchbook, have recently come to light. All were after Dutch paintings and included an *Interior*, by David Teniers; a couple eating (fig. 32), by Frans van Mieris (1635–81); and *Woman Tuning a Guitar* (fig. 33) and *The Hunter's Return* (fig. 34), both by Gabriel Metsu. Of further interest is the recent discovery of a copy in oil, possibly by Edmonds, of Metsu's *Woman Tuning a Guitar*. Efforts to determine its authorship have so far proved inconclusive, but it possibly reinforces Edmonds's admiration for the Dutchman.

One of Edmonds's lengthy notations in his travel diary concerned Metsu's use of color. He scrutinized his working method and even conjectured that the American artist Gilbert Stuart Newton also derived his style from Metsu. Edmonds himself had been connected with Newton. The diarist concluded, somewhat cryptically, "Metzu [*sic*] is unlike Teniers, Ostard [*sic*], Wouwermans [*sic*], or any other

FIGURE 32. Francis W. Edmonds, after Frans van Mieris, *A Peasant Meal*, 1841. Watercolor on paper, 5¾ × 4¼ in. Courtesy of Kennedy Galleries, New York.

FIGURE 33. Francis W. Edmonds, after Gabriel Metsu, *Woman Tuning a Guitar*, 1841. Graphite and watercolor on paper, 5¾ × 4¼ in. Courtesy of Kennedy Galleries, New York.

FIGURE 34. Francis W. Edmonds, after Gabriel Metsu, *The Hunter's Return*, 1841. Watercolor on paper, 5¾ × 4¼ in. Courtesy of Kennedy Galleries, New York.

FIGURE 35. Francis W. Edmonds, after Titian, *Saint Mark between the Saints Roch, Sebastian, Cosmos, and Damian*, 1841. Watercolor on paper, 5¾ × 4¼ in. Courtesy of Kennedy Galleries, New York.

Dutch master I have seen."[73] While it is difficult to determine Edmonds's exact meaning, he seems to be referring to Metsu's manner of working.

Edmonds's stay in Florence was instructive and productive, but the north beckoned. Durand and Edmonds took three weeks to return to Paris, visiting such picturesque cities as Venice, Geneva, and Lyon. Edmonds was always able to find one or two Dutch paintings that appealed to him. In Venice he delighted also in the works of Tintoretto (1518–94) and Paolo Veronese (c. 1528–88), made a small sketch after Titian's (c. 1487/90–1576) *Saint Mark between the Saints Roch, Sebastian, Cosmos, and Damian* (fig. 35), and mentioned seeing good pictures by Ostade, Nicolaes Berchem (1620–83), and other Dutch artists. Geneva was more memorable for its scenery and its proximity to Voltaire's chateau at Ferney than for pictures, but the Kunstakademie was included in the itinerary nonetheless. There Edmonds found a pleasing work by Claes Molenaer (before 1630–76), whom he likened to Teniers. In Lyon all he expected to find was evidence of the city's silk industry, but upon visiting the art museum he was forced to confess, "Here we met with a collection of paintings that quite surprised us—a very fine Snyders and Terbergh [*sic*], and several painters, natives of Lyons."[74]

Back in Paris the travelers presented Kensett with sketches they had made on their journey. Kensett saw the greatest progress in Edmonds's work:

> Mr. Edmonds efforts [are] more distinguished by greater boldness and character, though they may have been less true—There is a rigour as well as agreeable arrangement of lines and objects that gives them in my humble opinion an evident superiority.[75]

Edmonds continued to build on this artistic improvement, studying the paintings at the Louvre and making copies after works by Metsu and Gerard ter Borch (1617–81). He also spent considerable time at the annual Salon exhibition; his diary singled out a winter scene by the Dutch artist Peter Wickenberg (1808/12–46) and expressed a decided prejudice against French technique, on which he did not elaborate. Finding much food for thought, he compiled an extensive list of "Possible Subjects" at the back of the diary.[76]

When not indoors, Edmonds haunted the print stalls along the quays, seeking out engravings for study purposes, in most cases works after Dutch and Flemish originals. (In February, while traveling, he had written to Kensett asking for prints after Teniers, Ostade, and Philips Wouwerman [1619–68], adding, "You know how I am partial to interiors.")[77] Both Edmonds and Durand were diligent print collectors, and Kensett, visiting them at their hotel, marveled at their

shrewd acquisitions. "They have both made clever collections of prints considering their limited sojourn in this city," he wrote, "and they will doubtless form a valuable acquisition to their studio."[78] Unfortunately, this visual library has not survived.

On Edmonds's return to London, he went to view the modern works in the annual exhibition of the Royal Academy and then returned to the National Gallery, the site of his initial European encounter with the Old Masters. To his surprise, he found: "I was satisfied that a love of the old masters to a certain extent, like old wine, is an acquired taste—my first impressions were unfavourable, my last favourable—In other words I relished paintings now that I could not relish then."[79] Edmonds's artistic sensibilities had matured substantially in the course of six months.

The artist's critical faculties had also been sharpened. He was disappointed by the collection in the Dulwich Gallery, blaming his feelings on unreasonably high expectations. Conversely, he was favorably impressed by the paintings owned by Henry Thomas Hope, a well-known London collector. "Here [Mr. Hope's residence] we had a fine treat in viewing some of the Dutch masters," he wrote, "in many cases better than those in the Louvre or in any other collection on the continent that I have visited." His praise was enthusiastic: the ter Borchs were "excellent," the Aelbert Cuyp (1620–91) was "of the first water," and the Ostades were "some of the finest." Revealing his developing expertise, Edmonds observed a different style in the paintings by Metsu; they were not so highly finished, he contended, and displayed a freer handling of paint. He thought the *Man Writing a Letter* (fig. 36) very fine, although the wall and floor were a little too cold and gray. One of the other paintings he admired was the Pieter de Hooch *A Girl Drinking with Two Soldiers* of 1658 (fig. 15), which he recognized from Burnet's *Treatise on Painting* and which had played such a central role in the first version of *The Epicure*. He particularly liked the tone of the scarlet petticoat.[80]

While the Hope Collection proved a memorable experience, an even more exclusive treat awaited him: a visit to the Royal Collection at Buckingham Palace, arranged by Charles Robert Leslie (1794–1859). Edmonds was duly stunned by the magnificent array of Dutch pictures. Writing effusively of his good fortune, he noted, "The visit to the Palace was a great treat inasmuch as no one is admitted to the prviledge [*sic*] except a favoured few."[81] This tour of Buckingham Palace concluded Edmonds's intensive exposure to the Old Masters; during the remainder of his stay, he looked at contemporary paintings, took day trips, and made an extended journey to the north of England.[82]

As the day for his return to America drew near, Edmonds began

FIGURE 36. Gabriel Metsu, *Man Writing a Letter*, c. 1663. Oil on panel, 20⅝ × 15⅞ in. Beit Collection, Blessington, Ireland.

to reflect on the benefits of his trip. He listed his improved health and greatly expanded knowledge. However, he decided that the most significant improvement was the change in his personality. He felt that he had shed his diffidence and moroseness and had put his goals into perspective: he resolved to "paint but little and rather for pleasure than reputation."[83] Whether he kept this resolution is debatable, but Francis Edmonds returned to New York a man at peace with himself, ready to embark on a new phase of both his banking and artistic careers with renewed vigor.

CHAPTER III

The Years of Ascendancy, 1841–55

EDMONDS RETURNED FROM ABROAD TO A COUNTRY AND A CITY THAT were still in the financial doldrums. Yet the subsequent decade was to witness a remarkable recovery assisted in part by greatly enhanced maritime trade, westward expansion highlighted by the annexation of Texas, and the California gold rush. With the Civil War beyond the horizon, there was still a pervasive optimism in the national mood. All the commercial activity made these years very busy ones for Edmonds in his capacity as a banker. His personal life also witnessed a new development; he married Dorothea Lord in November of 1841 (a fact he neglected to mention in his autobiography). Despite a brief courtship, the marriage seems to have been a happy one and eventually added six offspring to Edmonds's family. With all this domestic and professional activity, not to mention his heavy involvement with various art institutions, it is remarkable that Edmonds found any time to paint. But paint he did, and this period of his career was one of intense productivity accompanied by an enhanced reputation.

After his return to New York, however, Edmonds was not able to resume painting until the following winter. He had an enormous backlog of bank-related work, and he was not fully recovered from his illness. He did exhibit one work, *The Sleeping Ostler* (unlocated), at the October exhibition of the Apollo Association; the painting was lent by his brother John Worth Edmonds and, presumably, was painted prior to his trip. Edmonds did not return to the easel until the winter of 1841–42. At this time the artist began work on a canvas titled *The Bashful Cousin* (plate 5) for his friend Jonathan Sturges, and he also completed *Italian Mendicants* (unlocated) in time to exhibit both at the National Academy of Design in the spring of 1842.[1]

Edmonds derived the subject of *The Bashful Cousin* from James Kirke Paulding's acclaimed novel of 1831, *The Dutchman's Fireside*.[2] This romantic tale, set in the Hudson River Valley in the mid-eighteenth century, dealt with the difficult courtship by the hero, Sybrandt Westbrook, of his distant cousin, Catalina Vancour. (Westbrook, an eligible but painfully shy bachelor, makes his first appearance in a chapter appropriately titled "The Reader Is Introduced to a Bashful Young Gentleman.") Rather than recording a specific episode, Ed-

monds conflated details from several events of the narrative. He divided the action into two distinct parts. In the left foreground, Catalina implores her rather diffident cousin to stay to tea; at the dining table to the right, her mother gestures toward the young couple and speaks to her husband who is engrossed in his newspaper and dish of tea. In the background, the black servant, Aunt Nantje, brings in a tray of food. Although theatrical in deference to its literary source, *The Bashful Cousin* offers an interesting commentary on the social mores of the time. The artist alluded to the division of labor in his depiction of the parents: the father with his newspaper symbolizes authority and worldliness—a concern with outside affairs; the mother's domain is the household, and one of her missions is to procure the best possible match for her daughter. Edmonds also touched upon changing domestic manners as he showed the man still drinking from a saucer while the wife practiced the newer, more refined mode of using a teacup. The novelty of this practice is illustrated in the diary of a young girl from upstate New York who visited her uncle in New York City in 1863. She was much impressed by such urban sophistication and observed: "People do not pour their tea or coffee into their saucers anymore to cool it, but drink it from the cup, and you must mind and not leave your teaspoon in your cup."[3]

Edmonds was *au courant*, since he was depicting this new form of etiquette by 1842. The recording of such social refinement has a precedent in Sir David Wilkie's *The Breakfast* (fig. 37), painted in 1817, which Edmonds could have known in its engraved form.[4] Edmonds must have added these social observations as an afterthought, since a recently discovered preliminary sketch (fig. 38) contains none of the embellishment of the finished version. Besides these additions, the artist drastically changed the composition of the final rendition. The room is completely different: the large fireplace has been eliminated, and the doorway at the rear has been moved to the side. Edmonds replaced the doorway with a transitional space leading to the kitchen. While the poses of the two young protagonists remain almost the same, the interaction between the parents does not yet exist. Only the father sits, somewhat hunched over, at the table. The ultimate setting appears more distinguished than in the original conception, perhaps a result of the added drama that Edmonds sought for the painting.

While addressing certain features of American social custom, Edmonds drew on several facets of Dutch art for his composition. The stagelike setting, dictated by the architectural framework, closely paralleled the single-corner motif common in Dutch interior scenes and so often adopted in Edmonds's work. He also continued to emulate Pieter de Hooch in the manner in which the light streams

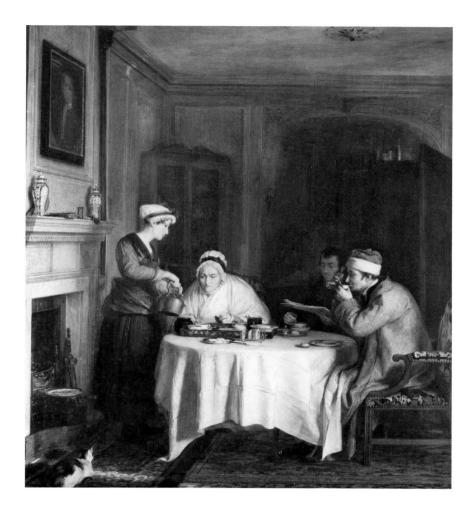

FIGURE 37. Sir David Wilkie, *The Breakfast*, 1817. Oil on panel, 29 × 26 in. In a private Scottish collection.

in from the windows and doors at the side and rear of the composition. (De Hooch used similar effects in *A Girl Drinking with Two Soldiers* [fig. 15] and *The Card Players* [fig. 39], two of the last paintings Edmonds saw in England.) *The Card Players* and *The Bashful Cousin* share another very important feature: both have spacious yet sparsely decorated settings, which create the impression that the figures in each painting are engulfed by the cavernous rooms. The planar recession through a series of doors and windows in *The Bashful Cousin* is another device the artist may have borrowed from de Hooch. Wilkie's *The Breakfast* also provides at least one structural similarity to *The Bashful Cousin*, namely the common use of an arched doorway to relieve the otherwise severe rectilinearity of the architectural setting. But formal elements were not the only devices that Edmonds derived from his preferred models.

Edmonds wasted little time in utilizing some of the technical notations he had made during his trip abroad. In *The Bashful Cousin*,

FIGURE 38. Francis W. Edmonds, study for *The Bashful Cousin*, c. 1842. Oil on paper, 4½ × 6 in. Courtesy of Kennedy Galleries, New York.

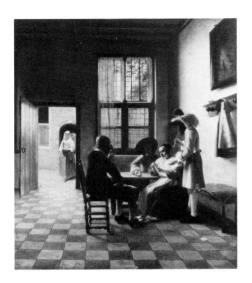

FIGURE 39. Pieter de Hooch, *The Card Players*, 1658. Oil on canvas, 30 × 26 in. The Royal Collection, Buckingham Palace, London (copyright reserved to Her Majesty Queen Elizabeth II).

the sense of atmosphere, the luminous effects, especially the light bouncing off the rear wall, and the transparent shadows (note the upper section of the door at the left) are all elements that the artist discussed in his travel diary in his first memorandum on Dutch painting. *The Bashful Cousin* also demonstrates a greater facility in handling paint than in some of his earlier works.[5] The application is looser; there is a sense of vibrancy and texture that does not exist in such paintings as *The Epicure* (plate 1 and fig. 13). Gabriel Metsu's works in the Hope Collection had intrigued Edmonds because of their freer handling of paint, and he may have decided to emulate this approach. The picture by Metsu in the Fesch Collection (fig. 26) also appears quite loose in its treatment, and a comparison of the shawl of the serving girl with the shawl of the mother in *The Bashful Cousin* reveals a striking affinity in the thick application of paint. Edmonds also benefited from studying the Dutch use of color and aspired to achieve similar delicate effects. Despite his lengthy memorandum on how Metsu employed color—especially red—he seems to have borrowed most from Pieter de Hooch. The juxtaposition of red skirt and blue apron was a favorite motif of this artist, visible for instance in the serving maids in *The Card Players* and *A Dutch Courtyard* (fig. 40). Edmonds vividly echoed this color combination in the skirt and apron of the young Catalina.

One final detail of interest in the production of *The Bashful Cousin* is Edmonds's use of a model for the shy suitor. In a recollection of 1884, the landscape painter Charles Lanman described his involvement:

> He [Edmonds] took me into his studio and exhibited to me his picture of the "Bashful Cousin," which was all finished excepting the head of the leading figure; and then telling me that he knew all about my innate bashfulness, asked me to help him in his work. I accordingly stepped out upon the floor to the proper distance, looked as sheepish and frightened as possible, and in a very short time the deed was done; and thus it was that the late Jonathan Sturges became the owner of my portrait.[6]

In addition to being a charming anecdote, this account reveals Edmonds's ongoing determination to work from the live model, thereby striving for that fidelity to nature that the critic of the *New-York Mirror* found lacking in 1838.[7]

The Bashful Cousin was well received by the press, although the critic for the *Knickerbocker* preferred *Italian Mendicants*. He praised both paintings for "their correct composition, great breadth of light and shade, and judicious arrangement of color," and observed with pleasure "the great care Mr. Edmonds bestows on the detail of his

pictures."[8] Although undoubtedly pleased by the critic's kind words, Edmonds noted in his autobiography that he considered *The Bashful Cousin* the better of the two paintings.[9]

Fortunately, as the painting is now lost, the same critic provided a lengthy discussion of *Italian Mendicants*:

> In this picture we discover that the artist has availed himself of his trip abroad to improve his style. Those who have travelled in Italy have noticed and been annoyed by the swarms of beggars that people that classic land, and have been struck with their apostle-like appearance as exhibited in the works of the old masters; their long beards and sun-burnt countenances. Mr. Edmonds has given us a very faithful pictures [*sic*] of one of those characters accompanied by his daughter. There is a brightness and clearness in the whole picture perfectly in keeping with the subject; for Italy with all her wretchedness still wears a cheerful aspect, and her mendicants, though begging with a doleful countenance at one moment, are the next dancing with light hearts and lively steps to a mountaineer's pipe.[10]

The description of the father and his daughter corresponds closely to a recently discovered sketch (fig. 41) that depicts just such a pair set before a triumphal arch to the right background and the ruins of the Colosseum to the left. The man extends his upturned hat in a gesture of supplication, and the young woman exudes a pathetic sense of poverty. The idea for this sketch had its origins in Europe, since Edmonds included it in the list of possible subjects on the back page of his travel diary, based on his visit to the Paris Salon exhibition in May of 1841: "Old man and his daughter (young say 12) the latter begging for *alms*—half length life size."[11]

The man's head and features reveal a close resemblance to the larger, more finished sketch titled *Head of a Man*, done around 1841 (fig. 25). Whether this head was copied from a work in a museum or painted from a live model is unclear. Its kinship to the head of the old man in the small sketch does bear out Mann's hypothesis that this larger sketch was an ingredient in the creation of the final version of *Italian Mendicants*.[12]

The *Head of a Man* also provides an interesting comparison with a heretofore unknown work by Edmonds still in the possession of a descendant. This work, known traditionally in family circles as *The Beggar* (fig. 42), is a far more finished work. Edmonds has handled the facial structure most admirably, yet with a nod to the general rather than the specific. Curiously, the depiction suggests an affinity with the type of the philosopher more than that of the beggar. The flowing white locks, full beard, and rose-tinged cheeks lend an aura of benevolence to this figure, while the rich orange-red cloak flecked

FIGURE 40. Pieter de Hooch, *A Dutch Courtyard*, c. 1660. Oil on canvas, 26¾ × 23 in. National Gallery of Art, Washington, D.C.; Andrew W. Mellon Collection.

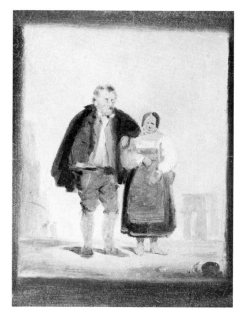

FIGURE 41. Francis W. Edmonds, study for *The Italian Mendicants* [?], c. 1842. Oil on board, 8 × 6 in. Courtesy of Kennedy Galleries, New York.

FIGURE 42. Francis W. Edmonds, *The Beggar*, c. 1843. Oil on canvas, 23½ × 19 in. Private collection.

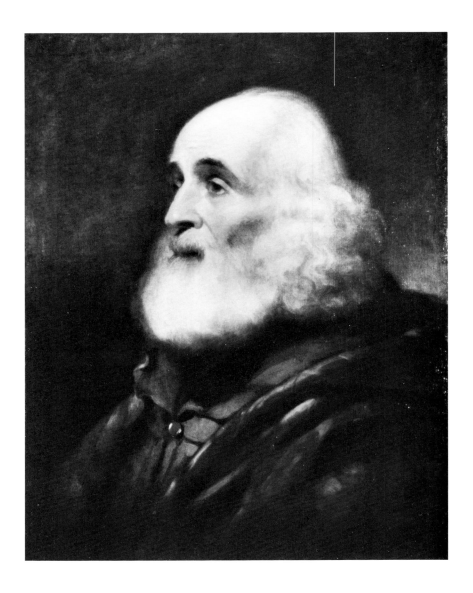

with streaks of green and the blue shirt underneath convey a sense of comfortable dress rather than poverty. The paint is applied thickly and freely, which suggests that the sketch was a post-European effort, and its rather bohemian presence associates it with the Italian sketches, even if a precise date cannot be assigned.

Italian Mendicants was lent to the National Academy by Charles M. Leupp, which implies that he purchased it soon after completion. Leupp, one of New York's most important collectors, demonstrated a strong preference for contemporary paintings.[13] He was a successful leather merchant who actively supported various art institutions in New York and was a patron and friend to many artists, including Edmonds. Leupp, moreover, was as concerned with giving an artist

exposure as he was with providing financial assistance. He lent *Italian Mendicants* to the third annual Boston Artists' Association exhibition in 1844, as well as to the Fourth Annual Exhibition of the Brooklyn Institute in October 1845.[14]

The extant correspondence between the two men reveals a close friendship. Topics run the gamut from outbreaks of cholera in New York to setting times to meet for National Academy of Design affairs, to the artist's keeping Leupp abreast of developments on his new house while the latter was in Europe. Although few of these letters survive, Edmonds offered a personal revelation in a letter of 21 August 1849. He mentioned visiting the great tragedian Edwin Forrest in his "castle" on the Hudson River and finding him very unhappy, adding, "I feel very sorry for him—particularly for his domestic troubles because I once, as you know, had a little experience in these matters and ones friends always side with the wife, right or wrong."[15] This is the only reference to marital strife that has come to light.

When Leupp committed suicide in October 1859, New York lost a staunch patron of the arts. Leupp's eulogist, John H. Gourlie, praised the collector's efforts:

> The private gallery formed by the taste and liberality of Mr. Leupp, was creditable to him. It contained some of the noblest and best productions of American art, from the pencils of Durand, Weir, Leutze, Cole, Kensett, Mount, Edmonds, and other artists of distinction. . . .
>
> It will be remembered that at this time the patronage of art and the formation of private galleries were not so general as they are at present. It is to the intelligent spirit and generous example of such men as Mr. Leupp that we are indebted for those noble collections of Art which adorn the homes of so many of our wealthy citizens. The refining and elevating influences of these examples will, we ardently hope, be continued and cherished everywhere throughout our country, until Art finds a true and devout worshipper in the heart of every American.[16]

Leupp's executors put all the paintings, except family portraits, up for sale the following year, including four by Edmonds: *Italian Mendicants, Gil Blas and the Archbishop* (plate 9), *Facing the Enemy* (see fig. 48), and *Sam Weller* (unlocated).[17] Like Jonathan Sturges, Leupp was committed to fostering native artistic expression. Edmonds's close relationship with these two important figures reinforces his own central role in the artistic affairs of New York.

In 1843 Edmonds's role as a banker and lobbyist took precedence over his art, since, in his own words, he "had but one picture in the [National Academy of Design] exhibition in consequence of a necessary absence from the city."[18] This refers to Edmonds's extended

residence in Albany to lobby on behalf of the Mechanics' Bank for a bill to reduce its capital stock. He had recently been named a director of the New York and Erie Railroad, so he also involved himself in legislative discussion of the problems of railroad organization and financing.[19]

Though he sacrificed time he could have devoted to it, he did not compromise himself when he found the opportunity to paint. His sole effort of this year, known as *Boy Stealing Milk*, received enthusiastic praise. Because the work is now unlocated, it is worth quoting the *Knickerbocker*'s review in full:

> Number 190, "Boy Stealing Milk," by F. W. Edmonds. Having "satisfied the sentiment" of this picture, by a survey of the threatening aspect of the old lady; the sort of mesmeric consciousness of her presence, expressed in the half self-satisfied half-fearful countenance of her victim; and the evident *coolness* of the atmosphere in the apartment; we would counsel an examination of the correct drawing of the figures and the finish and naturalness of the accessories.
> Observe the *tin* of the milkpan; the dripping line of rich deposit left by the receding fluid, and the thick stream *debouching* into the young thief's mouth; the hitched-up jacket, the jug, and *that* cabbage; and the interior of the upper shelves of the cupboard. These are so faithfully represented, that they form an excellent study for those who deem that labor lost which is devoted to the exhibition of truth in little things.[20]

The critic's observations show that Edmonds was continuing to develop several important points of his style: his concerns with emotion, convincing atmosphere, and especially the faithful rendition of even the most minute detail.

The subject is among the first treatments of the type of the mischievous young boy, later a staple of American genre painting. The reviewer's description of *Boy Stealing Milk* brings to mind the sort of urchin that was to become so familiar in the work of Edmonds's contemporary David Gilmour Blythe (1815–65).[21] The allusion to the "threatening aspect of the old lady" recalls the irate storekeeper in Albertus D. O. Browere's (1814–87) *Mrs. McCormick's General Store*, painted the year after *Boy Stealing Milk*, and the potential consequences of such activity are captured in Tompkins H. Matteson's (1813–84) *Caught in the Act* (fig. 43), painted in 1860. One supposes that Edmonds's painting had particular appeal for its purchaser, Jonathan Sturges, who launched his career in the wholesale grocery business.

In 1844, Edmonds compensated for his minimal artistic activity the previous year by submitting six works (including three drawings

made in Italy) to the National Academy of Design, by organizing the inaugural New-York Gallery of the Fine Arts exhibition (in which he was represented by three works), and by sending two paintings to Boston for display. Not all the works he exhibited were painted during the year, but at least four paintings and three Italian drawings were new to viewers' eyes.

What motivated Edmonds to show the finished drawings from his travels in Italy remains unclear, although by the 1840s larger and larger segments of the population had been abroad, and such works would have had a natural appeal as visual mementos. One of these watercolors, *Florence from the Arno* (fig. 44), can be tentatively identified. The drawing has all the requisite ingredients of the picturesque views that had such appeal at the time: the engaging anecdotal episode in the foreground; the emphasis on the venerable age of the dwellings along the river; and most importantly, the inclusion of two of Florence's major monuments, the Palazzo Vecchio and the Duomo, albeit in an improbable juxtaposition.

Edmonds's work shown in 1844 remains especially elusive today. Of the four works displayed for the first time, only one, *The Image Pedlar* (plate 6), is now located. This one, however, is among Edmonds's most subtle and interesting works. Iconographically, the painting reflects Edmonds's political tendencies, based as they were on egalitarian principles, and underscores his concern for the common man. It also combines his admiration for the ambitious entrepreneur

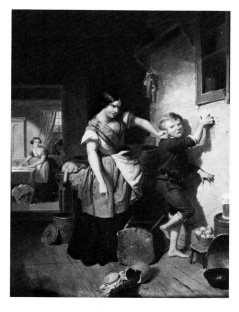

FIGURE 43. Tompkins H. Matteson, *Caught in the Act*, 1860. Oil on canvas, 28 × 18 in. Vassar College Art Gallery, Poughkeepsie, New York; Gift of Matthew Vassar.

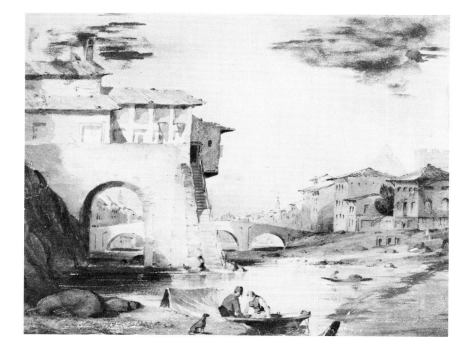

FIGURE 44. Francis W. Edmonds, *Florence from the Arno*, 1841. Watercolor on paper, 7 × 9¼ in. Collection of Paul Bigelow, Trustee for Cecil Bigelow.

with a sentimental depiction of domestic harmony and patriotism. The lines are drawn between traditionally male and female roles; the women cope with household chores, while the men consider more worldly issues. The trio at the left signifies the three ages of man as they study the bust of George Washington, who represents the pinnacle of their ideals. The image of the great military hero is placed by the open window—that quintessential nineteenth-century metaphor for freedom. In the painting's central subject, the vending of plaster statuettes, Edmonds visually echoes Alexis de Tocqueville's comments on the character of the fine arts in a democracy, with the inevitable sacrifice of quality for availability.[22]

The meaning of the statuettes is a matter of debate. Recently, a stimulating analysis of the painting's political implications, based on a detailed study of contemporary political cartoons, recognized a polarity between "the heritage of George Washington as revolutionary-era Whig," solidly pictured in the bust by the window, and the more pernicious Democratic tradition represented by such despots as Caesar, Napoleon, and Andrew Jackson—the figures of the plaster statuettes.[23] This linking of politicking with peddling surely catches an essential symbol in the painting; but it is difficult to suppose that Edmonds would have been casting the Democrats in such an unfavorable light, given his own political persuasion.

An alternative reading of the painting begins with the statuette of Napoleon. The artist had witnessed the apotheosis of Napoleon at the Salon of 1841,[24] and his own artistic output was affected subsequently. His offering at the Sketch Club meeting hosted by Thomas Cole interpreted the given topic, *The Trying Hour* (fig. 2), as a figure standing on the deck of a ship looking out at the sea and shoreline, assuming a heroic pose. The figure's costume and pose identify him with the statuette of Napoleon on the peddler's tray. The treatment in the sketch suggests that Edmonds admired the great French military figure, and it may be for this reason that Napoleon was included in *The Image Pedlar*, which addressed the reverence of heroes, among other issues.

The subject of the peddler is evocative of Asher B. Durand's *The Pedlar Displaying His Wares* of 1836 (fig. 45), and both Durand and Edmonds seem to have been indebted to Sir David Wilkie's *The Pedlar*, painted in 1814 and published as an engraving in 1834 (fig. 46).[25] Wilkie's engraving is especially critical to *The Image Pedlar*, since it reveals their shared motif of a patriarch seated near a window partially obscured by a curtain, in a stagelike setting of a room replete with myriad still-life elements. This composition was Edmonds's most ambitious to date, and he noted in his autobiographical letter to Durand that the painting "cost me a vast deal of study and labor"

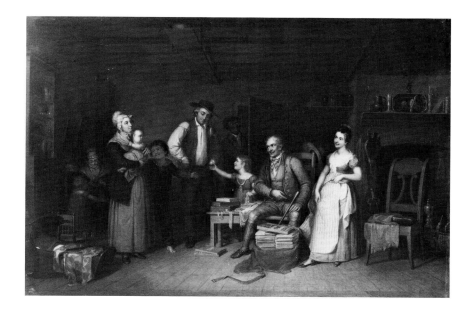

FIGURE 45. Asher B. Durand, *The Pedlar Displaying His Wares*, 1836. Oil on canvas, 24 × 34 in. The New-York Historical Society.

and that all the figures and accessories were painted from life.[26] The relationship between the architectural setting and the figures is more appropriately scaled than that of *The Bashful Cousin*, and there is a greater balance in the light sources provided by the windows in the left foreground and right rear. Furthermore, the serpentine configuration of the figures offsets the rigid interplay of the horizontals and verticals of the boxlike setting. While Edmonds borrowed foreign motifs to structure this painting, continuing to draw on the rich visual experience of his trip abroad, he created an image that was distinctly American.

The painting received high praise from the critic for the *Knickerbocker*, who preferred it to the painter's other offerings:

> *The Image Pedler* [*sic*] is an effort of a higher order; for the artist has attempted, and successfully too, to elevate the class of works to which it belongs. In short, he has invested a humble subject with moral dignity, which we hope our younger artists, who paint in this department will not lose sight of. . . . In color, light and shade, and composition it is masterly; and we see in it that minuteness of detail and careful finish are not incompatible with a broad and luminous effect.[27]

FIGURE 46. James Stewart, after Sir David Wilkie, *The Pedlar*, 1834. Engraving, 27 × 20 in. (sheet). Print Collection, Miriam and Ira D. Wallach Division of Art, Prints and Photographs, The New York Public Library; Astor, Lenox and Tilden Foundations.

The synthesis of the two stylistic approaches, alluded to in the final sentence, testifies again to the effects of Edmonds's European trip.

This author also offered an interesting reading of the narrative content. In his extended account of the scene, he identified the woman standing next to the peddler as the mother of the household who "takes her infant from the cradle, to gaze at the sights in the pedler's

[*sic*] basket."[28] If this is the case, then who is doing the dishes in the background? Surely she is too well dressed to be a maid. Since the itinerant has a basket with a tiny infant slung over his shoulder, what is to prevent the woman in question from being *his* wife? This ambiguity points up a shortcoming Edmonds never wholly overcame: a lack of attention to individual characterization.[29] All the faces in *The Image Pedlar*, and not only those of the resident family, reveal a similarity (especially apparent in the faces of the two young mothers). Despite Edmonds's claim that he worked from the live model, he appears to have used the same person in a number of roles.

Two of the other works Edmonds showed at the National Academy this year are known only through fragmentary descriptions, and a third, *An American Boy's Inheritance*, exists only in a photocopy of a lost photograph. All three paintings passed quickly into private hands, and so far efforts to trace them have proved fruitless. Of the first, the *Knickerbocker*'s critic observed:

> *Beggar's Petition* is a spirited and faithful representation of the cold indifference to the wants of others, displayed in the miser's disposition. The figure's are of life-size, and well drawn. The female supplicating in behalf of the distressed is graceful in attitude, and admirably contrasted with the hoarding miser.[30]

Edmonds himself preferred this picture to the more widely acclaimed *The Image Pedlar*, and wrote of it:

> This last picture is what is termed a knee picture of the size of life, and very attractive in an Exhibition because of its boldness, size, and effect. . . . I have become persuaded that if an artist wants to make a stir in an Exhibition he must not rely upon the merit of his work but upon its peculiar *attractiveness*—How far, however, he ought to court the popular eye by resorting to such means I will not pretend to say.[31]

The monumentality that Edmonds evidently sought in this painting, and the treatment of yet another begging scene culled from his reaction to the Paris Salon of 1841,[32] suggest a serious intention to break away from the "cabinet" picture mode and move his artistic expression to a more elevated height.

Edmonds's other contribution to the National Academy in 1844, *Sam Weller*, was taken from Charles Dickens's engaging *Posthumous Papers of the Pickwick Club*. The painting is said to have depicted "a youth in brown, green, and scarlet costume, with high-crowned hat, leaning against a low wall shining a riding boot. Behind is a balustrade and view of a village."[33]

Edmonds has painted the reader's first encounter with Sam, who

is employed as a bootblack at one of the venerable old inns situated in the "obscurer quarters" of London. The painting's neglect may have been due to the controversy that embroiled the English author in America at the time. Dickens had made a triumphal progress through America in 1842, and this tour may have inspired Edmonds to create a canvas based on the esteemed writer's work. Things began to go sour after Dickens's return to England, however. His *American Notes*, though for the most part complimentary, alienated many people, especially in the South, for its condemnation of slavery. Dickens's novel *Martin Chuzzlewit*, which began to appear in serial form in 1843, contained some sharper criticism; Philip Hone's diary records the bitter reaction of the Americans who had so recently lionized the author.[34]

The final painting to come before the public eye in 1844 was *An American Boy's Inheritance*, which Joseph N. Lord, now Edmonds's father-in-law, lent to the inaugural exhibition of the New-York Gallery of the Fine Arts. The work is known from an undocumented photocopy probably taken from an exhibition catalog.[35] Even so, one can detect an allegiance to English painting, particularly the work of Francis Wheatley (1747–1801). The photocopy shows a mother and her two children, a son and a daughter, in front of a cottage. The boy appears to be in his early teens and has his head bowed as his mother utters a farewell prayer prior to his departure. The sister weeps, and even the dog senses the pathos of the moment. Beyond the figures is a charming landscape that includes the spire of a little church jutting through the trees; the corner of the cottage frames the right side of the composition, but the landscape comprises a significant portion of the painting. This attention to the outdoors marks an important departure for Edmonds, although such scenes constitute a modest portion of his output.

Edmonds reached an artistic milestone in 1845 when his *Image Pedlar* (plate 6), along with works by Durand, Charles Ingham, and Henry Inman (1801–46), was taken to London to be engraved for George P. Putnam's *American Facts*. No version of this engraving survives, but the paintings were exhibited at the Royal Academy. Putnam devoted a full paragraph to Edmonds in his book (Mount received only two sentences) and proffered the now-familiar comparison to Wilkie.[36] Edmonds was also the object of Charles Lanman's encomiums in *Letters from a Landscape Painter*, published in 1845. Lanman had posed for the young man in *The Bashful Cousin* and was well acquainted with the artist and his work. His observations regarding Edmonds are particularly instructive since they recognized the conditions of the artist-banker's unusual circumstances:

His paintings are comparatively few, owing to his peculiar situation, and to the correct notion which he entertains, that a work of art should not be exhibited to the public until the author has done his best to make it perfect. His style of coloring is warm and glowing, and his drawing exceedingly accurate. As a designer, he is more particular than our artists generally; and very few, I think, understand the principles of composition so well. He is a man of extensive reading, and of expansive mind, and his pictures are an index to the humor which it contains. They are of a comical character, and never fail to tell their story at a single glance. They are always intended to make you laugh, and are, therefore, agreeable helpers on to a long life; and sometimes possess an undercurrent of poetry or philosophy, which makes them voiceless preachers to the thinking man.[37]

By the middle of the decade, then, Edmonds ranked among the foremost American artists currently working. His two new paintings for 1845, *Facing the Enemy* (unlocated) and *The New Scholar* (plate 7), mark an important development in his work, reflecting the broad sweep of his concerns for social issues of his day. Exhibited at the National Academy of Design, both canvases garnered positive reaction from both public and private quarters. George Templeton Strong (whose family patronized William Sidney Mount) had very little good to say about the exhibition but singled out Edmonds's two offerings as being "clever in his peculiar style."[38] The critic for the *Broadway Journal*, in his discussion of *Facing the Enemy*, illuminated the social context of the painting:

A reformed toper looking resolutely at a bottle of rum which is rendered doubly tempting by being placed on the sill of an open window, the light falling through it and rendering it very brilliant and cheerful; but a total abstinence paper is stuck upon the wall, and the old toper bends back in his chair as if to get out of harm's way, and we cannot but feel certain that he will come off victor over his temptations, worse than St. Antony's, in the end. . . . The old toper is one of those hard drinkers with carbuncled nose and crispy hair, who used to be common enough twenty years ago but are now growing very rare. A few years hence, and there will be no more red noses and then a picture like this will possess the kind of interest that the figures in old illuminations do, preserving the peculiar barbarisms of old age that can never be repeated. When drinking shall have gone entirely out of fashion the world will scarcely believe that it was indulged in to the excess that books and songs and pictures tell of.[39]

This painting, which survives in a preliminary drawing (fig. 47), a scaled-down oil sketch (fig. 48), and a full-sized engraving (fig.

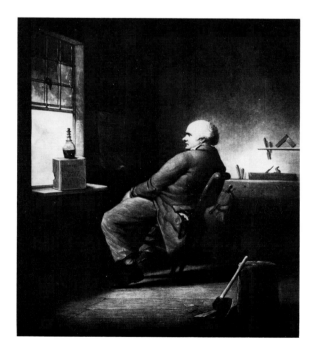

49), addressed what was an important topic of reform at the time. The American temperance movement dated from the second decade of the nineteenth century and gained substantial momentum under the aegis of Jacksonian society. Reformers of the time saw drink as inextricably associated with such social problems as crime, immorality, poverty, and insanity. A second, equally powerful constituency of reform was to be found among economic entrepreneurs who sought a more disciplined, sober, hence productive work force. Consequently, much of the impetus was urban-based and centered in the Northeast; New York City rallied strong support for temperance agitation by the late 1830s.[40]

Edmonds's painting reflects a new direction taken by the movement in the 1840s with the growing popularity of "Washingtonian" temperance societies. These organizations targeted alcoholic artisans of the lower and lower-middle classes and exhorted them to renounce the bottle. This was precisely the kind of individual Edmonds depicted, and the flyer that was published in 1847 to accompany the engraving identified the toper as a mechanic. Mann astutely points to the delicacy of this anguished soul's predicament, suggested by the way he tips precariously in his chair (an element already present in the early drawing).[41] His decision literally and figuratively hangs in the balance.

Edmonds is thorough in setting up the moral implications of this scene. The man, a carpenter by trade, sits in his tidy, well-ordered workshop, a result of his abstinence. The discipline and concomitant neatness he brings to his life while sober contrasts sharply with the chaos brought on by inebriation, a theme that found popular appeal in such prints as *The Drunkard's Progress* (1826; fig. 50). The visual dichotomy ultimately derives from the moralizing prints of William Hogarth (1697–1764), especially *Beer Alley* and *Gin Lane*.[42] The man's vulnerability is apparent as he contemplates the bottle of brandy that sits on a box of tea, also an amber liquid but infinitely preferable. Will he become a teetotaller? Here Edmonds has embellished the initial drawing, which depicts the decanter on the work table. The widow is open, again a metaphor of freedom, and reveals a world filled with glorious sunshine. Will he free himself from his dependence on the "demon rum," and will he look beyond the bottle and see the light? The moral underpinnings of this picture provide a compelling visual counterpart to one of the most popular melodramas of the time, William Henry Smith's *The Drunkard*, which opened in Boston in the winter of 1844.[43] With the success of this play, the temperance movement gained another influential venue; the arts were playing their part assiduously in the name of social reform.

Although Edmonds's own drinking habits are not known, his upbringing as a Quaker surely must have affected his attitude. He

endorsed the temperance movement by allowing *Facing the Enemy* to be engraved (fig. 49) and distributed with a circular urging the uncommitted to take the pledge. By 1847, when this distribution took place, the sentiment for abstinence was so powerful that popular opinion was endorsing prohibition, which had its initial enforcement in Maine.[44]

Several of Edmonds's contemporaries also treated the perils of drink. Some alluded to the place of alcohol in festive occasions, such as James Goodwyn Clonney (1812–67) in *Militia Training* (1841; fig. 51) and, most compellingly, George Caleb Bingham (1811–79) in *The County Election* (1852; fig. 52). Others, like Edmonds, focused on the single figure of the drunkard. Mount's *Man in Easy Circumstances* (1832; unlocated) was in fact commissioned by the local temperance society—but returned, since the patron thought Mount had "represented the drunkard so happy that it will not answer for the cause."[45] David Gilmour Blythe addressed the topic a number of times, perhaps most forcefully in *Temperance Pledge* of about 1856–60 (fig. 53), in which an obvious drunk studies the pledge while a bottle looms in his peripheral field of vision.[46] Blythe attains the same resonance as Edmonds in probing the human dilemma, and his imagery is made all the more forceful through his unrefined technique. Edmonds himself turned to the theme again toward the end of his career, in the painting known today as *Waiting* (fig. 99).

The other offering for 1845, *The New Scholar* (plate 7), has recently come to light. Its subject was a timely one for the artist, since both of his children by his first marriage were of school age.

FIGURE 51. James Goodwyn Clonney, *Militia Training*, 1841. Oil on canvas, 28 × 40 in. The Pennsylvania Academy of the Fine Arts, Philadelphia; Bequest of Henry C. Carey (The Carey Collection).

FIGURE 52. George Caleb Bingham, *The County Election*, 1852. Oil on canvas, 38 × 52 in. Boatmen's National Bank of Saint Louis, Saint Louis, Missouri.

FIGURE 53. David Gilmour Blythe, *Temperance Pledge*, c. 1856–60. Oil on board, 15 × 12 in. The Carnegie Museum of Art, Pittsburgh, Pennsylvania; Gift of G. David Thompson, 1953.

In his autobiographical letter to Durand, Edmonds recounted an episode from his own school days when he was flogged for an artistic indiscretion, a satirical sketch of the schoolmaster.[47] Thus the stick the schoolmaster wields in the painting may have had special poignancy for the artist. Nonetheless, the humor of the scene was not lost on a reviewer who alluded to the schoolmaster as a "Geoffrey Crayon impersonation," thus identifying him with Washington Irving's notable pedagogue.[48]

Two later works on educational themes, *The Sleepy Student* of 1846 (fig. 57) and *The Two Culprits* of 1850 (fig. 62), recall Edmonds's apparent struggle with the learning process, one depicting the soporific effect of studying, the other mischievous behavior. In contrast, *The New Scholar* conveys the greatest sense of order. Everything is in its place. Even the schoolmaster's belongings seem appropriately situated, while the kite and balls and bats for rounders are placed neatly in the opposite corner. The teacher is well groomed and neatly dressed, and the young boy clutching his mother's skirt is awestruck by the teacher's imperious presence. So persuasive is his manner that his students in the room behind resist the temptation to interrupt their studies while he has stepped out to meet the new boy. The boys' fate is reflected in part by their juxtaposition with the window, a favorite motif of the artist. In this instance the window is closed, thus denying them physical contact with the outside world. Rather than offering freedom, it closes them in and underscores their cloistered existence. This orderly schoolroom scene becomes all the more

intriguing when compared with a recently discovered preliminary oil sketch for the painting (fig. 54). In the study, Edmonds did not include all the exquisite still-life elements; the young boy has no dog to serve as a buffer. The organization of the three figures in the front room anticipates the finished version. The major alteration between preliminary and final idea occurs in the action taking place in the room beyond. In the first version Edmonds depicted a scene of modest pandemonium erupting in the absence of the watchful eye of the schoolmaster. The final rendition suggests rather an American faith in the educational process. The potential for advancement that education offered was recognized as early as 1811 when Pavel Svinin, a Russian diplomat, recorded in his observations of America:

> You should not look for profound philosophers and celebrated professors in America; but you will be astonished at the correct notions of the humblest citizen respecting the most abstract matters. The son of the first banker in the land goes to the same school with the son of the most destitute day laborer. Everyone studies the geography of his country, knows the rudiments of arithmetic and has a general idea about other sciences. . . . Education at home is unknown here: all the children go to public schools, and this develops their ideas the sooner and teaches them, in a sense, to think concertedly and see things in the same light.[49]

One other painting from about this period eludes identification with any work that Edmonds exhibited but is clearly his. Known

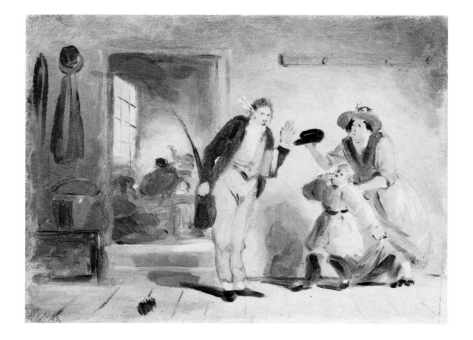

FIGURE 54. Francis W. Edmonds, study for *The New Scholar*, c. 1845. Oil on board, 4½ × 6 in. Private collection.

by its modern title, *First Aid* (fig. 55), the painting is signed but not dated at the lower left. On stylistic grounds, it can be assigned to the first half of the 1840s. The paint is thick and the highlights are handled in a manner that suggests Edmonds was responding to what he had recently seen in England and on the Continent. The picture has a decidedly British cast, recalling the rustic scenes of George Morland (1763–1804) and William Shayer (1788–1879). Like the roughly contemporary *An American Boy's Inheritance*, the painting is unusual in Edmonds's oeuvre in that it is set out of doors. Yet the artist has delimited the sense of space through careful placement of the wooden fence and barn in the distance. Here again, the spatial organization is reminiscent of seventeenth-century Dutch courtyard scenes, especially those of Pieter de Hooch. Even the young child possesses the solid architectonic quality so similar to the Dutch artist's

FIGURE 55. Francis W. Edmonds, *First Aid*, c. 1840–45. Oil on canvas, 17 × 14 in. Collection of Henry Melville Fuller.

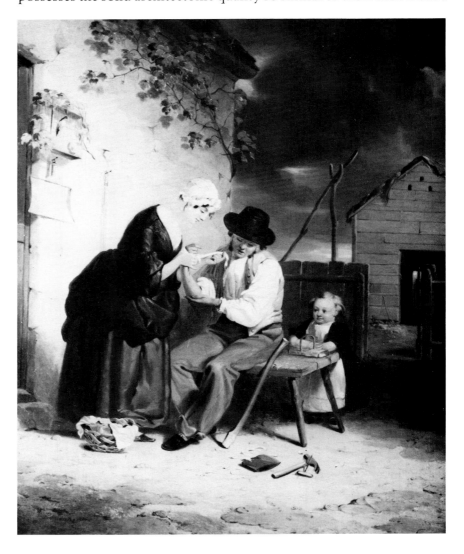

rendering of children. Edmonds handles each detail with a crisp precision that recalls his early training in wood engraving. This clarity enhances the drama of the scene, though this is undermined in part by the somewhat vapid expressions of the characters.

In composing the scene, Edmonds continued to define the roles of each character. The child is a passive onlooker. The mother, aligned with the basket of rags at her feet and the dustpan and birdcage that hang behind her, is the model of domesticity. The dustpan obviously alludes to the woman's function as housekeeper; the birdcage suggests a variety of interpretations, but most likely refers to the female's willingness to remain close to home.[50] (The way Edmonds uses this motif anticipates James Goodwyn Clonney's *Offering Baby a Rose* of 1854 [fig. 56], where the emphasis on domesticity is reinforced by the inclusion of the bird cage. Here again the motif is aligned with mother and child, while the worldlier book, writing materials, and map are placed in conjunction with the husband.)[51] In Edmonds's painting, the farmer is defined by the tools and yoke that lie near him. He has injured himself in the process of repairing his axe. Our eye is led back by the diagonal of the axe handle through the open gate to the barn's slightly open doors in the background. The obvious implication is that the man's sphere, unlike his wife's, exists beyond the boundaries of the house. This depiction of the agrarian setting suggests a preference for the rural ideal, a preference that may have been sensitized by Edmonds's travels abroad. When he visited some of England's industrial cities, he was moved to hope that America would develop as an agricultural rather than a manufacturing nation.[52]

The paintings associated with the National Academy exhibition of 1846 typify the extent of Edmonds's interests: a landscape study; a literary subject; and a straightforward genre scene.[53] Again one can only gain a limited idea of the artist's development, since two of the three canvases elude identification, but he continued to impress contemporary critics. Of the landscape study the *Knickerbocker* said:

> A pleasant bit of tangled wild-wood scenery may be seen in No. 300. The trees are well painted, and the gray-blue sky, "flecking" opaquely through the interwoven foliage, is very natural. As to the round white cloud filling the small distant gap at the horizon, we "like not *that*."[54]

The approbation of the sky and foliage as "natural" was significant, because the shift to a more meticulous rendering of nature was currently taking place under the impetus of Edmonds's good friend Asher B. Durand.[55] His own sympathy with this new attitude was especially understandable as it had its inspiration in seventeenth-century Dutch landscape painting.[56]

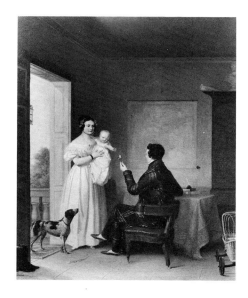

FIGURE 56. James Goodwyn Clonney, *Offering Baby a Rose*, 1854. Oil on canvas, 25 × 19½ in. Hirschl & Adler Galleries, New York.

Edmonds's literary subject for 1846 attests to his ongoing admiration of Sir Walter Scott; Edmonds had even made a pilgrimage to Abbotsford, Scott's residence, during his travels through Great Britain.[57] In this instance Edmonds took his subject, *Lord Glenallan and Elspeth Macklebackit* (unlocated), from Scott's *The Antiquary*, depicting an episode in which Lord Glenallan learns of his mother's maid Elspeth's complicity in preventing his marriage to Eveline Neville.[58] The reviews were uniformly favorable; Edmonds must have imbued his scene with just the right level of emotion. The *New-York Mirror* complimented the artist for skillful delineation and "nice discrimination of character," and alluded to his consummate handling of the subordinate parts, which were "put in with most admirable effect and finished with a delicacy of touch which few of our artists attempt."[59] The reviewer for the *Knickerbocker* was more precise in his description of the details:

> When you have carefully noted the accessories of the cottage—the brass kettle, the suspended haddock, the "pot of jam" on the shelf, etc.,—"do us the favor to observe" the characters. Is Elspeth's glance directed *"anywhere else"* than at Glenallan?—is that warning finger raised at *any* thing save him? Can *his* look be mistaken by anybody? No; it tells the tale.[60]

It is especially disappointing that this painting remains unlocated, since Edmonds created something that was lacking in many of his other works, namely a rendering of emotionally charged personalities.

The Sleepy Student (fig. 57), the artist's third offering to the National Academy in 1846, signals Edmonds's continued interest in schoolboy themes. How natural it was to curl up in a corner with textbook and faithful dog for companions, only to end up asleep. Edmonds captured the moment with particular poignancy, and the plethora of anecdotal detail supported the scene's authenticity. The clay pipe sticking out of the top of the boy's left boot was an especially deft touch in its allusion to his aspirations to manhood. The enormous cabbage, cut into like a large loaf of bread, heralds the bounty of the harvest. So fastidious was Edmonds in his recording of detail that one critic heard "the droning buzz of a fly in the window."[61] The reviewer for the *Knickerbocker* was equally impressed with "the dog in his lap; the dropped book; the wash-bench, with its variety and completeness of utensils; and the no less natural adjuncts beneath; all are to the life."[62] Not all the reaction was positive; the critic for the *New-York Mirror* faulted Edmonds for the unconvincing way the light played against the wall, arguing that it was not true to nature. This criticism is justified since the aureole of light that encircles the

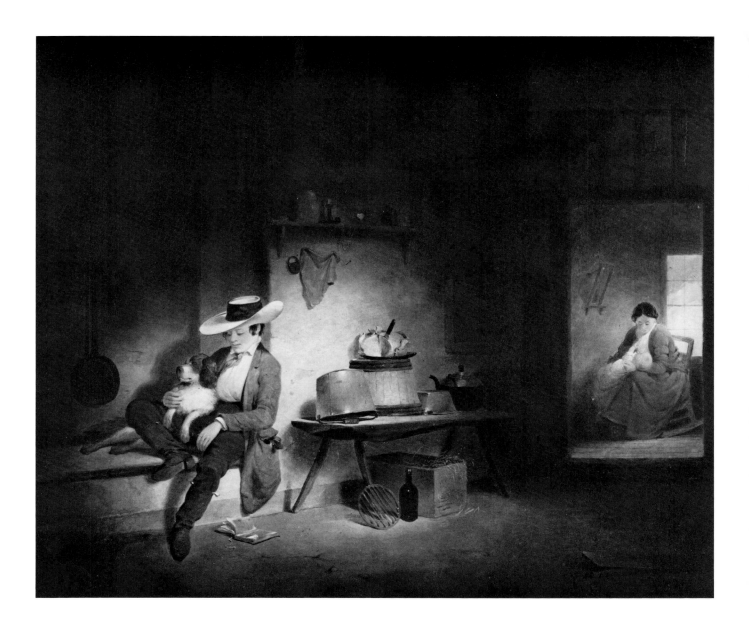

central figures, and the penumbral gloom in the corners of the room, have a decidedly theatrical presence. The scene is relieved from further darkness by the light streaming in from the windows in the room beyond, illuminating the mother as she nurses her child.

The picture, with its wealth of detail, invites closer interpretation. Edmonds offers a parallel bond between the boy and his dog and the mother and her child. Although the mother is ever vigilant to her responsibilities, the boy has let his slip through his fingers, preferring to close his eyes. The lock placed prominently on the wall behind the boy's head is tantalizing. Was the artist inviting the viewer

FIGURE 57. Francis W. Edmonds, *The Sleepy Student*, 1846. Oil on canvas, 20 × 24 in. Collection of Victor R. Coudert, Jr.

FIGURE 58. John McCrae, after Francis W. Edmonds, *The Orphan's Funeral*, 1850. Engraving. From *Gems by the Wayside* (New York: Edward Walker, 1850), between pages 300 and 301. Harry Ransom Humanities Research Center, University of Texas at Austin.

to unlock the real meaning of the painting? Yet there is a harmony and sense of well-being in this scene which, coupled with the happiness of Edmonds's own situation at the time (he was recently a father), infuse the painting with a resounding contentment.

In the ensuing few years Edmonds exhibited little, his painting impaired by his banking career and various other responsibilities. Yet he managed to retain a certain degree of visibility. In 1847 he offered *The New Scholar* for distribution by the American Art-Union; it went to an Albert S. Barnes of New York City.[63] The artist also submitted a painting titled *The Orphan's Funeral* to the National Academy of Design (now lost, but represented by an engraving of 1850 [fig. 58]) and created the previously mentioned work to illustrate Fitz-Greene Halleck's *Poetical Works* (fig. 5). In the latter project Edmonds was in league with such artists as Asher B. Durand and Charles Loring Elliott (1812–68). For his part, Edmonds selected a vignette from *Fanny*, a narrative poem chronicling the aspirations of a man who, having acquired a fortune, desires social acceptance and influence for himself and his daughter Fanny. His overzealous ambition drives him to overextend himself financially, which results in his ruin. Edmonds chose to depict the aftermath of their downfall, specifically the stanza whose last words provide the title for his painting:

> Anxious, however, something to discover,
> I passed their house—the shutters were all closed;
> The song of knocker and of bell was over;
> Upon the steps two chimney sweeps reposed;
> And on the door my dazzled eyebeam met
> These cabalistic words—"this house to let."[64]

Consistent with his experience as a banker, Edmonds's illustration touched upon the folly of greed.

Though one critic thought "*This House to Let*" "might better have been omitted," the critic for the *Knickerbocker*, a periodical emphatically partial to Edmonds's work, judged it "one in Edmonds' best vein . . . a scene of melancholy desolation."[65] The latter author provided a detailed description of the sweeps playing marbles, the cobwebs in the corners of the doors, the absence of the doorplate underscored by the nail holes where it once was—enough to convey Edmonds's penchant for detail.

The artist pursued the theme of industry in two of the paintings he exhibited the following year. Edmonds redoubled his efforts for the exhibitions of 1848, since he was able to contribute two works to the National Academy of Design (both now unlocated) and offer another for distribution through the American Art-Union.[66]

Of the two pictures sent to the National Academy, *First Earnings* was deemed the more successful. The reviewer in the *New York Post*, commending "the artist's peculiarly clear, clean and careful handling," offered an extensive description:

> In the picture of "First Earnings," we have a capital interior of a humble dwelling. A young lad, the eldest of the flock, has just entered, after a day of virtuous toil, and is depositing the produce of his honest labor in the hand of his delighted and proud mother, who glances from her work to the proffered coin and thence to the sparkling eye of her noble boy, with an indescribable expression of pleasure and pride. A younger urchin is trying to relieve the youthful laborer of the hoe which he bears under his arm, while the house dog comes up to wag his congratulations upon the auspicious occasion.[67]

The artist's other offering, *Trial of Patience*, has proved equally elusive, but the description in the *New York Post* helps to clarify the painter's objectives:

> "The Trial of Patience," is another capital story, told with equal felicity. A rude boar of a husband sits smoking his cigar before the fire, and is spitting his tobacco juice upon the nicely cleaned floor, some of which has stained an otherwise spotless garment, hung before the fire to be aired. His youthful wife holds up the abused linen, with a look of mild and gentle reproach, while he looks upon the mischief he has done with an air of careless unconcern, a perfect "what the deuce do I care—take your duds out of the way then," expression.[68]

The theme of domestic cleanliness, represented by the wife, was familiar to Edmonds's time as part of the Dutch legacy in America.[69] One writer discussed the penchant for neatness in seventeenth-century Holland and pointed out its survival in America, commenting:

> The descendants of the Dutch in this country retain the same fondness for scrubbing. It is said, that in Albany they have their firewood piled in heaps with the smooth ends outwards, which are regularly rubbed and kept clean and bright in the same manner as articles of furniture. Many other stories are told whether true or not, of their "strange and curious cleanliness."[70]

Edmonds himself grew up in an environment steeped in the Dutch heritage; with his intense admiration for interior scenes by Pieter de Hooch and Gabriel Metsu that mirrored this meticulous sense of order, it is not surprising that he would attempt this kind of subject himself.

The third painting that Edmonds put before the public in 1848 was *The Strolling Musician*, known today as *The Organ Grinder* (plate

8). Like *The Image Pedlar* (plate 6), this painting reflects Edmonds's interest in the itinerant entrepreneur. Edmonds offers one of the earliest known renderings of this particular subject, anticipating such works as Christian Schussele's (1824/26–79) *The Organ Grinder* of 1857 and George Henry Story's (1835–1923) kindred canvas of 1877.[71] Schussele had emigrated from France in 1848, and Story had studied in Europe. Thus they would have been favorably disposed to such subject matter as these street musicians. Story's, in particular, offers numerous visual links to the Old World. The subject matter had visual precedents in seventeenth-century Dutch art, and Edmonds had seen at least two renditions of similar musicians by Adriaen van Ostade, one in the Fesch Collection (fig. 27) and one in the Hope Collection (fig. 59), during his European sojourn. He would have known a third example by this Dutch artist through John Burnet's *Treatise on Painting* (fig. 16).

In addition to these precedents, the wandering musician was a common phenomenon in America, and artists and writers alike responded to it. In 1845 Nathaniel Hawthorne saw an organ-grinder attended by a monkey soliciting money in Boston and recorded the event in appropriately meticulous detail in his diary:

> In Boston, a man passing along Collonnade row grinding a barrel-organ, and attended by a monkey, dressed in frock and pantaloons, and with a tremendously thick tail appearing behind. While his master played on the organ, the monkey kept pulling off his hat, bowing and scraping to the spectators roundabout—sometimes, too, making a direct application to an in[di]vidual—by all this dumb show, beseeching them to remunerate the organ-player. Whenever a coin was thrown to the ground, the monkey picked it up, clambered on his master's shoulder, and gave it into his keeping; then descended, and recommenced his pantomime entreaties for more.[72]

He utilized this scene six years later in *The House of the Seven Gables*.[73]

The Strolling Musician was well received critically; one reviewer referred to the painting as "of the Wilkie school," no doubt linking it with *The Blind Fiddler* (fig. 23).[74] Although this link is partially justified, the forceful presence of Adriaen van Ostade cannot be neglected. The impish quality of some of Edmonds's facial types—particularly the young man strumming the plate—bears a close affinity to those of the Dutch artist, and the latter's group of peasants at the right of the *Bagpiper at an Inn* (fig. 59) is indicative of the models Edmonds would have used. There is a sameness in the physiognomies rendered by both artists, and one cannot argue with the reviewer who lamented: "Why cannot Edmonds vary his countenance more? The same female face is seen in every one of his pictures."[75] This homogeneity saps the painting of any emotional piquance; while

FIGURE 59. Adriaen van Ostade, *Bagpiper at an Inn*, 1657. Oil on copper, 11¼ × 14⅛ in. Present location unknown; photograph courtesy of Rijksbureau voor Kunsthistorische Documentatie, The Hague, Netherlands.

in marked contrast, the countenance of Wilkie's characters exude a profound sentimentality.

Compositionally, Edmonds resorted to a simplified single-corner interior illuminated by a centralized light source. The relationship of the figures to their setting is reminiscent of *The Bashful Cousin* (plate 5): the room seems to dwarf the people. Moreover, the figures are strung out across the picture plane and there is little attempt to enliven their interrelationship. Despite his success with *The Image Pedlar* (plate 6), Edmonds appears to have been intimidated by the complexity of arranging so many people, and, for the sake of clarity, he has simply fanned them out across the surface of the canvas. Nevertheless, *The Strolling Musician* was well received, and its success hinged upon its interpretation as "a cheerful picture for a cheerful household room."[76]

The year 1849 constituted another lull in Edmonds's productivity, but his only new painting was interesting on several accounts. The story of *Gil Blas and the Archbishop* (plate 9) was taken from a novel by the eighteenth-century French author Alain-René Lesage. The *Literary World*, in a report taken from the *Evening Post*, neatly summarizes the scene:

> Edmonds has just finished one of his best things for the Art-Union. It represents Gil Blas in the act of passing that unfortunate criticism upon the sermons of his patron, the Archbishop, which cost the poor valet his place. The aspect of complacency with which Gil Blas

is uttering his judgment is extremely well contrasted with the expression of utter contempt for his opinion seen on the face of the ecclesiastic. The comic effect is more decided than in any other work of this artist which we remember. The still life of the picture is admirably painted, and the coloring pleases us more than that of some of Edmonds' recent works.[77]

The report that he had "just finished" the work raises an interesting problem. The recent discovery of two drawings in an early sketchbook (figs. 60, 61) and reference to a finished sketch of *Gil Blas and the Archbishop* (unlocated) existing by 1842 throw into question the precise date of the final version of this painting. The two drawings are on consecutive pages of the same sketchbook that contains the initial drawing for *The City and the Country Beaux* (fig. 21), and stylistically they can all be dated to the same time period, approximately 1839. The finished oil sketch of *Gil Blas and the Archbishop* was a present from Edmonds to Charles Lanman in gratitude for his posing for *The Bashful Cousin* (plate 5) in late 1841 or early 1842. Although this sketch remains unlocated, it is obvious that the subject was very much on his mind in the late 1830s and early 1840s when he was immersing himself in such English authors as Tobias Smollett, who coincidentally had translated *Gil Blas* from the French.[78]

In the sketchbook, the two figures are first rendered in a limited setting, then given a more elaborate and spacious interpretation. The finished painting accords closely with the simpler sketch, particularly

FIGURE 60. Francis W. Edmonds, study for *Gil Blas and the Archbishop*, c. 1839. Graphite on paper, 6⅝ × 8¼ in. The Metropolitan Museum of Art, New York; Sheila and Richard J. Schwartz Fund, 1987.

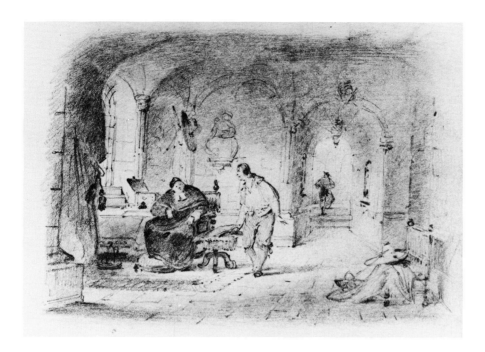

FIGURE 61. Francis W. Edmonds, study for *Gil Blas and the Archbishop*, c. 1839. Graphite on paper, 6⅝ × 8¼ in. The Metropolitan Museum of Art, New York; Sheila and Richard J. Schwartz Fund, 1987.

in the arrangement of the figures and the more constricted space of the room. Edmonds made some telling changes. In the early drawing, the faces of both characters verge on caricature and define very little of the specific narrative. In the painting, Edmonds captured the essential features of each through their expressions. The artist imbued the archbishop with a contemptible sneer that sags under the weight of his prodigious jowls. It is not surprising that an enormous beer tankard stands at his elbow. Gil, on the other hand, has been depicted with a gaze of almost naive innocence, and his features border on perfection in every respect. His dismissal must have been a doubly bitter pill to swallow, since Gil had been told continually by the archbishop that the only way to go through life was by being completely honest. The literally two-faced characterization of the archbishop may provide a key to the figurative meaning of the picture.

Before turning to this important aspect, it is necessary to dwell on the other significant change that Edmonds made between the drawing and his completed canvas. The archbishop works by a large window in the drawing; ultimately he is set against a solid wall adorned by a large unidentifiable painting in a heavy gilt frame. The light-filled room and its visual contact with the outside world have been replaced by a closed, almost claustrophobic barrier relieved only by a painting so dark it cannot be read, which in its darkness becomes decidedly ominous. The only escape from this room is the sliver of a doorway at the right-hand edge of the composition.

Though modern viewers tend to see a good-natured humor in this scene, it may have had a controversial side to it in the 1840s. The anti-Catholic sentiment of the Nativist movement had elicited passionate sentiment by the middle of the 1830s, reaching its peak in 1850.[79] It was a serious force in American politics (Martin Van Buren, in his bid for the presidential nomination in 1836, had to refute his alleged support of Catholicism).[80] Maybelle Mann suggests that *Gil Blas and the Archbishop* carried an anti-Catholic message.[81] Whether the painting was politically motivated or simply a probing essay on human nature, the artist clearly defined forces of good and evil. The sinister expression of the porcine archbishop leaves little doubt as to how the artist perceived him, and this powerful editorial commentary on the hypocrisy of the Catholic church cannot be denied.[82]

The year 1850 witnessed Edmonds's return to a more humorous vein in the two paintings he exhibited at the National Academy of Design. They were listed as *The Two Culprits* and *Courtship in New Amsterdam*.[83] Both pictures remain lost, although *The Two Culprits* is known through a photograph (fig. 62) as well as a preliminary oil sketch (fig. 63).

The Two Culprits is the third picture Edmonds devoted to the subject of schoolboys (the others are *The New Scholar* [plate 7] and

FIGURE 62. Francis W. Edmonds, *The Two Culprits*, 1850. Oil on canvas. Present location unknown; photograph courtesy of Kennedy Galleries, New York.

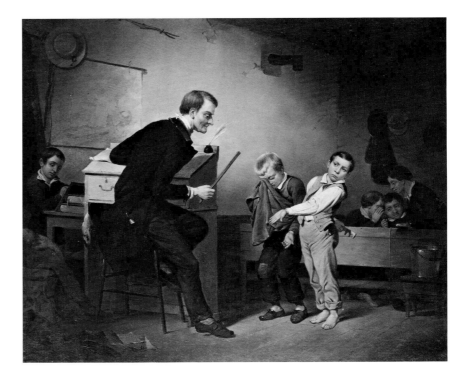

The Sleepy Student [fig. 57]). The scene depicts a rather sadistic-looking schoolmaster meting out punishment to two youthful miscreants. They are presumably guilty of fighting, since the blond-haired boy at the left is already in tears, no doubt as a result of the nineteenth-century equivalent of brass knuckles that his adversary holds. The group in the background confers on the proceedings while the student at the far left is a model of discipline, as he continues his lessons unaffected by the disturbance. The inclusion of this student is the only major modification made to the preliminary sketch. Possibly Edmonds decided to infuse the scene with a moral overtone that would offset the humorous reaction to the tableau.

The contemporary audience saw the more mirthful quality, and one critic identified the schoolmaster as "a pedagogue of the Ichabod Crane genus."[84] While the teacher in the painting shares Crane's willingness to use the rod, he doesn't possess the gawky, bumbling quality that Irving bestowed upon him and that Felix O. C. Darley (1822–88) captured so effectively in his illustrations published in 1849 (fig. 64).[85] Darley and Edmonds share one important element: their classrooms comprise an entirely male world. Though there were numerous avenues of education open to young women, the drastic changes of the Civil War were still in the future, when women would assume a far more visible role as teachers and educational philosophy would take on more humanitarian attitudes.[86]

Both *The Two Culprits* and *The New Scholar* epitomize Nicolai Cikovsky's account of the pre–Civil War school as bastion of stern discipline, where the strap was often the only effective pedagogical tool.[87] Edmonds has intimated that some schoolwork does get done and at least has included maps (the one in *The Two Culprits* is clearly of southern New England) as references to auxiliary teaching tools. The map was a favorite accessory of his and again may derive from his appreciation of seventeenth-century Dutch painting, where the map was such a pervasive motif.[88] Why he chose to include a map depicting such a limited geographical area is unclear, but its allusion to worldly knowledge is reinforced by its placement—directly behind the only student immersed in his studies.

The artist's other offering to the National Academy for 1850 also explored a theme that had enormous appeal—that of budding romance. *Courtship in New Amsterdam* recalls earlier efforts by Edmonds such as *Sparking* of 1839 (plate 3) and *The Bashful Cousin* of about 1842 (plate 5), and anticipates *Time to Go* (fig. 87), painted in 1857. Although the picture is unlocated, its humorous content emerged in a review in the *Literary World* observing that Edmonds "turns the laugh upon a Knickerbocker swain of the old school."[89] The critic faulted the work for its lack of finish and slipshod draftsmanship but

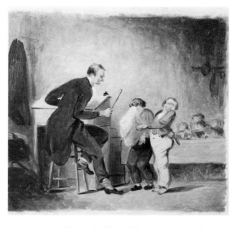

FIGURE 63. Francis W. Edmonds, study for *The Two Culprits*, c. 1850. Oil on paper, 6½ × 7¼ in. Courtesy of Kennedy Galleries, New York.

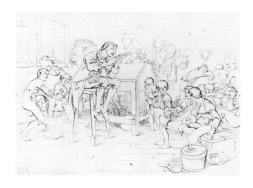

FIGURE 64. Felix O. C. Darley, *Illustrations of the Legend of Sleepy Hollow*, plate 1, 1849. Etching, 8½ × 11⅛ in. Henry Francis du Pont Winterthur Museum Library, Winterthur, Delaware; Collection of Printed Books.

could not deny the glittering effect of the still life: "But the inside of the tin kettle turned up against the door is in the highest style of copper. It is burnished to almost California brightness, and reflects the housewifery of New Amsterdam to the great credit of the young *vrouw* who sits in the doorway beside it."[90] The allusion to the kettle's "California brightness" referred not only to the furor over the discovery of gold in California but also balanced the early part of the paragraph, which discussed William Sidney Mount's painting *News from the Gold Diggings*. Although the *Literary World* was not kind to Edmonds critically, it found it appropriate to link his work with the premier genre painter of the time.

The subject matter of *Courtship in New Amsterdam* provides an interesting precursor to the theme of Edmonds's sole offering for 1851 at the National Academy of Design.[91] The latter painting interpreted Robert Burns's poem "What Can a Young Lassie Do wi' an Auld Man," which chronicled the matrimonial unhappiness that the disparity in age can bring, especially when the motive is pecuniary:

> What can a young lassie, what shall a young lassie,
> What can a young lassie do wi' an auld man?
> Bad luck on the penny that tempted my minnie
> To sell her poor Jenny for siller an' lan'![92]

The picture is known today only through a small preliminary sketch (fig. 65) and a wood engraving reproduced in the *Bulletin of the American Art-Union* for December 1851 (fig. 8). The sketch is freely painted and concentrates on the arrangement of the two figures: the young woman stands by the window and looks over her left shoulder at her aged husband, who is hunched over in his chair stirring his bowl of porridge. The faces are not finished, yet they clearly indicate the misery of the situation. The artist clarified these ideas in the finished version—as evidenced in the wood engraving. The young woman now holds a broom, and the brick floor is spotless. Edmonds employs his favored interior setting of a room with a doorway leading to a room beyond, and he displays a rich variety of still-life elements, including a flagon, a mirror, a skein of yarn, a saw, and a key hanging from a nail on the wall. The choice and arrangement of some of these items offer interesting insights into Edmonds's interpretation of the poem.

The motif of the open window as a metaphor of freedom is now familiar in the artist's oeuvre; in this depiction it is particularly telling that while the young woman faces the window, she arches back from it and averts her head almost as though she cannot confront the beckoning liberty that lies beyond. What a poignant contrast this makes to the window as means of escape for the young couple in

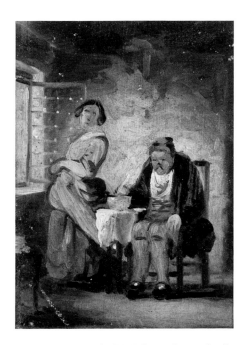

FIGURE 65. Francis W. Edmonds, study for *"What Can a Young Lassie Do wi' an Auld Man,"* c. 1851. Oil on board, 5 × 3½ in. Private collection.

Tompkins Matteson's *Now or Never*, painted in 1849 (fig. 66). That Edmonds placed the mirror adjacent to the window was no accident; it forced the miserable wife's gaze to reflect back into the interior of the room and onto the source of her imprisonment. Her incarceration is symbolized by the placement of the key on the wall. The critic for the *Literary World* identified the lamentable circumstances in this painting and noted, "gout, and elasticity, imbecility and contempt, are capitally rendered."[93]

The painting was one of two by Edmonds auctioned at the dispersal sale of the American Art-Union in December 1852.[94] The other was *Preparing for Christmas* (unlocated), which carried this brief description: "Two men in the open air, before a stable, are picking turkeys for the kitchen; a negro is blowing his hands to keep them warm. The ground is covered with snow."[95] This description brings to mind a work of George Henry Durrie (1820–63; fig. 67), and also invites comparison with an equally elusive work by Edmonds known as *Man Buying Chickens outside a Barn*, which surfaced in Somerset County, New Jersey, in the early 1970s only to quickly submerge again.[96] This painting, known through a photograph, also begs comparison with Durrie, as the composition contains the unmistakable blend of architectural structure, everyday activity, and exquisitely rendered still-life elements. Both paintings include black farmhands, and Edmonds has seemingly avoided the stereotype by according

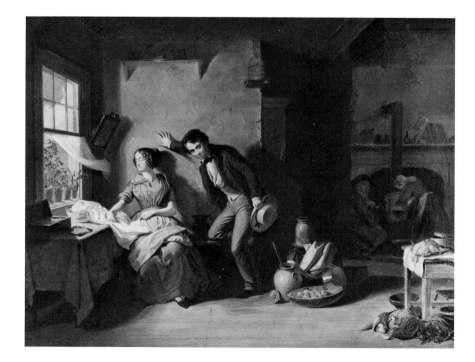

FIGURE 66. Tompkins H. Matteson, *Now or Never*, 1849. Oil on canvas, 26⅝ × 33¾ in. The Parrish Art Museum, Southampton, New York; Clark Collection.

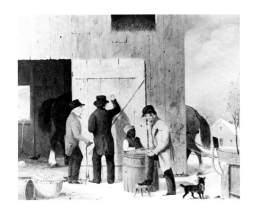

FIGURE 67. George Henry Durrie, *Farmyard in Winter, Selling Corn*, 1852. Oil on panel, 19½ × 24 in. Shelburne Museum, Shelburne, Vermont.

them a certain measure of humanity and respectability. (One other work shows Edmonds's interest in outdoor settings at this time, an admirable pencil drawing entitled *Just in Time* [fig. 68] that depicts a doctor arriving to attend a woman in childbirth.)

In addition to settling the affairs of the American Art-Union, Edmonds in 1852 exhibited a major work, *The Speculator* (plate 10), at the National Academy.[97] This painting depicts a farmer and his wife receiving a sales pitch for a plot of land adjacent to a railroad line from a smooth-talking real-estate agent. It was an obvious pictorial condemnation of questionable procedures in real-estate speculation; Edmonds's critical posture takes on added poignancy in light of the attack he came under concerning his integrity as a banker in 1855. The artist concerned himself with the issue of shady real-estate dealings as early as 1838, when he created a wash drawing called *The Paper City* (fig. 69), referring to the practice of luring buyers to take land in cities that existed as yet only on paper.[98] This early sketch was unquestionably prompted by one of the contributing factors to the Panic of 1837, the collapse in real-estate prices that had been inflated by speculation. This drawing, a preliminary oil sketch (fig. 70), and the finished version all pit a country bumpkin against a city slicker, an idea Edmonds had used before in *The City and the Country Beaux* (plate 4). In the final version, which closely echoes the preliminary oil, the sturdy builds and plain clothing of the farmer and his wife contrast sharply with the sartorial elegance of their urban

FIGURE 68. Francis W. Edmonds, *Just in Time*, c. 1850–55. Graphite on paper, 9¹/₁₆ × 11⅝ in. Munson-Williams-Proctor Institute, Utica, New York.

FIGURE 69. Francis W. Edmonds, *The Paper City*, 1838. Wash on paper, 7 × 8¼ in. The New-York Historical Society; Bequest of Emily Ellison Post.

FIGURE 70. Francis W. Edmonds, study for *The Speculator*, c. 1852. Oil on board, 11¼ × 14 in. Collection of Charles O. Coudert.

counterpart. There is an air of homogeneity about the country figures that prompted one critic to observe: "There is a command in the Sanscrit version of the Old Testament, that 'a man shall not marry his sister.' From the close resemblance of the married pair which forms this groupse [*sic*], mutual ignorance or contempt of authority is obviously inferable."[99] Edmonds's seeming inability to render individual features was an ongoing source of criticism.

Compositionally, *The Speculator* subscribes to the familiar stage-like interior, but it is unusual in its hermetic quality. Edmonds eschewed any light source from a window or relief of the compressed space by his usual device of an open door to the room beyond. Perhaps the intent is to underscore the claustrophobic existence of the couple and to make the salesman's proposition more appealing. The farmhouse is sparsely furnished, although there is an abundance of still-life accessories that give the setting atmosphere. The style of painting is tight and slick, as Edmonds meticulously renders textures, including the obligatory still-life elements. One item that caught the attention of the critic for the *Home Journal* was the jug in the left foreground, which prompted him to observe: "We were almost tempted to draw the cork from a demi-john artfully concealed under the table, but reflecting that the 'Maine Law' was inaugurated at the recent festival at the Academy, we deferentially abstained from setting a pernicious example to lighter heads than our own."[100]

Curiously, the artist came under some fire from the critics. The *Literary World* thought more attention should be paid to the drapery, while the *Home Journal* suggested that the accessories were not taken far enough in their truthful rendition.[101] Whatever the contemporary objections, it is to the artist's credit that he did not sentimentalize the scene; yet, as the farmer and his wife listen to the huckster's entreaties, there is a sense of premonition about the inevitable erosion of the rural ideal.

Edmonds was philosophically sympathetic to this ideal although he was well aware that it was incompatible with his own career. In *The Speculator* he acknowledges that railroads are prime offenders in such speculative ventures (in the plan the real-estate agent holds, "Rail Road Ave." cuts through the center of the development), even though he himself had been one of the principal reorganizers of the New York and Erie Railroad in 1843.[102] The one decoration the farming couple have permitted themselves may be of importance. It is a picture of a bull placed where one might expect to find a portrait of a family member or a revered hero such as George Washington, and it signifies their obvious dedication to animal husbandry.[103] This emblem may stiffen their resolve against the ministrations of the slippery salesman. Edmonds, having recently bought a house in the

country, was sensitive to the rural life and enjoyed working the land, an activity he considered beneficial to his health.[104]

The following year, 1853, was to mark the beginning of significantly expanded financial responsibilities as Edmonds became actively involved in the creation of the New York Clearing House; yet he managed to show two new works, one in New York and one in Philadelphia.

Edmonds persisted in his admiration for Robert Burns, submitting a second work to the National Academy of Design based on his poetry.[105] Although titled only *Passage from Burns,* the painting was accompanied by the pertinent text:

> To daunton me, and me so young
> Wi' his fause heart and flattering tongue;
> That is the thing you ne'er shall see,
> For an auld man shall never daunton me.[106]

The verse, taken from Burns's poem "To Daunton Me," chronicles the defiance of a young girl to submit to the prospect of a comfortable life spent with a much older man.[107] From a textual point of view, the subject stands in telling contrast to Edmonds's previous effort taken from Burns, *"What Can a Young Lassie Do wi' an Auld Man?"* (figs. 8 and 65).

Although the connection remains tenuous, a painting by Edmonds has come to light recently that corresponds closely to the spirit of the Burns passage. The canvas, known today only as *Cottage Interior* (fig. 71), was owned by Edwin Forrest, the great tragedian, whom Edmonds knew. Forrest was an energetic collector and patron of the arts whose legacy included the Edwin Forrest Home for Retired Actors, which also housed his collection.[108] Many of Forrest's paintings were theatrical in inspiration; consequently, the composition by Edmonds was not inappropriate. His familiar boxlike interior had a close affinity to a stage set, and the powerful characterization of both protagonists reflects a theatrical bearing. The young girl almost seems to mug coyly to the audience, while the man stares archly at her. His ramrod demeanor is echoed by the equally rigid posture of the terrier at his feet. Moreover, the dog's origins may be as Scottish as the gentleman's, judging from the latter's carefully clipped sideburns and ruddy complexion, especially his pomegranate cheeks. Despite his forceful presence, the young girl is not about to capitulate to his entreaties, and the artist tellingly conveys the notion that the course of love does not always run smoothly. This idea might have held added poignancy for Forrest, since he had endured a highly publicized divorce proceeding in which he was cast in an unfavorable light.[109]

Edmonds signals the girl's attitude toward her suitor through

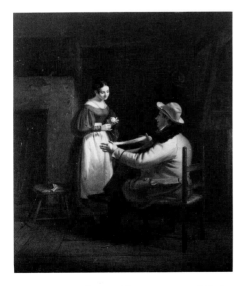

the disposition of her knitting. She has let the ball of yarn drop to the floor, which provides a metaphor of her intentions regarding her caller. Knitting was a convenient vehicle to illustrate the judgment of Cupid, and Edmonds may have taken his cue from William Sidney Mount's *Courtship*, also known as *Winding Up* (fig. 72), painted in 1836.[110] The motif enjoyed a certain longevity and appeared in scenes of domestic harmony such as Eastman Johnson's (1824–1906) *The Brown Family* of 1869 (fig. 73), but it also continued as a harbinger of discord. A postwar example of this attitude is found in Seymour Joseph Guy's (1824–1910) *Knitting* (fig. 74).[111] A young suitor with a bouquet of flowers interrupts a domestic scene, and judging from the father's arch stare he may not be entirely welcome. If this painting is the one Guy exhibited as *Not in the Skein*, then the play on words, "not in the scene," becomes even more telling. Guy has reaffirmed the tenuous position of the young man by casting him in shadow that contrasts sharply with the intense light that focuses on the girl and her young brother. As she works to disentangle her knitting and her personal affairs, she will not leave her caller long in the dark regarding his situation. There is a psychological depth in Guy's painting that differs sharply from the sense of burlesque in both Mount and Edmonds.

The year 1853 also marked a continuance of Edmonds's exposure beyond the confines of New York City, *The Beggar's Petition* appearing at the annual exhibition of the Boston Athenaeum and *The First*

Step at that of the Pennsylvania Academy of the Fine Arts.[112] The latter painting, too, remains lost, and nothing in the way of a description has come to light. But correspondence survives that is instructive about Edmonds's attitude toward the disposal of his art and the network of his patronage.

The owner of *The First Step*, James L. Claghorn, was the model patron for Edmonds, since, in the words of *Harper's Weekly*, "his thoughts were divided between finance and fine art, and he best liked to use his money in buying pictures."[113] In addition to being a successful merchant and influential banker, Claghorn was a trustee, and subsequently president, of the Pennsylvania Academy. Despite these extraordinary parallels in their activities, they did not know each other, and Claghorn purchased the painting through a mutual friend from New York, Edmund M. Young. The negotiations were carried on by letter; at one point in their correspondence Young offered an interesting insight into the painter's artistic personality:

> Edmonds is a queer fellow sometimes about painting. I have known him to decline an order, merely because he did not fancy the person who wanted it. But with this picture for you, he entered right into the spirit of the thing—liked the idea of painting a picture to go to Philadelphia—especially as he believed it would be seen. He would feel obliged, if you would permit the picture to be exhibited at your regular exhibition next season.[114]

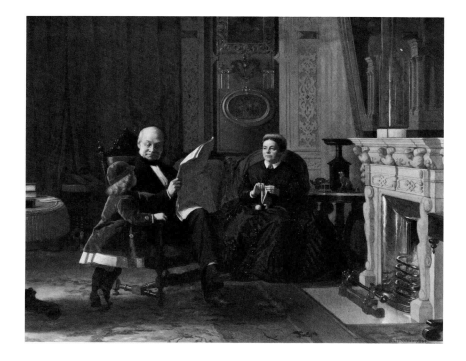

FIGURE 73. Eastman Johnson, *The Brown Family*, 1869. Oil on paper, mounted on canvas, 23⅝ × 28½ in. National Gallery of Art, Washington, D.C.; Gift of David Edward Finley and Margaret Eustis Finley.

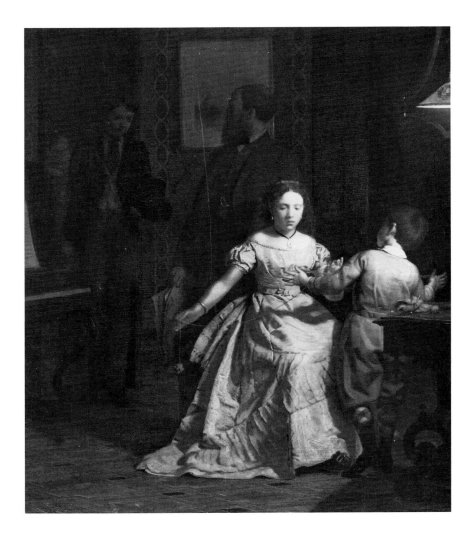

Claghorn accommodated Edmonds in this latter request, and the artist must have been especially pleased to be represented in the collection of such an influential Philadelphian. Edmonds was selective about where his paintings went, and he was concerned that they go where they would be appreciated and where they would enhance his reputation. This second consideration implies a concern that goes well beyond the objectives of an amateur.

Edmonds, as his responsibilities and influence as a banker continued to grow, found it increasingly difficult to find time to paint. His involvement in the forming of the New York Clearing House began in earnest in the summer of 1853, and this undoubtedly necessitated a curtailment of his creative pursuits. He also suffered a deep personal tragedy when his oldest son, Francis Henry, died in November 1853.[115] Perhaps painting provided an emotional outlet for

Edmonds, since he was able to submit one work, *Taking the Census* (plate 11; preliminary oil sketch, fig. 75), to the National Academy of Design.[116]

The critic for the *Home Journal* enthusiastically described the picture:

> Here we have represented the census-taker with an important official air, noting down the family statistics; his assistant, a lad standing in the business-like attitude, and all alive with the novelty of the occasion; farmer—, rough and awkward, reckoning in brown, study the number of "the boys and girls" evidently more at home in the use of the ox-gad which lies on the floor than in "figuring"—and so on through nine figures, each one of which is a character and triumph. Why has this admirable artist treated us to but one picture in this collection?[117]

Edmonds, who was a bank officer, city chamberlain of New York, and chairman of the New York Clearing House at the time, must have had mixed emotions about the answer to the critic's question, but, no doubt, he took great satisfaction in its asking.

Taking the Census is quintessential Edmonds. The boxlike setting with the door in the right background letting in light has become almost a compositional signature for the artist. Edmonds, in this instance, offsets the balanced, structural rectilinearity by arranging the figures in a series of diagonal relationships. Thus, he infuses the painting with a visual dynamic. The lovingly painted still-life ele-

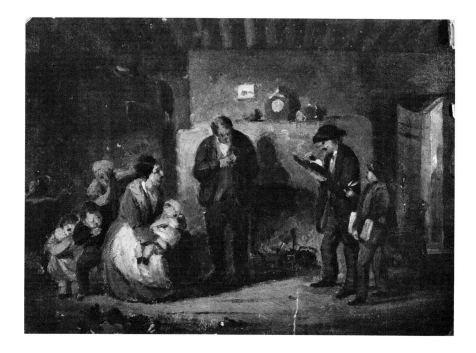

FIGURE 75. Francis W. Edmonds, study for *Taking the Census*, c. 1854. Oil on board, 4⅜ × 5⅞ in. Collection of Jo Coudert.

ments are another integral stylistic feature of the artist, who often used them to add resonance to the interpretation of the work. Above the father the artist has placed a small portrait of George Washington, long recognized as the "Father of Our Country," whose role as leader was aspired to in every household in America. The wife's role is depicted in the children who surround her, and above her head the artist has carefully placed three ears of corn, which signify fertility.

Taking the Census also offers a rich commentary on its time. Initially, one must take issue with the critic of the *Home Journal* regarding the apparent stupidity of the farmer. There are books on the mantlepiece, a large book on the table at the left, and an illustrated book, possibly an alphabet primer, lies open on the floor beside the chair where the mother sits. Thus there is strong evidence of the premium placed upon learning in this household. The cause of the father's apparent befuddlement may stem from other sources. The census of 1850 was a landmark event in that it initiated the method of recording facts separately for each individual rather than grouping them by family. In light of the wealth of information concerning each person that was solicited, it is little wonder that the head of the household had to pause to get his facts straight. Indeed the complexity of the new census schedules engendered a plethora of jokes confusing census and senses.[118]

Edmonds's motives for dealing with the question of the census remain unclear; *Taking the Census* certainly stands as one of the earliest known visual records of this activity. Perhaps the political implications of the census were a sensitive issue for him, since his position as city chamberlain was a political plum tied to the fortunes of the Democratic Party in New York. By mid-century America was in the midst of a period of enormous growth; from 1840 to 1860 the population swelled from about seventeen million to over thirty-one million, and immigration constituted a major factor in the increase.[119] This had obvious ramifications for the political process, particularly in the cities, which experienced the greatest growth. Indeed, so dramatic was the increase through immigration that the *Crayon*, normally devoted to aesthetic issues, was prompted to publish an article reflecting on the census in which particular attention was paid to the immigration issue. The author was less than kind in his estimation of this foreign influx, writing:

> As far as the masses of foreigners are concerned, who contribute so much to swell our population, they have long ceased to offer any charms of novelty. The majority of them are inferior in education and intelligence to corresponding American classes, and their position in society is governed by this fact.[120]

The article was especially condescending about the waves of Irish and Germans that were making their way into the country. While this specific account postdates Edmonds's painting by a number of years, it does reflect a sentiment that was very much in the air. Questions regarding place of birth were on the census schedule of 1850.[121] Edmonds, with his Democratic alignment, presumably would have been more sympathetic to immigrants, since they would have benefited the Democratic Party.

Edmonds did paint other pictures during 1854. There are references in his diary to portraits he was working on, but also he embarked on his most ambitious work, which was remarkable for being a religious subject. In addition to all his other activities, Edmonds became active in the Episcopal Church in this year, and events of

FIGURE 76. Francis W. Edmonds, *Felix Trembled*, c. 1855. Oil on canvas, 140½ × 107¾ in. Private collection.

the church were to inspire his *Felix Trembled* (fig. 76), which depicts the harassment of Saint Paul by Felix, the procurator of Judea.[122] Edmonds embarked on preliminary sketches for the painting after his return from the Episcopalian convention in October of 1854.[123] Since it was intended as an altarpiece, the work was to be his most ambitious, and the canvas measures nearly twelve by nine feet. His preoccupation with this commission accounted for his absence in the exhibition scene of 1855, with the exception of *First Earnings*, which appeared at the Pennsylvania Academy. The theme of persecution in *Felix Trembled* was perversely prophetic, since Edmonds was to undergo his own ordeal as a banker during the summer of 1855.

While the painting cannot rank as one of his most successful efforts, he unquestionably brought to its creation a deep personal feeling. The accusations that forced him from the banking profession were the culmination of a series of personal disappointments that followed a decade of tremendous success in both his banking and artistic careers. He was not broken by these misfortunes, but he did retrench, finding respite in his painting. Although he did not divorce himself from business affairs, the last eight years of his life were to be conditioned primarily by the solace that he took from his painting. And, true to the disappointments that he endured, his artistic vision was to assume the depth and profundity of one who has encountered the harshest realities of life.

The Years of Solace, 1855–63

IN THE FINAL EIGHT YEARS OF HIS LIFE, EDMONDS DID NOT SHOW A dramatic increase in his artistic output; thus, his resolve to devote greater amounts of time to painting was not entirely realized. Edmonds could not divorce himself completely from his business pursuits, and he maintained a hectic pace juggling commerce and creativity. But the nightmare of the Mechanics' Bank affair deeply affected his world view. Artistically, Edmonds's vision developed a marked profundity and a sense of wistfulness. He eschewed the amusing anecdote taken from literature and focused on the often stark realities of everyday life. This is not to say that his painting became lugubrious; it simply embraced a greater sensitivity to the foibles of human nature. In addition to the turmoil in Edmonds's own life, these years saw a growing national tension that finally issued in civil war and an economic collapse brought on by the Panic of 1857, which, to Edmonds's undoubted satisfaction, was mitigated in great part by the controls regulating credit that were imposed by the New York Clearing House.[1] The personal disappointments Edmonds encountered and the unsettled tenor of the times prompted the artist to rely on painting for solace, refuge, and reflection in the waning years of his life.

Despite the enormous amount of time and energy Edmonds expended during the summer of 1855 clearing his name as a banker and working on the monumental *Felix Trembled* (fig. 76), he found time to complete at least three canvases: *The Thirsty Drover* (plate 12) and *All Talk and No Work* (fig. 77), included in the National Academy of Design exhibition in the spring of 1856,[2] and *The Scythe Grinder* (fig. 83). All three are rural in character, reflecting the increased amount of time Edmonds was spending in the rustic confines of his house in Bronxville and the concomitant sense of remove he must have felt from the lively tempo of city life.

The Thirsty Drover reaffirms the ideal of an agrarian America that Edmonds had alluded to in *The Speculator* of 1852 (plate 10). At mid-century, agriculture was still a prominent factor in both the work force and the economy; Jesse Buel articulated this dual importance in his manual *The Farmer's Companion*, which enjoyed con-

siderable circulation throughout the 1840s.[3] Buel argued passionately for agriculture's role as a cornerstone of the young nation, and his opinion found a sympathetic response in Edmonds.

The painting depicts a pair of drovers taking their cattle to market. One of the riders has stopped for a drink of water at a farmhouse by the road. The "Domestic Art Gossip" column in the March 1856 issue of the *Crayon*, noting this painting among Edmonds's works in progress, took particular interest in the well: ". . . over it [the well] is one of the long *sweeps* (to which a bucket is attached), a primitive machine, common in our country, but which is fast disappearing before water-rams and *patent* Egyptian bucket-lifters, or species of *sakkiehs*."[4] Significantly, the columnist alludes to the impact that the technological revolution had on agriculture, a point that Edmonds deftly deflects in his picture.

A girl offers the drover a pitcher of water while her mother continues to grapple with a tub full of laundry. A sense of hospitality and an aura of good feeling radiate from the scene; everyone is well fed and nicely dressed. The picture suggests the importance and ostensible rewards of such agrarian pursuits, providing in this a visual counterpart to John Greenleaf Whittier's *Songs of Labor*, a volume of verse glorifying the working man, published in 1850.[5] Whittier heralded the activities of shoemakers, lumbermen, huskers, and drovers, intending his verses to be read by his subjects in order to increase their self-respect. The lines devoted to the drovers describe the richness of the land and extol the rewards of the work:

> In our good drove, so sleek and fair,
> No bones of leaness rattle;
> No tottering, hide-bound ghosts are there,
> Of Pharaoh's evil cattle.
> Each stately beeve bespeaks the hand
> That fed him unrepining;
> The fatness of a goodly land
> In each dun hide is shining.[6]

In addition to the effusive chronicling of the drover's good life, Whittier also underscores the independent nature of their profession:

> Then let us on through showers and sun
> And heat and cold be driving;
> There's life alone in duty done,
> And rest alone in striving.[7]

Whittier turned his attention to a crucial stratum of society in his hymns to the laboring class, but only to its male half. By contrast, Edmonds in *The Thirsty Drover* showed an ongoing sensitivity to the work done by women. Inevitably, the woman's function centered on the household and its orderly management, in this instance the unceasing chores of doing the laundry and looking after the children. Edmonds nicely echoed this latter responsibility in the vignette of the mother hen looking after her chicks, in the right foreground of the composition. This was not a new conceit and had a basis in the sentimental works of Jean-Baptiste Greuze (1725–1805). Greuze, too, admired Dutch paintings of the seventeenth century, and his own works were accessible through engravings.[8] The mother's domestic ties are also symbolized in the inclusion of the caged bird, a motif Edmonds used a decade earlier to make the same point in *First Aid* (fig. 55). The artist conveys the drudgery of the woman's lot, portraying her in almost a trance as she goes through the motions of her various tasks. In a preliminary oil sketch (fig. 78), she appears more animated and involved in the proceedings, turning her attention

FIGURE 78. Francis W. Edmonds, study for *The Thirsty Drover*, c. 1856. Oil on board, 9¼ × 13¼ in. Collection of Rex Tatum, Jackson, Mississippi.

FIGURE 79. William Sidney Mount, *Bargaining for a Horse*, 1835. Oil on canvas, 24 × 30 in. The New-York Historical Society.

to the interchange between daughter and drover, and the caged bird is not in the picture. In the final version, however, Edmonds chose to allude to the tedium of her existence and to the plight of her entrapment.

If this was Edmonds's message it was lost upon the reviewer for the *Crayon*, whose notice gave the picture a mixed review.[9] While

proclaiming it the best picture Edmonds had produced, he questioned the lack of attention to detail, which should compensate for a picture's humble subject. The author balanced this criticism by commending the painting for its absence of "affectation or impertinence." The review was contradictory, and its ambiguity in conjunction with the emphasis on capturing nature's details reflects the *Crayon*'s Ruskinian inspiration.

Edmonds's other offering to the National Academy, *All Talk and No Work*, received similar treatment from the *Crayon*: the heads of the two main figures were praised for their individuality; but the lack of story line and of meticulous rendering were noted. Indeed, the critic severely chastised Edmonds on this last point: "There is no excuse in Mr. Edmonds' case, for the lack of thorough detail painting, and it is the only thing which will ever make his paintings really valuable."[10] Edmonds may have been attempting to broaden his technique at this time and to move philosophically from a consideration of the particular to the more general and hence universal; but the attitudes of the *Crayon* were not sympathetic to this new direction.

Although demonstrating a freer, less meticulous technique, *All Talk and No Work* reflects Edmonds's preference for theatrical devices. Both figures, with their fixed stares, assume a statuelike quality. Edmonds carefully controls the light to give the scene a feeling of artificiality, and his composition reinforces this concern. While the figures are set out of doors, they are surrounded by an architectural complex that provides rigid structure and spatial limitation. (William Sidney Mount had used a similar balance of interior and exterior in *Bargaining for a Horse* [1835; fig. 79].)[11] The only reference to the landscape beyond is through the opening in the barn, a device reminiscent of Edmonds's use of open doors in his interior scenes. The dwelling set into the hillside appears to be part stucco and part brick, and the gambrel roof is reminiscent of the so-called Dutch-colonial style that flourished in New York and New Jersey in the last quarter of the eighteenth century.[12]

The painting captures both men in a quiet moment, which may reflect the artist's new-found delight in the leisurely pace of rural life. He also shows a sympathy for blacks that was unusual for his time. More often in such scenes, the black man was caricatured as the embodiment of idleness. James Goodwyn Clonney's *Waking Up* of 1851 (fig. 80) shows a pair of young white boys tickling a black man's nose as he snoozes while fishing. The prank echoes similar activity in Mount's *Farmers Nooning*, but Mount at least justifies his worker's repose. Edmonds infuses his black with a sense of dignity and equality, an approach perhaps conditioned by his egalitarian politics.

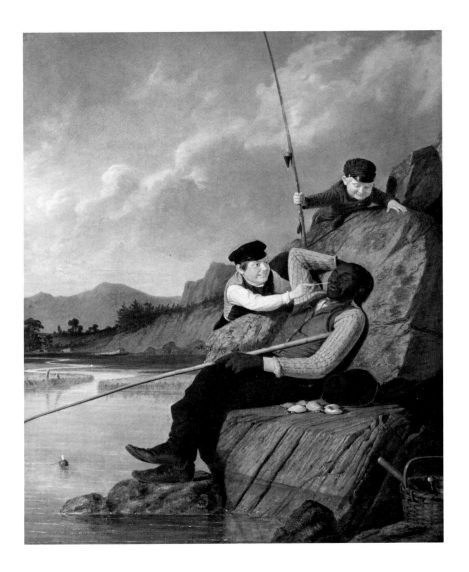

All Talk and No Work assumes further interest because the main characters figure in other compositions by the artist. The black man reappears in a bank-note engraving, *About to Milk the Cow* (fig. 81), in which the straw basket has been replaced by a milk pail and the rhetorical gesture of the right hand has been transformed into a reassuring pat on the cow's flank. Edmonds imbued this little vignette with a sense of mutual trust that reflects positively on the black man's ability and character.

The white man leaning on the pitchfork appears in a small sketch, *Farm Scene with Figures and Animals* (fig. 82). The sketch's composition is otherwise unrelated to that of the finished painting; if *Farm Scene with Figures and Animals* was a preliminary study, the final version has yet to surface. But this little sketch is important for a number

of reasons. It reaffirms Edmonds's concern for recording pastoral life, his ability in portraying animals, and his dedication to racial harmony. The two boys in the wagon, one black and one white, collaborate in urging the oxen on their way. The black youth on the horse is an unusual figure; the fact that he is riding implies skill and responsibility. Edmonds underscored this by depicting him in the act of reading a letter or document. This feature is truly remarkable given the limited access to education blacks had prior to the Civil War.[13] Such progressive subjects raise tantalizing questions about Edmonds's patronage.[14]

As *All Talk and No Work* depicts a moment of idleness, so *The Scythe Grinder* (fig. 83), also painted in 1856, treats industry. It seems possible that the two were intended as a pair, since they share the same dimensions and vertical format.[15] The parallel sense of cooperation between black and white figures and similar compositional concerns reinforce the hypothesis. Edmonds presents an interesting formal variation in *The Scythe Grinder*. The void that punctuates the barn and leads our eye up through an empty landscape to the farmhouse in the first painting is here replaced by the activity of pitching hay into the barn, which effectively closes off the space. This establishes a compelling formal contrast between the two paintings, with leisure set in a more expansive context while labor appears constricted.

Whatever the intended relationship of these two pictures, Edmonds set out to address a different range of issues in *The Scythe Grinder*. In this painting he recognizes how the pace of rural life at

FIGURE 81. After Francis W. Edmonds, *About to Milk the Cow*, late 1850s. Engraving, 1⅝ × 2¼ in. (image). Print Collection, Miriam and Ira D. Wallach Division of Art, Prints and Photographs, The New York Public Library; Astor, Lenox and Tilden Foundations.

FIGURE 82. Francis W. Edmonds, *Farm Scene with Figures and Animals*, c. 1850–60. Oil on canvas, 8 × 12¼ in. Collection of Carolyn Coudert.

FIGURE 83. Francis W. Edmonds, *The Scythe Grinder*, 1856. Oil on canvas, 24⅛ × 20 in. The New-York Historical Society; Gift of Charles E. Dunlap.

certain moments can quicken, as one races against the ever-looming threat of the elements. The viewer is caught up in the flurry of activity that accompanies the harvest and storing of hay, which must be done while the proverbial sun shines. Edmonds, in his literal interpretation, departs from a visual antecedent, Mount's *Who'll Turn the Grindstone?* of 1851 (fig. 84), which took its inspiration from a literary source.[16] The narrative that inspired Mount's picture tells how a young boy was bullied into providing the strenuous labor of turning the wheel, which caused him to miss school.

Edmonds eliminated the overdramatic tension of Mount and concentrated on the everyday quality of the activity. He showed the black boy not only turning the wheel but intently scrutinizing the sharpening technique of his white mentor. Here again, Edmonds demonstrated an unusual sensitivity to the position of the black and

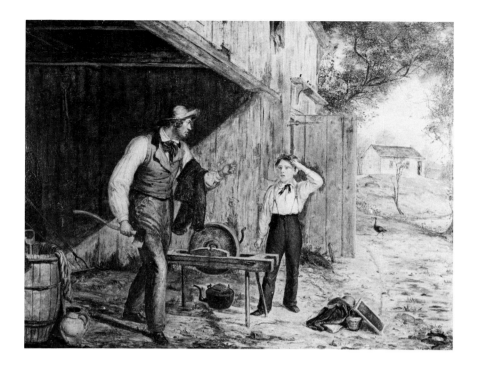

FIGURE 84. William Sidney Mount, *Who'll Turn the Grindstone?*, 1851. Oil on canvas, 28⅞ × 35¾ in. The Museums at Stony Brook, Stony Brook, New York; Museums Purchase, 1950.

through visual means tried to offer some element of hope, seeming to imply that hard work will have its rewards. This optimistic image also found wide circulation in the currency designed by Edmonds's bank-note engraving company (fig. 85). The rest of the composition has been modified, but the artist has remained relatively consistent in his treatment of the central figures. They accord more closely with a preliminary design (unlocated).[17] The precise chronology of these related works is difficult to determine, but the finished oil painting presumably comprised Edmonds's ultimate solution.

By 1856 Edmonds had earned a certain reputation for his abilities in depicting the landscape. Ten years earlier he had been commended for studies that demonstrated "a genuine love for trees and green fields," and in 1851 the *Home Journal* deemed his sketches from nature "exquisite."[18] *Landscape with Hut and Figures* (fig. 86) exemplifies the kind of outdoor picture that garnered this praise and dates from when he was spending a great deal of time on his Bronxville property. The activities of the two figures in the scene—the white youth watering his horse and the black youth sitting and whittling in the smoke-house—reveal little of consequence. One might comment again on Edmonds's racial attitudes, but the scale and relationship of the figures to their surroundings connotes a greater concern for physical than human nature. Apparently working directly from the landscape did not come particularly easily to Edmonds. Edward D. Nelson (1821–

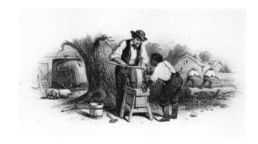

FIGURE 85. After Francis W. Edmonds, *The Scythe Grinder*, late 1850s. Engraving, 1¾ × 3¼ in. (image). Print Collection, Miriam and Ira D. Wallach Division of Art, Prints and Photographs, The New York Public Library; Astor, Lenox and Tilden Foundations.

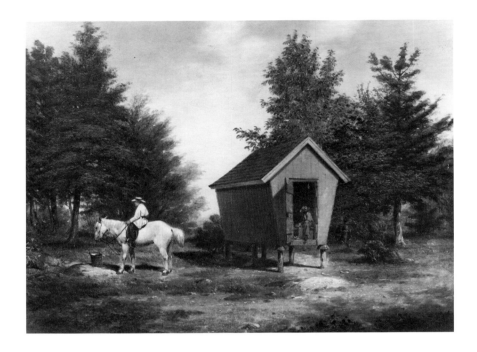

71), a friend and fellow artist, joined him in a roadside study and recounted that "He [Edmonds] winced and fidgeted considerably under the experience, but endured it better than I thought he would."[19] Perhaps Nelson fueled Edmonds's perseverance by marveling at the rich material for study in the vicinity of the estate. The painting conveys the feeling of a personal vignette with the Bronxville property as the focus. The figures and architecture are secondary to the setting, and the handling of the trees—especially those directly behind the smokehouse—reflects a crisp precision reminiscent of Durand. Other passages reveal a looser, more spontaneous technique; possibly some of Edmonds's discomfiture came from trying to strike a balance between these two approaches. He did not eschew his love for detail, embellishing the pylons on which the smokehouse rests with the requisite inverted bowls to prevent four-legged intruders from gaining access to the goods being cured. Edmonds also infused the picture with a vibrant note of color by making the black youth's shirt a striking red, offsetting the canvas's visual serenity. While Edmonds derived great pleasure and even therapy from these pastoral scenes, he never forsook the interior scene that constituted the hallmark of his style.

Although Edmonds did not exhibit any interior scenes in 1856, the March issue of the *Crayon* noted a work in progress: "The parents [*sic*] of a young girl hinting 'notice to quit' to her beau, by raking out the fire, and getting ready to shut up for the night, the clock-

dial indicating the hour of ten—*time to go home.*"[20] And it was under the title *Time to Go* (fig. 87) that Edmonds exhibited this work at the National Academy of Design in 1857.[21]

The subject matter had special significance for the artist, since his oldest daughter, Nora, had just turned twenty, and courting would have been an important part of her life. The picture offers a splendid counterpoint to Edmonds's youthful effort *Sparking* (plate 3), where he might have been casting himself as the suitor rather than the scrutinizer. Just as *Sparking* reflected Abram C. Dayton's attitudes toward flirtatious behavior in his *Knickerbocker Life*, *Time*

FIGURE 87. Francis W. Edmonds, *Time to Go*, 1857. Oil on canvas, 25½ × 30 in. Blount, Inc., Montgomery, Alabama.

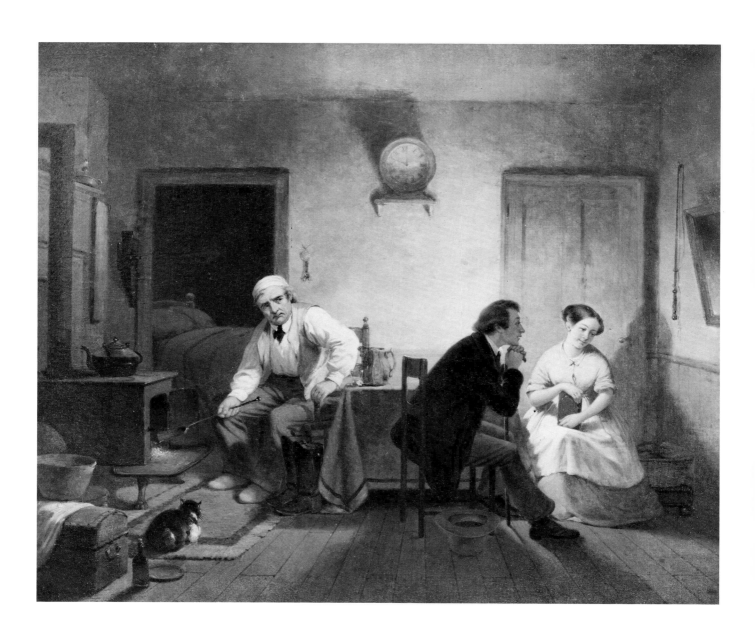

to Go elucidated certain rigid matters of etiquette. Dayton dwelt at length on the ritual of visiting between young members of the opposite sex and emphasized the supremacy of parental rule. In addition to socializing under the vigilant watch of either or both parents, the young understood the inflexible rule that "when the old clock on the stairs struck ten, guest or guests quietly departed, or they would have received a demonstrative hint by the closing of inside shutters and a general preparation to retire."[22]

Edmonds used the device of damping down the fire as the signal for the young man, who remains oblivious, to take his leave. The couple appear to be so absorbed in their romantic revery that they totally insulate themselves from the anticipatory glance of the patriarch and the menacing hour hand of the clock.

While the composition uses the artist's familiar boxlike setting, it is unusual in its almost claustrophobic quality. The picture is devoid of any opening that connects the viewer with the outside; the only passage is to an equally cloistered bedchamber. The parlor is cramped, and one has to appreciate the fervor of the young couple's feelings that enables them to shut out the hovering presence of a chaperone. Edmonds underscored the nature of the constricted space by cluttering it further with carefully rendered still-life elements. They enhance the anecdotal quality and generate visual rhythms, such as the sweeping curve described by the large bowl next to the stove, the young man's hat, and the basket of sewing on the footstool next to the girl. The splayed legs and feet of the wood stove set up an amusing visual discourse with other similar components in the picture. They echo the casual placement of the young visitor's feet and counteract the rigid, almost military demeanor of the old man's boots, which in turn visually connect with the back legs of the young man's chair. Thus, Edmonds has cleverly introduced a formal subplot that reinforces the main anecdote.

The backlighting from an artificial source enriches the sentiment of the narrative; in addition to being consistent with the nocturnal aspect of the story, it provides a literal counterpart to the figurative glow emanating from the amorous couple. On all these points Edmonds received high marks from the reviewer in the *Crayon,* who considered *Time to Go* one of the artist's best works in recent years.[23] While the subject invited possibilities for a far more theatrical reading, Edmonds exercised restraint and let the tenderness and innocence of youthful emotions surface.

Edmonds's other known work created in 1857 was also an interior scene (plate 13), and it too emphasized an endearing sentiment, in this instance the loyalty between faithful retainer and master. So little is known about the painting that its current title, *Devotion,* is

a recent appellation based on the narrative element of the scene, which depicts a black servant carefully proffering a bowl of steaming broth to her aged master. The picture has a strong circumstantial connection with a painting by Edmonds known in the nineteenth century as *Waiting for Supper*.[24] There also survives a preliminary sketch (fig. 88), the latest known example of the artist creating a carefully rendered prototype for a finished painting. In this case, Edmonds anticipated the ultimate version in a one-quarter-scale model, and comparison of the two reveals only slight modifications in the treatment of accessories. The small throw rug is changed from a red and green stripe pattern to bluish gray with a gold braid border; thus it seems a little more refined. The blue and white bowl containing the steaming broth is smaller in the finished painting, and the teacup and saucer on the table by the old gentleman also seem more delicate and refined in the final version. Additions to the picture include the white sack hanging from a nail in the room beyond. This modification further necessitated placing a napkin in the man's left hand to provide visual balance. The candle-sconce hanging above the gentleman's head and the service bell on the tea table enrich the final composition, the bell reflecting Edmonds's awareness of the increasing demands that the infirmities of advanced years can bring.

Devotion, judging from the furniture and clothing, attempts to record an earlier time, which distinguishes it from his other work.

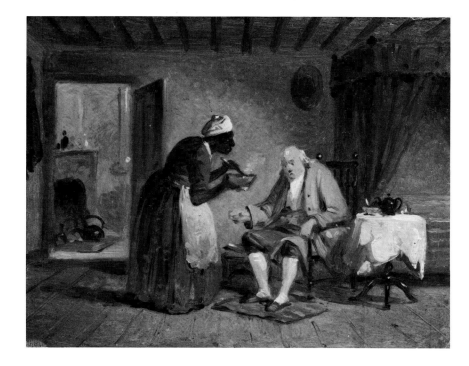

FIGURE 88. Francis W. Edmonds, study for *Devotion*, c. 1857. Oil on board, 4¾ × 6 in. Collection of Mr. and Mrs. E. G. Nicholson.

Even the most old-fashioned had stopped wearing britches by the 1830s, and the painting's furniture, with the exception of the footstool, harkens back to the eighteenth century. The broad-brimmed hat that hangs on the wall is intriguing, since it could be suggestive of the type of headgear worn by Quakers in earlier times. There is a strong element of nostalgia in the work of this stage of his career, perhaps offering escape from the bitter disappointments of his own recent history.

Devotion is an excellent characterization of old age, and Edmonds records with consummate skill the tension that exists between dignity and dependence. The picture stands in telling contrast to *Time to Go*, which heralds the exuberance, infatuation, and optimism of youth. It is no accident that the latter composition is cluttered and complex, literally bursting at the seams, while *Devotion* is spare and refined. It is as though the artist has peeled away all the superficial artifice to focus on the poignant aspects of growing old. This was a theme Edmonds considered earlier in his career, and it is all the more lamentable that *Comforts of Old Age*, painted in 1838, remains lost, since a comparison might offer a telling insight into Edmonds's development. Edmonds, moreover, had broached the possibility of creating a second work on the topic for a friend of his cousin Thomas Worth Olcott. Two other works on this theme (both unlocated) belonged to Abraham M. Cozzens: *Old Man with a Pipe* and *Sunday Evening Lecture*. The second painting was included in the Cozzens sale held in May 1868; and the auctioneer characterized it as "one of Mr. Edmonds' best studies of character. The figure asleep in his chair is one of the best studies of humorous character he made."[25] While the picture contains the ingredient of humor, one can envision it in a tender rather than harsh satirical mode. Less evidence survives regarding *Old Man with a Pipe*, but Edmonds's growing emphasis on this type of subject matter and the concomitant reverence for the elderly correspond with similar Dutch attitudes in the seventeenth century. (One need only recall Rembrandt's portrayals of his mother reading the Bible or more generalized treatments such as *The Benediction* by Nicolaes Maes.)[26] Edmonds celebrated his fiftieth birthday in 1856; constantly plagued by a fragile constitution, he perhaps sensed his own mortality more keenly than others.

The exhibition season of 1858 began in New York with a series of artists' receptions, evening affairs that, according to the *Crayon*, attracted "the elite of the city."[27] Edmonds lent works to two of the three receptions. For the February display he sent a sketch, *First Step in Dancing* (unlocated), which may bear association with a drawing known today as *Stir the Mush Three Times* (fig. 89). He also included a still life that as yet eludes identification. For the last reception of

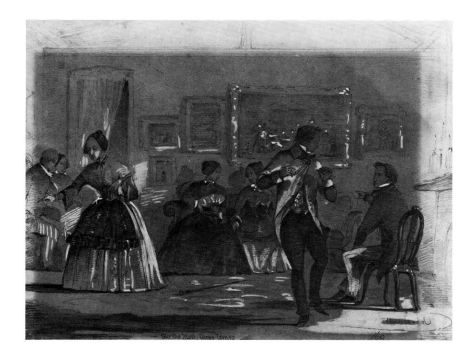

FIGURE 89. Francis W. Edmonds, *Stir the Mush Three Times*, c. 1855–60. Graphite and Chinese white on brown paper, 8 × 10½ in. Private collection.

the year, held in March, Edmonds pursued his ongoing interest in two themes: the elderly and pastoral existence.[28] The picture delineating the second topic remains unknown, but *Reading the Scriptures* (fig. 90) can be identified. This painting bears a strong thematic affinity with the unlocated *Sunday Evening Lecture* from the Cozzens collection, but a disparity in size precludes them from being a pair.[29] The work again reflects the artist's deep and abiding interest in seventeenth-century Dutch painting.

Reading the Scriptures recalls the northern European tradition in its portrayal of a deeply felt piety, and the artist's moving depiction of this woman at her daily devotion may constitute a memorial to his mother.[30] But Edmonds also speaks to the pervasiveness of religion in ante-bellum America and to its greatest manifestation in the printed word. This era witnessed the phenomenal popularity of religious tracts, and, without question, the Bible was *the* best seller. In 1856 the American Tract Society reported that twenty out of twenty-one families owned a Bible.[31] Edmonds's choice of subject matter obviously found an extensive audience, and any personal tribute simply adds to its poignancy.

Visually, the picture had many precedents familiar to Edmonds. The illustration of *Woman Reading*, attributed to Pieter de Hooch, in John Burnet's *Treatise on Painting* (fig. 18), may have provided the earliest source. Gerrit Dou's (1613–75) *Old Couple Reading the Bible* (fig. 91) may have been equally influential; Edmonds could have seen

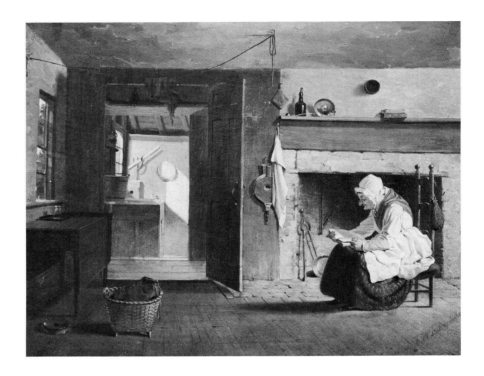

this painting firsthand in the Louvre or been familiar with it through John Gadsby Chapman's copy, which Jonathan Sturges had owned since 1849.[32] Most intriguing, however, is the compositional affinity between *Reading the Scriptures* and de Hooch's *Maternal Duty* (fig. 92), a comparison made all the more remarkable since Edmonds would not have known this specific painting.[33]

Both works depict the figure seated in profile and engaged in everyday activities. A prolific interplay of horizontals and verticals rigidly articulates each setting. To relieve this severe rectilinearity, there are occasional diagonal elements, such as open doors or raking shafts of light. Both artists took great pains in arranging their compositions, which place the main figures to one side. Their location is balanced by the careful positioning of objects on the opposite side— the cat in the de Hooch and the basket in the Edmonds. This balance is enriched by the spatial recession into the room beyond. Moreover, each interior is immaculate, and one easily senses pride in keeping an orderly household. Finally, a sense of duty permeates both scenes, although different objects of devotion are considered. Thus, *Reading the Scriptures* serves as an eloquent reminder of how thoroughly Edmonds assimilated Dutch principles of composition and how completely he captured the feeling of domestic harmony in his own work, a concern that becomes especially resonant in his later efforts.

In fulfilling his obligations to the National Academy, Edmonds sent three works to the spring exhibition of 1858: *The Pan of Milk*

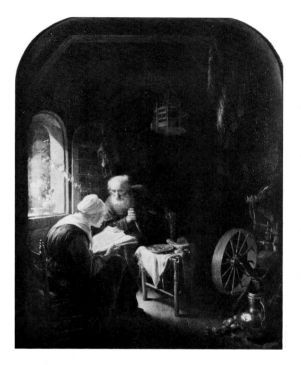

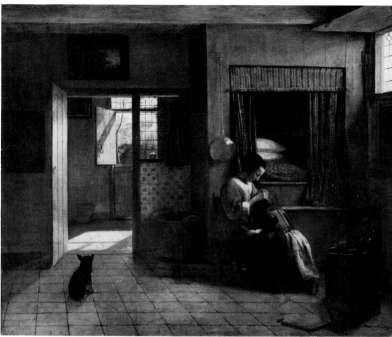

(fig. 93), *The Wind Mill* (fig. 94), and *Bargaining (The Christmas Turkey)* (plate 14).[34] While there was no decline in his output, the quality of these paintings varies substantially.

The weakest of the three is *The Pan of Milk*. The subject is a challenging facet of a young girl's education, the precarious task of carrying the pan of milk. But the various still-life elements seem out of scale in relation to the girl, and they and the girl are also disproportionate to the room. The individual objects are well painted, but they do not form a cohesive whole. The picture also suffers from a sense of oversentimentalization. Even the fact that the little girl fails to deliver the bowl of milk intact does not mitigate the mawkishness of the narrative.

The Pan of Milk offers an interesting social comparison with *The Wind Mill*, in which the father demonstrates the little wooden windmill he has just whittled for his son. The father appears almost emotionless as he blows on the blades of the toy; his exhalations could hardly generate the degree of propulsion that Edmonds depicts. Nevertheless, both the boy and dog are riveted by the adult's handiwork. The functionless wizardry of the windmill speaks eloquently of a different part of the child-rearing process. Responsibilities will come later; for the moment father and son (unlike the little girl in *The Pan of Milk*) can share in the happy distractions of leisure activities.

Ironically, this episode of male camaraderie is set in the kitchen,

FIGURE 91. Gerrit Dou, *Old Couple Reading the Bible*, c. 1645. Oil on panel, 23⅞ × 18⅛ in. Musée du Louvre, Paris.

FIGURE 92. Pieter de Hooch, *Maternal Duty*, 1658–60. Oil on canvas, 20⅝ × 24 in. Rijksmuseum, Amsterdam; On loan from the City of Amsterdam since 1855.

where the shavings sully an otherwise pristine floor. The room itself heralds technological progress as a coal- or woodburning stove has been set into the old fireplace, and the tin match container rests on the mantle. The kitchen retains its position of central importance to the household, and a sense of order is paramount, to which the gleaming copper utensils testify. This painting succeeds where *The Pan of Milk* doesn't. There is a unity and proper scale to the composition, and Edmonds engages the viewer by the disarming expressions of child and dog, which he does not permit to become saccharine.

The third painting on view at the National Academy, *Bargaining (The Christmas Turkey)* is perhaps the most successful. The picture centers on the negotiation between the elderly mistress of the house and the itinerant purveyor of poultry. In other subjects dealing with the theme of bargaining, Edmonds often builds on the contrast of dupe and huckster, as in *The Speculator*. This is not the case in *Bargaining*. Edmonds portrays the participants as equals, and the salesman realizes he won't be able to hoodwink this customer. She inspects the dead fowl with a knowing eye and clutches her purse in a way that indicates she won't pay a penny too much. The intensity of this negotiation is offset nicely by the sleeping cat, the curve of whose tail establishes a visual counterpoint to the salesman's whip that lies

on the ground beside him. Cat and whip underscore the contrast between the domestic nature of the woman's work and the man's livelihood that takes him farther afield. The handling of the other still-life objects is typical of Edmonds's high standards, and he returns to a more theatrical mode of illumination that focuses the light on the central characters.

What sets this painting apart from the other two offerings to the National Academy is the gripping visual intensity that he infuses into the scene. The concentration of the figures on their given tasks—the woman to assess the bird and the salesman to assess the woman's reaction—generates dramatic tension and signifies the expertise that each brings to their assignments. One generation is played off against the other, and while neither seems to have the advantage, Edmonds eloquently states his sympathetic reading of the elderly.

The three paintings exhibited at the National Academy were bought as a group by Robert L. Stuart. Edmonds, sensitive to the disposition of his work, was not accustomed to selling *en bloc*. In a letter to John Durand, who mediated the sale, he initially balked at the prospect of offering a discount:

> I do not like to lessen the value of my pictures by selling them below my usual price, but as Mr. Stuart purchased the other two I would be willing to let him have the one you refer to [*The Pan of Milk*] for $150. It is true that the picture is painted on a smaller canvas than the "Windmill" but it cost me quite as much time and labor.[35]

Edmonds was keenly aware of price as a barometer of a painter's success, but also of the prestige that accrued from inclusion in the Stuart collection.[36]

Toward the end of 1858, Edmonds donated a picture to the Ranney Fund auction (held to benefit the widow and children of fellow-painter William Ranney; the forerunner of the Artists' Fund Society).[37] From its title, *The Poor Neighbor* seems to have been an essay on poverty, contrasting starkly with the final canvas Edmonds is known to have completed in 1858, which addressed the issue of the morality of materialism. This work, *The New Bonnet* (plate 15), is one of Edmonds's finest. The painting attracted curiously little attention at the National Academy exhibition, though the notice it received was positive. The reviewer for the *Crayon* grouped it among the important figure subjects; in a subsequent article he singled out the "well-drawn humorous head of an old man."[38] Another publication, the *Home Journal*, provided the most extensive critique: " 'The New Bonnet' is one of Edmonds' happiest of efforts. The story is well told, the characters sharply defined, with a great deal of good

detail painting. As a theme of humor and universal sympathy, it arrests attention and provokes mirthful comment."[39]

In its depiction of the parents' horrified reaction to extravagance, the painting provides a vehicle for humor, but Edmonds seems to skirt this avenue. The artist underscores his ambivalence by the pathetic little delivery girl's enigmatic reaction to the proceedings. Had Edmonds intended to make his audience laugh, he would have used her to this end. Instead, her wistful nature establishes a decidedly different mood, and this elegiac quality is reinforced by the understated reaction of the elderly couple. Only the mother reveals any overt emotion, as she recoils involuntarily at the sum she sees on the bill. The father is a marvelous study in controlled outrage, while the daughter is oblivious to all and has eyes only for her new possession.

The bonnet's commentary on the morality of luxury finds an interesting parallel in a roughly contemporary English painting by James Collinson (1825–81),[40] also titled *The New Bonnet* (fig. 95; destroyed). Collinson's young lady is in the final stages of primping before going off to the races with her beau, who holds the day's program in his right hand. This kind of outing placed as much emphasis on seeing and being seen as it did on following the races themselves. Such aspirations to haute couture accompany the quest for a new social status; in Edmonds's case, the painting articulates a gap between the values of the older and younger generations.

Edmonds demonstrates his usual painstaking care in arranging the composition, visible in his placement of the bonnet. The girl holds the hat almost reverentially, placing it on an imaginary pedestal. It is the focal point of the composition, and the use of complementary colors—yellow and violet—reinforces this visual dominance. By elevating the bonnet, Edmonds juxtaposes it against another of his favorite devices, the wall map, and provides his picture with a symbolic focus. Maps and globes were often found in seventeenth-century Dutch paintings; in addition to their geographical interest they could take at least two figurative meanings, both of which were echoed by later American painters. Washington Allston (1779–1843) in *The Poor Author and Rich Bookseller* of c. 1808–11 included a map and a globe, in this case an allusion to worldly knowledge (a recognized domain of the bookseller). But the use of cartographic devices could also signify another form of worldliness in *Vrouw Wereld*, or the worldly woman, which held less pure associations.[41] Following the Dutch, William Hogarth used the symbol of *Vrouw Wereld* in his *Rake's Progress* (fig. 96). Edmonds's placement of the bonnet against the map recalls Hogarth's format, though Edmonds complicates the issue by also placing the man's bottle of port or sherry in front of the map. Even though the diminutive glass signals moderation, the implication

FIGURE 95. James Collinson, *The New Bonnet*, no date. Oil on canvas, destroyed. Reproduced from Graham Reynolds, *Painters of the Victorian Scene* (London: B. T. Batsford, 1953), plate 41.

FIGURE 96. William Hogarth, *A Rake's Progress*, plate 3, 1735. Engraving, 13¹⁵⁄₁₆ × 16¹⁄₁₆ in. Yale Center for British Art, New Haven, Connecticut; Paul Mellon Collection.

emerges that the older gentleman is not entirely faultless.

Through the open door behind the delivery girl is a crescentlike urban architectural configuration; the window behind the older couple reveals an openness that relates to a more rural and, by extension, halcyon setting. The only concession to progress is the gleaming stove set into the fireplace. The simple dress of the elderly couple signals a less pretentious existence that stands in marked contrast to the stylish appearance of their daughter. Edmonds drives the point home by establishing a strong diagonal counterpoint between the array of vegetables in the right foreground and the hat box held by the delivery girl at the left of the composition. The fecundity of the harvest contrasts the shallowness of material acquisitions. Thus Edmonds alluded to a passing age. The preeminence of the matriarch, with her paring knife at the ready, representing the paragon of domestic virtue, is being challenged by more artificial criteria.

The Flute (plate 16), first shown at an artists' reception at Dodsworth's Hall on 6 March 1859, is especially resonant with the artist's growing philosophical concerns of his later years.[42] Formally, the work reveals Edmonds's consummate assimilation of Dutch spatial organization and backlighting and his ability to render still-life elements with utmost conviction. But the subject matter dominates, particularly since Edmonds painted this picture on the eve of the Civil War.

Two black children stand transfixed by a spellbinding musical performance by the somewhat older white boy. There is no hint of caricature; both black boys are imbued with a quiet dignity. Though their clothes have patches, they are not shabby, and this treatment signifies an attempt to maintain respectable appearances. In this sympathetic record, Edmonds visually underscores the desire for dignity, which, at this juncture of his life, was at a premium.

Certain elements of the scene are intriguing. The musician is not in a formal performance position and seems to be playing from memory. His costume, especially the pants, hints at some form of uniform, and it is instructive to remember that the upsurge in popularity of military bands was the single most important factor in the flowering of the music trade.[43] The hand position and embouchure are extremely accurate in their rendering. Especially interesting is the flute itself. Once again, Edmonds is faultless in his quest for authenticity. He has depicted a one-keyed instrument in four sections fashionable in the late eighteenth century: a type of flute that by this time was passé. Although one-key flutes survived well into the nineteenth century, they increasingly became folk instruments. Since Edmonds did not stray very far from New York City, one of the important music capitals, this choice was not the result of cultural ignorance.

Edmonds depicted an old-fashioned folkloric flute and intimated that the young musician plays from memory. Does he, in fact, intend to transmit a sense of nostalgia? In a way, through the somber, almost spiritual mood of this picture, Edmonds anticipated the profundity of post–Civil War painting; yet, in the work's implicit sense of harmony, he simultaneously seemed to deflect the unfolding realities of the time.

In choosing to depict a flute performance, Edmonds selected an instrument that had a rich history in American music. In its early days it was primarily associated with gentleman amateurs for use in parlor music; the indefatigable Dr. Hamilton, in his *Itinerarium* of 1744, recounted visiting a minister in Marblehead, Massachusetts, who entertained him with some tunes on the flute.[44] Many painters used the flute to establish the image of a gentleman in portraiture, exemplified in the likeness of *Dr. Abraham Beekman* painted by Lawrence Kilburn (1720–75) around 1761 (fig. 97).[45] In the nineteenth century the flute gained vogue as an instrument for performance in churches, dance halls, and military bands. Its appeal for a more broadly based audience tended to identify the flute with democratic principles. This is the context of Edmonds's painting, which in this capacity offers an interesting comparison with a work of 1847 by William

FIGURE 97. Lawrence Kilburn, *Dr. Abraham Beekman*, c. 1761. Oil on canvas, 47 × 38½ in. The New-York Historical Society.

FIGURE 98. William Sidney Mount, *The Novice*, 1847. Oil on canvas, 30 × 25 in. The Museums at Stony Brook, Stony Brook, New York; Museums Purchase, 1963.

Sidney Mount titled *The Novice* (fig. 98). Mount came from a musical family and is known for his interest in the violin.[46] He depicted himself holding a flute in an early *Self-Portrait*, but that instrument did not figure in many of his musical subjects. *The Novice* was an exception, although Mount depicted a fife rather than a flute. The young boy fingering it is as unsure of what he is doing as the youth in the Edmonds work is confident. The fife, of course, had military associations, and this would be an obvious interest of three young boys, especially as reports of the Mexican War filtered down to them. Mount infused his subject with a youthful zest and innocence that ignored the specter of mortality in the military life. Edmonds, by contrast, created a more somber mood despite the absence of an overt allusion to war.

Edmonds painted another work suggestive of the Civil War around this time, one that defies identification with any of the pictures he exhibited. Known today as *Waiting* (fig. 99), the painting is unusual in Edmonds's oeuvre for its execution on panel. The paint is thin and its application is somewhat loose, which is consistent with Edmonds's later approach. The subject matter has a penetrating poignancy reminiscent of *The Flute*. One can only sympathize with the young woman who waits patiently for her spouse, either the ill-tempered drover who concentrates with a ferocious intensity on his gambling or the young soldier who assumes the role of avid spectator. Her situation is all the more pitiable since she seems to be pregnant, judging from the way her skirt hangs away from her legs. (The way she holds the items in her cape also anticipates her future burden.) Edmonds further reinforced the moral dichotomy of the two zones of the painting by including visual references to military figures in each. In the front room he depicted a small oval portrait of an officer, distinguishable by the epaulets that imply his honorable station. In the back room, where the physical and moral disarray is symbolized by the broken tumbler on the floor, Edmonds depicted the soldier (and possible husband), who, though not a participant, watches the gambling with an intensity equal to the player's. That this soldier is not directly involved in the gambling is beside the point; Edmonds specifically chose to depict him without the veneration that was accorded most military figures. The Civil War profoundly affected the glamour of military life; consequently, artists began to address its tedium, such as the interminable waiting recorded in Winslow Homer's (1836–1910) *Home Sweet Home* of about 1863, or the mundane but ubiquitous activity of drinking coffee chronicled in Edwin Forbes's (1839–95) *Drummer Boy Cooling His Coffee*, painted between 1860 and 1864.[47] Edmonds depicts the temptation confronting the young soldier in a gambling den.

FIGURE 99. Francis W. Edmonds, *Waiting*, c. 1855–60. Oil on panel, 14¾ × 11½ in. Courtesy of Kennedy Galleries, New York.

The depiction of home life also continued to interest Edmonds in his late years, and he usually centered these paintings around the kitchen. *Dame in the Kitchen* (fig. 100) does not appear in any exhibition records, but its looser handling, especially the mottled quality of the wall, and the fact that it is painted on panel, place it toward the end of his career and link it with *Waiting*. He considered it a finished work, since he put his initials on the sack that sits on the cupboard in the left background. A preliminary oil sketch (fig. 101) concentrates on the pose of the woman working in the kitchen; her attitude is almost identical with that of the finished version. The rest of the composition changes quite markedly: the vertical orientation of the sketch shifts to a horizontal format, and the activity no longer

FIGURE 100. Francis W. Edmonds, *Dame in the Kitchen*, c. 1859. Oil on panel, 10¾ × 13¾ in. Private collection.

takes place by a window but moves to the other side of the fireplace. Edmonds chose to keep the large iron kettle resting on the hearth in the composition, but in expanding the view of the room he permitted himself greater freedom in the inclusion of accessories. The painting continues to reflect Edmonds's love of still-life elements, but these seem inordinately large in relation to the furniture in the room.

Although it is difficult to assign a specific source to this kitchen scene, Edmonds clearly derived his inspiration from Dutch prototypes. A comparison of *Dame in the Kitchen* with *Kitchen Maid* (fig. 102), attributed to Quiringh van Brekelenkam (c. 1620–88), reveals the general basis for Edmonds's conception. His shallow, single-corner interior is not as complex or profusely decorated as the Dutch painter's, but the purpose is the same: to extol the virtues of efficient household management.

Dame in the Kitchen reflects an understated sensitivity to the labors of women; in its quiet admiration it varies the treatment of the theme by other painters of the time. Lilly Martin Spencer's (1822–1902) *Shake Hands?* of 1854 (fig. 103) depicts a good-natured attitude toward the lot of women. The artist delights in contrasting the power of the female in her domain with the discomfort of the male when he strays into it (a predicament that is also the basis of her *The Young Husband: First Marketing*, also of 1854, where the groceries strewn on the sidewalk vividly demonstrate the male's ineptitude). Other artists shared Edmonds's disposition to portray the more reflective moments of kitchen life; Thomas Hicks's (1823–90) *Kitchen Interior* of 1865 (fig. 104) focuses on a woman peeling apples. Once again, this charming and intimate type of scene has many precedents in the seventeenth century; one need only recall Nicolaes Maes's *The Apple Peeler* (fig. 19). The common thread among the paintings by Edmonds, Hicks, and Maes is the introspective tendency (or is it tedium?) brought on by such activity. Nevertheless, Edmonds imbued the figure in *Dame in the Kitchen* with a dignity and sense of purpose that reflected his understanding and appreciation.[48]

Exhibition records for the final three years of Edmonds's career reveal a very small output—four paintings—of which only one is known today. He stopped exhibiting at the National Academy of

FIGURE 101. Francis W. Edmonds, study for *Dame in the Kitchen*, c. 1859. Oil on board, 5⅞ × 3⅝ in. Collection of Jo Coudert.

FIGURE 102. Attributed to Quiringh van Brekelenkam, *Kitchen Maid*, 1650. Oil on panel, 28 × 33 in. Present location unknown; photograph courtesy of National Gallery of Art Photographic Archives, Washington, D.C.

FIGURE 103. Lilly Martin Spencer, *Shake Hands?*, 1854. Oil on canvas, 30⅛ × 25⅛ in. Ohio Historical Center, Columbus, Ohio.

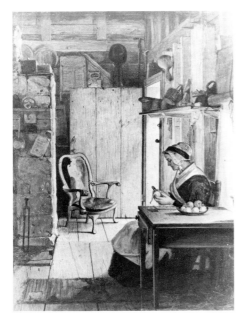

FIGURE 104. Thomas Hicks, *Kitchen Interior*, 1865. Oil on canvas, 18 × 12 in. IBM Corporation, New York.

Design, presumably because of his falling out with Thomas Cummings, and channeled his energies into the new Artists' Fund Society. Three of the four paintings recorded in these years were exhibited and sold through the auspices of this benevolent society; only a *Vignette of Rural Life* (unlocated) was shown at an artists' reception. The other two works that prove elusive are *The Morning Lesson*, which brought $115 at the first annual Artists' Fund Society sale held in December 1860, and *Barking up the Wrong Tree*, the last documented work by Edmonds to come before the public, which was auctioned at the Artists' Fund sale in 1862. The humor suggested by that title would serve as a welcome antidote to the rather somber message of his last located canvas, *Hard Times*, or as it was titled at the Artists' Fund Society in 1861, *Out of Work and Nothing to Do* (fig. 105).[49]

This work depicts an interior sparsely furnished with farm and cooking implements. The farmer, possibly victimized by the Panic of 1857, dozes, having found little solace in the newspaper that lies at his feet. His tools, a shovel and a hoe leaning against the wall, stand in telling contrast to the advertisement for the labor-saving but financially inaccessible plow. The turnips and cabbage, direct results of the farmer's efforts, are painted with meticulous care—as are all the other still-life elements. Curiously, they, as well as the man, appear disproportionately large for the scale of the room. Perhaps the low ceiling and ribbonlike quality of the stairs were intentional, as Edmonds more emphatically highlights the human element. In any event, the artist adhered to a predictable architectural framework for his composition. The interplay of horizontal and vertical supplies a stability that is given dynamic tension by the occasional diagonals, such as the door and the staircase. Through the open door one sees a woman absorbed in her own tasks; Edmonds poignantly calls attention to an irony in the division of labor: a woman's duties do not alter regardless of the economic situation. This point was not lost on the critic for the *Home Journal*, who observed:

> "Out of Work and Nothing to Do" is a characteristic picture . . . representing an old man waiting for something to "turn up"—his attitude gives one so strong an impression of natural laziness of disposition, that we are led to surmise that he would rather have dinner "turn up" than any task work.[50]

In *Out of Work and Nothing to Do* there is an introspective quality that lends an aura of profundity to the overall scene.

In its treatment of the contemplative world of the male, Edmonds's work was unusual but not unique. Thomas Hicks's *Calculating* of 1844 (fig. 106) offers an interesting antecedent, one whose structure clearly parallels Edmonds's own compositional objectives.

FIGURE 105. Francis W. Edmonds, *Hard Times (Out of Work and Nothing to Do)*, 1861. Oil on canvas, 16 × 21 in. Albrecht Art Museum, Saint Joseph, Missouri; The Enid and Crosby Kemper Foundation Collection.

Hicks's image, however, conveys a sense of positive activity; the man deep in his figures projects a concern and presumably an optimism for what lies ahead. This implied energy contrasts sharply with the sense of resignation that emanates from Edmonds's scene. The latter's passive attitude accords more closely with the nostalgic reminiscence of such later works as *Patience* of 1884 by Platt Powell Ryder (1821–96) or *Embers* of about 1880 by Eastman Johnson.[51]

Out of Work and Nothing to Do, with its poignancy and heartfelt concern for the human condition, is emblematic of Edmonds's late career. Yet he never lost sight of the importance of humor, and, to recall Charles Lanman, his pictures "are generally intended to make you laugh, but often they possess an undercurrent of philosophy which makes them voiceless preachers to the thoughtful man."[52] This delicate balance is all the more remarkable given the deep personal

tragedy and bitter professional disappointments he had suffered at the pinnacle of his business career. Consequently, Edmonds sought and found primary refuge in his art. His heightened sensitivity bespeaks a compassion all the more compelling since he avoids any overbearing sentimentality. His art generated enormous appeal because he touched on issues that were immediately graspable. His straightforward approach, tempered with the crucial ingredient of mirth, went to the marrow of American existence while touching its funny bone. And while this chemistry was not unusual within the scheme of genre painting at mid-century, Edmonds brought to it a resonance that gives his work a distinctive appeal even today.

Notes

CHAPTER I

The Milieu: Edmonds as a Public Man

1. John F. Kensett to John R. Kensett, 27 February 1841 (Edwin D. Morgan Papers, New York State Library at Albany [hereafter cited as Morgan Papers, NYSLA]).

2. Francis W. Edmonds, "Autobiography III," May 1844, p. 6, manuscript in the possession of Mrs. Francis Edmonds Tyng, Clifton, New Jersey (microfilm, Archives of American Art, Washington, D.C. [hereafter cited as AAA]). This manuscript and two other drafts were in the form of letters written to Asher B. Durand apparently in response to his request for biographical information for the preparation of a book on American artists. Such a volume never appeared. These documents will hereafter be cited as "Autobiography I, II, or III"; the last and most extensive was published as "The Leading Incidents and Dates of My Life: An Autobiographical Essay by Francis W. Edmonds," in *American Art Journal* 12 (Autumn 1981): 4–10.

3. Maybelle Mann, *Francis W. Edmonds: Mammon and Art* (New York: Garland Publishing, 1977), has been the cornerstone for my research and provides a thorough introduction to the life and career of Edmonds.

4. Lucien Brock, *The Bench and Bar of New York*, 2 vols. (New York: no publisher, 1870), 1: 317. For information on Olcott, see *The National Cyclopaedia of American Biography*, 76 vols. (New York: James T. White and Co., 1891–1984), 18: 204. On Worth's and Olcott's connections to Van Buren, see Donald B. Cole, *Martin Van Buren and the American Political System* (Princeton, N.J.: Princeton University Press, 1984), p. 28.

5. This issue will be addressed in Elizabeth Johns's forthcoming study of American genre painting, 1830–60. I am indebted to Professor Johns for discussing her ideas with me and offering many helpful suggestions.

6. On Jackson's financial policies, see Bray Hammond, *Banks and Politics in America from the Revolution to the Civil War* (Princeton, N.J.: Princeton University Press, 1957), pp. 405–99.

7. *The Diary of George Templeton Strong*, ed. Allan Nevins and Milton Halsey Thomas, 4 vols. (New York: Macmillan Co., 1952), 1: 62–63, 4 May 1837.

8. "Francis William Edmonds," *National Cyclopaedia*, 11: 298.

9. Edmonds to William Cullen Bryant, 27 January 1843 (Bryant-Godwin Collection, New York Public Library [hereafter cited as NYPL]). On the politics of the Mechanics' Bank, see Hammond, *Banks and Politics*, p. 415.

10. Edmonds to William Cullen Bryant, 27 January 1843 (Bryant-Godwin Collection, NYPL).

11. George Bancroft, *A History of the United States, from the Discovery of the American Continent to the Declaration of Independence*, 10 vols. (Boston: Little, Brown and Co., 1834–74), 1: 1ff.

12. Frances Trollope, *Domestic Manners of the Americans*, ed. Donald Smalley (New York: Alfred A. Knopf, 1949), p. 242.

13. Sketch Club Minutes, 26 March 1852 (Archives of the Century Association, New York).

14. *The Works of Ralph Waldo Emerson*, ed. J. E. Cabot, 12 vols. (Boston and New York: Houghton Mifflin and Co., 1883–93), 1: 110–11.

15. Oliver Wendell Holmes, *Ralph Waldo Emerson* (Boston: Houghton Mifflin and Co., 1885), p. 115.

16. Nathaniel Hawthorne to Horatio Bridge, 3 May 1846; cited in *Nathaniel Hawthorne: The American Notebooks*, ed. Randall Stewart (New Haven, Conn.: Yale University Press, 1932), p. xxii. Interestingly, both Hawthorne and Edmonds chose, independently, to treat one "little particular," a man with a barrel organ and monkey; see the discussion of *The Organ Grinder* (plate 8) in chap. 3 herein.

17. James T. Callow, *Kindred Spirits: Knickerbocker Writers and American Artists, 1807–1855* (Chapel Hill: University of North Carolina Press, 1967), pp. 12ff.

18. Edmonds, "Autobiography III," p. 17. Edmonds to Asher B. Durand, 17 January 1839 (Asher B. Durand Correspondence, NYPL). Sketch Club Minutes, 12 January 1844 and passim (Archives of the Century Association).

19. Edmonds, "Autobiography III," p. 17. For the sketches of "The Trying Hour," see *M. & M. Karolik Collection of American Watercolors and Drawings, 1800–1875*, 2 vols. (Boston: Museum of Fine Arts, 1962), 1: 272–74.

20. Sketch Club Minutes, 12 January 1844 (Archives of the Century Association). On the founding of the Artists' Sketch Club, see Callow, *Kindred Spirits*, p. 19.

21. Allan Nevins, "The Century, 1847–1866," in Allan Nevins et al., *The Century, 1847–1946* (New York: Century Association, 1947), pp. 5, 6. For a list of founders who were members of the Sketch Club, see ibid., p. 299; there is an apparent discrepancy since in the text (pp. 5, 6) Nevins cites twenty-five individuals as founders and Sketch Club members, but he lists only twenty-three names in his appendix (p. 299).

22. Sketch Club Minutes, 10 December 1858 (Archives of the Century Association).

23. On Halleck, see Nevins, *The Century*, p. 11. On the dinner, see "Dinner to Fitz-Greene Halleck," *Home Journal*, 28 January 1854, p. 2; and Francis W. Edmonds, "Diary 1854," 18 January 1854 (AAA). Among the people Edmonds listed as being in attendance were William Cullen Bryant, Halleck, Gulian Verplanck, William Kemble, Abraham M. Cozzens, Charles M. Leupp, Dudley Field, and Henry Kirke Brown. For Edmonds's illustration, see *The Poetical Works of Fitz-Greene Halleck* (New York: D. Appleton and Co., 1847), opp. p. 202.

24. Samuel Osgood, "Art in Relation to American Life," *Crayon* 2 (July 1855): 54. Although Osgood's comments about American reluctance to respond to certain types of foreign art were valid, he was too severe in belittling the degree of general enthusiasm for the arts, as testified by the success of a number of institutions in the mid-nineteenth century, most notably the American Art-Union.

25. John F. Kensett to John R. Kensett, 22 April 1843; John F. Kensett to Thomas P. Rossiter, 11 February 1844 (Morgan Papers, NYSLA).

26. On the Apollo Association, see Lillian B. Miller, *Patrons and Patriotism: The Encouragement of the Fine Arts in the United States, 1790–1860* (Chicago: University of Chicago Press, 1966), pp. 160ff.

27. Edmonds to Thomas Cole, 28 October 1842 (Thomas Cole Papers, AAA).

28. Edmonds to Thomas Cole, 17 December 1842 (Cole Papers, AAA); and see Charles E. Baker, "The American Art-Union," in Mary Bartlett Cowdrey,

American Academy of Fine Arts and American Art-Union, 2 vols. (New York: New-York Historical Society, 1953), 1: 102ff.

29. Baker, "American Art-Union," pp. 165ff.

30. Cowdrey, *American Academy*, 2: 127. Maybelle Mann, *The American Art-Union* (Otisville, N.Y.: A.L.M. Associates, 1977), pp. 43, 69. *Bulletin of the American Art-Union*, December 1851, p. 141.

31. "The Fine Arts," *Literary World*, 25 December 1852, p. 406. On the downfall of the Art-Union, see Mann, *American Art-Union*, pp. 28ff.

32. Wayne Craven, "Luman Reed, Patron: His Collection and Gallery," *American Art Journal* 12 (Spring 1980): 40–59, offers the most recent and thorough assessment of Reed's collecting activities. Craven discusses the evolution of the New-York Gallery of the Fine Arts and the eventual donation of the collection to the New-York Historical Society. See also Maybelle Mann, "The New-York Gallery of Fine Arts: 'A Source of Refinement,'" *American Art Journal* 11 (January 1979): 76–86.

33. For a full listing of officers and trustees, see the *Catalogue of the Exhibition of the New-York Gallery of the Fine Arts* (New York: James van Norden and Co., 1844), p. 2 [hereafter cited as *New-York Gallery of the Fine Arts*, 1844 exh. cat.]. See also Baker, "American Art-Union," p. 106.

34. Edmonds to Asher B. Durand, 16 September 1844 (Durand Correspondence, NYPL).

35. "The New-York Gallery of the Fine Arts," *Broadway Journal*, 1 March 1845, pp. 134–35. Sturges's reply, signed with the initials S. J., was "The New-York Gallery of the Fine Arts," *Broadway Journal*, 22 March 1845, p. 187.

36. *Catalogue of the Exhibition of the New-York Gallery of the Fine Arts* (New York: E. B. Clayton, 1846), p. 6. For the loans, see *New-York Gallery of the Fine Arts*, 1844 exh. cat., p. 16; and *The Washington Exhibition in Aid of the New-York Gallery of the Fine Arts* (New York: John F. Trow, 1853), p. 6.

37. "Domestic Art Gossip," *Crayon* 4 (December 1857): 377. For Edmonds's attempt to secure the Morse painting, see "Domestic Art Gossip," *Crayon* 4 (September 1857): 287. The *Crayon* noted the episode, taking its facts almost verbatim from correspondence between Edmonds and Asher B. Durand; for the letter, see Edmonds to Asher B. Durand, 15 August 1857 (Charles Henry Hart Autograph Collection, AAA).

38. Edmonds to Asher B. Durand, 10 September 1849 (Durand Correspondence, NYPL).

39. Mary Bartlett Cowdrey, *National Academy of Design Exhibition Record, 1826–1860*, 2 vols. (New York: New-York Historical Society, 1943), 1: 143–44 [hereafter cited as *National Academy Exhibition Record*].

40. "Proposed Exhibition of the Works of Cole," *Evening Post*, 19 February 1848, p. 2.

41. Mann, *Edmonds: Mammon and Art*, pp. 155–56. See also Edmonds to Asher B. Durand, 20 August 1861, and Thomas S. Cummings to Asher B. Durand, no date [1861] (Durand Correspondence, NYPL); and Lois Fink, "American Renaissance: 1870–1917," in Lois Fink et al., *Academy: The Academic Tradition in American Art*, exh. cat. (Washington, D.C.: Smithsonian Institution Press for National Collection of Fine Arts, 1975), p. 50.

42. Thomas S. Cummings, *Historic Annals of the National Academy of Design, New-York Drawing Association, Etc., with Occasional Dotings by the Way-Side from 1825 to the Present Time* (Philadelphia: George W. Childs, 1865), pp. 265–66. See also Neil Harris, *The Artist in American Society: The Formative Years, 1790–1860* (New York: George Braziller, 1966), p. 271.

43. Edmonds to John F. Kensett, 10 December 1860 (Morgan Papers, NYSLA).

44. Francis W. Edmonds, "Plan to Make Changes and Settle Business Daily among the New York City Banks," no date (Archives of the New York Clearing House, New York). For the background, see Fritz Redlich, *History of American Business Leaders: A Series of Studies*, 2 vols. (Ann Arbor, Mich.: no publisher, 1940), 2: 48ff.; and Mann, *Edmonds: Mammon and Art*, pp. 119ff.

45. "Minutes: Bank Officers and Clearing House Association, Vol. I: 1853–1865," 23 August 1853 (Archives of the New York Clearing House) [hereafter cited as Clearing House Minutes].

46. Moses King, ed., *The Clearing House of New York City* (New York: no publisher, 1898), p. 3.

47. Clearing House Minutes, vol. 1, 6 August 1855 (Archives of the New York Clearing House).

48. Strong, *Diary*, 2: 229–30, 31 July and 2 August 1855.

49. See Redlich, *American Business Leaders*, 2: 49–50, for a thorough treatment.

50. Edmonds, "Diary 1854," 13 December 1854 (AAA). Mann (*Edmonds: Mammon and Art*) offers an excellent sampling of this document that reveals the wide range of Edmonds's interests.

51. Mann, *Edmonds: Mammon and Art*, pp. 126–27.

52. Edmonds's defense was published as *Defence of Francis W. Edmonds, Late Cashier of the Mechanics' Bank, against the Charges Preferred against Him by Its President and Cashier* (New York: no publisher, 1855). See Mann, *Edmonds: Mammon and Art*, pp. 129ff., for the reactions of some of his friends.

53. "Making Money: The American Banknote Company," *Harper's New Monthly Magazine* 24 (February 1862): 308. For the firm's subsequent history, see William Griffiths, *The Story of the American Bank Note Company* (New York: no publisher, 1959).

54. Edmonds, *Defence*, p. 54.

55. Cummings, *Historic Annals*, pp. 317–20. See also "Deaths," *New York Times*, 9 February 1863, p. 5.

CHAPTER II

The Early Years, 1806–41

1. Edmonds, "Autobiography III," pp. 1ff.

2. Ibid., pp. 5–6. He hoped to apprentice to Gideon Fairman of Philadelphia, but the fee was $1,000 plus expenses.

3. Edmonds, "Autobiography II," p. 1. William Dunlap later became the American "Vasari" with his two-volume *History of the Rise and Progress of the Arts of Design in the United States* (1834). Although Edmonds was still too little known to be included, he owned a copy of the *History* and used it in his researches on Samuel F. B. Morse's *House of Representatives* when he was trying to secure it for the New-York Gallery of the Fine Arts. (Edmonds mentions consulting Dunlap in a letter of 15 August 1857 to Asher B. Durand [Durand Correspondence, NYPL].)

4. Edmonds, "Autobiography II," p. 1. See also "Autobiography III," p. 6.

5. Edmonds, "Autobiography III," p. 6.

6. Francis W. Edmonds, "Technical Notebook" (manuscript in private collection), pp. 4, 5, 12. On Hoyle, see George Groce and David Wallace, *The New-York Historical Society's Dictionary of Artists in America, 1564–1860* (New Haven, Conn.:

Yale University Press, 1957), p. 331. Raphael Hoyle was a landscape painter who came to America from England around 1823; he divided his time between New York City and Newburgh, New York, and had planned to go west on an exploring expedition before succumbing to an illness in 1838.

7. Edmonds, "Autobiography III," p. 7. For the painting's exhibition, see Cowdrey, *National Academy Exhibition Record*, 1: 143.

8. Samuel Butler, *Hudibras* (London: George Bell and Sons, 1903), part 1, canto 2, 910ff.

9. Cummings, *Historic Annals*, p. 116; Edmonds, "Autobiography III," p. 7.

10. For his return to Hudson and first marriage, see "Edmonds," *National Cyclopaedia*, 11: 298. None of his autobiographies mention either his first or second marriage.

11. Edmonds, "Autobiography III," p. 8.

12. Edmonds, "Technical Notebook," pp. 13–24. The portraits of Edmonds and his wife are unlocated.

13. "The Editor's Table: The National Academy of Design, Eleventh Annual Exhibition," *Knickerbocker, New-York Monthly Magazine* 8 (July 1836): 115. See also Cowdrey, *National Academy Exhibition Record*, 2: 209.

14. *Catalogue of the Eleventh Annual Exhibition of the National Academy of Design, 1836* (New York: Sackett and Co., 1836), p. 6.

15. Edmonds's comments on his method are in "Autobiography III," p. 9. For Neal's views, see Harold E. Dickson, ed., *Observations on American Art: Selections from the Writings of John Neal (1793–1876)* (State College: Pennsylvania State College Studies No. 12, 1943), p. 76. The article originally appeared as "American Painters Abroad," in *Yankee, and Boston Literary Gazette*, 11 March 1829, pp. 181–86. Neal asserted that the use of such a device would be typical of Gerrit Dou, but never Rembrandt. For Wilkie's importance in America, see Catherine Hoover, "The Influence of David Wilkie's Prints on the Genre Paintings of William Sidney Mount," *American Art Journal* 13 (Summer 1981): 4–33.

16. "National Academy of Design: Seventh Notice," *New-York Mirror and Literary Gazette*, 10 June 1837, p. 399. See also Cowdrey, *National Academy Exhibition Record*, 2: 209; and Mann, *Edmonds: Mammon and Art*, pp. 17ff.

17. James Fenimore Cooper, *The Spy* (1821) (New York: G. P. Putnam's Sons, 1896), p. 13.

18. I wish to thank Monroe Fabian, Marc Pachter, and Donald Kloster for their assistance in answering questions about the costumes in this painting.

19. Hoover, "Influence of David Wilkie's Prints," p. 31.

20. Sir Walter Scott, *Guy Mannering* (1815) (Edinburgh: Adam and Charles Black, 1852), pp. 75ff.

21. "National Academy of Design: Seventh Notice," *New-York Mirror*, 10 June 1837, p. 399.

22. Edmonds, "Autobiography III," p. 10.

23. "The Fine Arts: National Academy of Design," *New-York Mirror and Literary Gazette*, 30 June 1838, p. 6. Contrary to the reviewer's opinion, there were plenty of Old Masters in America; see H. Nichols B. Clark, "The Impact of Seventeenth-Century Dutch and Flemish Genre Painting on American Genre Painting, 1800–1865," Ph.D. diss., University of Delaware, 1982; and idem, "A Fresh Look at the Art of Francis W. Edmonds: Dutch Sources and American Meanings," *American Art Journal* 14 (Summer 1982): 73–94.

24. For useful background, see Johan H. Huizinga, *Dutch Civilization in the Seventeenth Century and Other Essays* (London: Collins, 1968); K. H. D. Haley, *The Dutch in the Seventeenth Century* (London: Thames and Hudson, 1972).

25. George Murray, "Notice of the Fourth Annual Exhibition in the Academy of the Fine Arts," *Portfolio*, 4th ser., 3 (June 1814): 569. I am indebted to Wayne Craven for this reference.

26. Clark, "Dutch and Flemish Genre Painting," chaps. 2 and 3.

27. "Diary of William Sidney Mount," 22 April [1846?], quoted in Alfred Frankenstein, *William Sidney Mount* (New York: Harry N. Abrams, 1975), p. 142.

28. Henry T. Tuckerman, *Book of the Artists: American Artist Life Comprising Biographical and Critical Sketches of American Artists Preceded by an Historical Account of the Rise and Progress of Art in America* (New York: G. P. Putnam and Son, 1867), p. 412.

29. Edmonds, "Travel Diary, 25 November 1840–17 July 1841," 2 vols. (Columbia County Historical Society, Kinderhook, New York), vol. 2, 10 June 1841.

30. Edmonds, "Technical Notebook," p. 12.

31. Minutes of the National Academy of Design, 20 April 1832, p. 48 (National Academy of Design, New York). I wish to thank Lois Fink for bringing this to my attention.

32. Burnet, "The Education of the Eye," pp. 66–67 and passim, in *A Treatise in Four Parts Consisting of an Essay on the Education of the Eye with Reference to Painting and Practical Hints on Composition, Chiaroscuro, and Colour* (London: J. Carpenter and Son, 1827). Burnet's treatise was published in various editions, with various titles, during the nineteenth century.

33. Ibid., "Practical Hints on Colour," p. 60.

34. John Burnet, "Autobiography of John Burnet," *Art Journal* 12 (1850): 275.

35. X rays at the Wadsworth Atheneum reveal this transformation. I am indebted to Betsy Kornhauser for letting me consult the x rays.

36. For the exhibitions, see Cowdrey, *National Academy Exhibition Record*, 1: 143; and *Fourth Annual Exhibition of the Brooklyn Institute* (Brooklyn, N.Y.: no publisher, 1845), p. 6. The painting was lent by Edmonds; as far as is known he never parted with either version. The Wadsworth Atheneum painting descended through the family, and the other version is still owned by the family.

37. Lanman's description is from his *Letters from a Landscape Painter* (Boston: James Monroe and Co., 1845), p. 240.

38. Edmonds, "Autobiography III," p. 10.

39. Carl Bode, *The Anatomy of American Popular Culture, 1840–1861* (Berkeley: University of California Press, 1959), pp. 250ff.

40. "National Academy of Design," *Commercial Advertiser*, 24 April 1839, n.p.

41. *Catalogue of Paintings of the Third Exhibition of the Boston Artists' Association, 1844* (Boston: Clapp and Son's Press, 1844), p. 4.

42. Tobias Smollett, *The Adventures of Peregrine Pickle* (1751) (New York: Tudor Publishing Co., 1935), pp. 8ff.

43. Hone, *The Diary of Philip Hone, 1828–1851*, ed. and with an introduction by Bayard Tuckerman, 2 vols. (New York: Dodd, Mead and Co., 1889), 1: 353–54.

44. Edmonds to Thomas Worth Olcott, 25 February 1839 (Thomas Worth Olcott Papers, Columbia University, New York). On Olcott, see "Thomas Worth Olcott," *National Cyclopaedia*, 18: 204.

45. Edmonds to Thomas Worth Olcott, 25 February 1839 (Olcott Papers, Columbia University).

46. Edmonds to Olcott, 25 April 1839.

47. Edmonds to Olcott, 17 July 1839.

48. Edmonds to Olcott, 25 April 1839.

49. Cowdrey, *American Academy*, 1: 102–3. For the exhibition, see 2: 127.

50. In 1943 they were sold in a single transaction by M. Knoedler and Co. to Sterling Clark; today they hang together, flanking a window in the Sterling and Francine Clark Art Institute, Williamstown, Massachusetts.

51. On his wife's illness, see Edmonds to Thomas W. Olcott, 16 December 1839 (Olcott Papers, Columbia University).

52. This information is in a letter from Edmonds's grandniece Cornelia Flagler Schantz to Frank Weitenkampf, curator at the New York Public Library, 7 December 1920 (Archives, NYPL).

53. Washington Irving, "The Legend of Sleepy Hollow," in *The Sketchbook of Geoffrey Crayon, Gent.* (1819) (New York: G. P. Putnam's Sons, 1894), p. 270.

54. Abram C. Dayton, *Last Days of Knickerbocker Life in New York* (1882) (New York: G. P. Putnam's Sons, 1897), pp. 29–30.

55. Edmonds, "Autobiography III," p. 11.

56. "Editor's Table: The Fine Arts," *Knickerbocker* 16 (July 1840): 82. Edmonds's notes are in his "Technical Notebook," pp. 7, 16, 17.

57. James Kirke Paulding, *The Dutchman's Fireside*, ed. Thomas F. O'Donnell (New Haven, Conn.: College and University Press, 1966), p. 192 and passim. Edmonds later turned to this novel for inspiration for *The Bashful Cousin* (plate 5); see discussion in chap. 3 herein.

58. Dayton, *Knickerbocker Life*, pp. 119–20.

59. Edmonds, "Autobiography III," p. 11.

60. "National Academy of Design: Review of the Exhibition," *American Repository of Art, Science, and Manufacturing* 1 (June 1840): 365.

61. "Editor's Table: The Fine Arts," *Knickerbocker* 16 (July 1840): 82–83.

62. See Arthur S. Marks, "Wilkie to 1825," Ph.D. diss., University of London, 1968, p. 36 and passim.

63. This journey, the last and greatest stage of Edmonds's artistic education, has been treated thoroughly by Maybelle Mann, who based her narrative on the artist's two-volume travel diary. See Mann, *Edmonds: Mammon and Art*, pp. 24–58.

64. Edmonds, "Travel Diary," vol. 1, 30 December [1840]; "Autobiography III," p. 12; "Travel Diary," vol. 1, 31 December [1840]; vol. 2, 11 July 1841.

65. Edmonds, "Travel Diary," vol. 2, 12 July 1841 and 11 July 1841. Asher B. Durand to John Durand, 4 July 1840 (Durand Correspondence, NYPL).

66. Edmonds, "Travel Diary," vol. 1, 14 January [1841]. Guido Reni (1575–1642) was a Bolognese painter who enjoyed the highest reputation in the seventeenth, eighteenth, and early nineteenth centuries, until he was blasted by John Ruskin. Philips Wouwerman (1619–68) was a pupil of Frans Hals who painted genre scenes of horsemen, battles, and camp life.

67. John F. Kensett, "Journal, 1 June 1840–31 May 1841," 2 vols. (Frick Art Reference Library, New York), vol. 2, 14 January 1841.

68. Asher B. Durand to Mary Durand, 15 January 1841 (Durand Correspondence, NYPL).

69. Edmonds, "Travel Diary," vol. 1, 13 February [1841].

70. *Catalogue des tableaux composant la galerie de feu son eminence le Cardinal Fesch* (Rome: Joseph Salviucci et Fils, 1841), p. 10, no. 184.

71. Edmonds, "Travel Diary," vol. 1, 13 February [1841]. In crossing out Flemish and inserting Dutch, perhaps Edmonds was striving for precision in his analyses.

72. Ibid., 18–19 April [1841].

73. Ibid., 20 April [1841].

74. Ibid., vol. 2, 12 May 1841.

75. Kensett, "Journal," vol. 2, 15 May 1841.

76. Edmonds, "Travel Diary," vol. 2, 16 and 19 May 1841 and back page [no date].

77. Edmonds to John F. Kensett, 10 February 1841 (Morgan Papers, NYSLA).

78. Kensett, "Journal," vol. 2, 28 May 1841.

79. Edmonds, "Travel Diary," vol. 2, 7 June 1841.

80. Ibid., 9 June 1841; 10 June 1841.

81. Ibid., 15 June 1841.

82. Mann, *Edmonds: Mammon and Art*, pp. 51ff.

83. Edmonds, "Travel Diary," vol. 2, 5 July 1841.

CHAPTER III

The Years of Ascendancy, 1841–55

1. Edmonds, "Autobiography III," p. 15. See Cowdrey, *American Academy*, 2: 127, for a reference to *The Sleeping Ostler*.

2. See chap. 2, n. 57, above.

3. Caroline Cowles Richards, *Village Life in America* (New York: Henry Holt and Co., 1913), p. 156.

4. Hoover, "Influence of David Wilkie's Prints," p. 32.

5. Oliver W. Larkin, *Art and Life in America* (New York: Rinehart and Co., 1949), p. 220, referred to Edmonds's brushwork in this painting as "sleek and monotonous" and considered the artist "a second-rater."

6. Charles Lanman, "Artist's Recollections," *Art-Union* 1 (August–September 1884): 158.

7. See chap. 2, n. 23, above.

8. "Editor's Table: The Fine Arts," *Knickerbocker* 19 (June 1842): 591.

9. Edmonds, "Autobiography III," p. 16.

10. "The Fine Arts," *Knickerbocker*, June 1842, p. 591.

11. Edmonds, "Travel Diary," vol. 2, no date, back page.

12. Maybelle Mann, *Francis William Edmonds*, exh. cat. (Washington, D.C.: International Exhibitions Foundation, 1975), p. 40.

13. James T. Callow, "American Art in the Collection of Charles M. Leupp," *Antiques* 118 (November 1980): 998–1009.

14. *Third Exhibition of the Boston Artists' Association, 1844*, no. 109; *Fourth Annual Exhibition of the Brooklyn Institute*, no. 118.

15. The Leupp-Edmonds correspondence is located in the Charles M. Leupp Papers, Alexander Library, Rutgers University, New Brunswick, New Jersey. This quotation is from Edmonds to Charles M. Leupp, 21 August 1849.

16. John H. Gourlie, *A Tribute to the Memory of Charles M. Leupp: An Address Delivered before the Column, February 10, 1860* (New York: Wm. C. Bryant and Co., 1860), pp. 14–15.

17. E. H. Ludlow, Auctioneer, *Catalogue of Valuable Paintings and Engravings, Being the Entire Gallery of the Late Charles M. Leupp, Esq.* (New York: Hall, Clayton and Co., 1860), nos. 12, 48, 70, and 72. See also "Domestic Art Gossip," *Crayon* 7 (December 1860): 354; and "Leupp Sale," *New-York Daily Tribune*, 14 November

1860, p. 8. Although the sale attracted considerable notice, it did not fulfill everyone's expectations; the critic for the *Crayon* thought a more spacious exhibition hall and a less politically agitated climate would have brought a larger aggregate sum than the $10,079 realized.

18. Edmonds, "Autobiography III," p. 16.

19. Mann, *Edmonds: Mammon and Art,* pp. 90ff.

20. "Editor's Table: The Fine Arts," *Knickerbocker* 21 (June 1843): 581.

21. Bruce Chambers, *The World of David Gilmour Blythe (1815–1865),* exh. cat. (Washington, D.C.: Smithsonian Institution Press for National Collection of Fine Arts, 1980), p. 52 and passim. The little black boy illicitly draining off a mug of cider under the table in the left foreground of John Lewis Krimmel's (1789–1821) *View of Centre Square on the 4th of July* (c. 1810–12) anticipates such characters by thirty years.

22. On the open window, see Lorenz Eitner, "The Open Window and the Storm-Tossed Boat: An Essay in the Iconography of Romanticism," *Art Bulletin* 37 (December 1957): 279–90. For Tocqueville's comments, see *Democracy in America* (1835–40), trans. Henry Reeve, 2 vols. (New Rochelle, N.Y.: Arlington House, 1966), 2: 49–54. See also Theodore E. Klitzke, "Alexis de Tocqueville and the Arts in America," in Antje Kosegarten and Peter Tigler, eds., *Festschrift Ulrich Middeldorf,* 2 vols. (Berlin: De Gruyter, 1968), 2: 553–58.

23. Elizabeth Johns, "This New Man: National Identity in American Genre Painting, 1835–1851," paper delivered at Woodrow Wilson International Center for Scholars, Washington, D.C., 22 April 1986, pp. 15ff.

24. *Explication des ouvrages de peinture, sculpture, architecture, gravure, et lithographie des artists vivants, exposés au Musée Royal le 15 Mars 1841* (Paris: Vinchon Fils, 1841), passim.

25. Hoover, "Influence of David Wilkie's Prints," pp. 32–33.

26. Edmonds, "Autobiography III," p. 16.

27. "Editor's Table: The Fine Arts," *Knickerbocker* 23 (June 1844): 597.

28. Ibid.

29. See Hermann Warner Williams, Jr., *Mirror to the American Past: A Survey of American Genre Painting, 1750–1900* (Greenwich, Conn.: New York Graphic Society, 1973), p. 73.

30. "The Fine Arts," *Knickerbocker,* June 1844, p. 597.

31. Edmonds, "Autobiography III," p. 16. *The Beggar's Petition* was bought by Samuel J. Hooper of Boston, who lent it to the Boston Athenaeum in 1853 (Robert F. Perkins, Jr., and William J. Gavin III, *The Boston Athenaeum Art Exhibition Index, 1827–1874* [Boston: Library of Boston Athenaeum, 1980], p. 53). Little is known about Hooper's connections with New York, but it is known that he was a successful merchant in the shipping and importing business ("Samuel Hooper," *National Cyclopaedia,* 4: 499). More to the point, he was a director of the Merchants' Bank of Boston and of the Eastern Railroad Company. Through these latter two pursuits, he could have known Edmonds. No doubt Edmonds derived a certain measure of satisfaction from knowing that his work was owned by one of the leading citizens of Boston and Massachusetts.

32. In the list of "Possible Subjects" at the back of his "Travel Diary," vol. 2, Edmonds noted: "A beggar and her child at a window soliciting alms, the latter very young (3 or 4) holding up its little apron."

33. *Sale Catalogue Number 1025, Parke-Bernet Galleries, Inc., January 6, 7, 8, 1949* (New York: Parke-Bernet, 1949), no. 330. The incident is from Charles Dickens, *The Posthumous Papers of the Pickwick Club* (1836) (London: Oxford University Press, 1947), pp. 118–19. Charles Leupp had bought *Sam Weller* before it was exhibited at the Academy (Cowdrey, *National Academy Exhibition Record,* 1: 143). After the

painting was sold in 1860 to Sidney Mason ("Leupp Sale," *New-York Daily Tribune,* 14 November 1860, p. 8), it passed into oblivion for almost ninety years before resurfacing at Parke-Bernet in 1949.

34. On Dickens's American tour, see Hone, *Diary,* 2: 107, 117, and passim. For Hone's reaction to *Martin Chuzzlewit,* see also p. 196.

35. Edmonds Folder, Inventory of American Paintings (National Museum of American Art, Washington, D.C.). For its appearance at the inaugural exhibition, see *New-York Gallery of the Fine Arts,* 1844 exh. cat., no. 71.

36. George P. Putnam, *American Facts* (London: Wiley and Putnam, 1845), pp. 120ff. See also Mann, *Edmonds: Mammon and Art,* p. 96.

37. Lanman, *Letters from a Landscape Painter,* pp. 239–40.

38. Strong, *Diary,* 1: 258–59, 20 April 1845.

39. "National Academy of Design," *Broadway Journal,* 10 May 1845, p. 306.

40. For an overview of the temperance movement, see Ian R. Tyrrell, *Sobering Up: From Temperance to Prohibition in Antebellum America, 1800–1860* (Westport, Conn.: Greenwood Press, 1979). The "Washingtonian" temperance societies are discussed on pp. 159ff.

41. Mann, *Francis William Edmonds,* p. 24, reproduces the circular in the Edmonds File (Art Division, NYPL).

42. For Hogarth's treatment of the theme, see Ronald Paulson, *Hogarth: His Life, Art, and Times,* 2 vols. (New Haven, Conn.: Yale University Press, 1971), 1: 230ff.

43. Bode, *American Popular Culture,* pp. 6ff.

44. Tyrrell, *Sobering Up,* p. 218; see also p. 18 and passim on Quaker attitudes toward drinking. For Edmonds's part in the temperance circular, see "The Fine Arts," *Anglo-American,* 13 February 1847, p. 405.

45. Frankenstein, *William Sidney Mount,* p. 25. Mount essayed the theme again in *Loss and Gain* of 1847. A subsequent effort by Mount known as either *Bar-room Scene* or *The Breakdown* (1835; Art Institute of Chicago) alludes to the issue of sobriety and includes a temperance notice.

46. Chambers, *David Gilmour Blythe,* p. 162 and passim. Blythe devoted approximately six works to this topic.

47. Edmonds, "Autobiography III," p. 3.

48. "The Fine Arts," *Literary World,* 10 May 1851, p. 380.

49. Pavel Svinin, "A Glance at the Republic of the United States," in Avrahm Yarmolinsky, *Picturesque United States of America, 1811, 1812, 1813, Being "A Memoir on Paul Svinin"* (New York: William Edwin Rudge, 1930), p. 15.

50. On the birdcage as symbol, see E. De Jonghe, "Erotica in Vogelperspectief: De dubbelzinnigheid van een reeks 17de eeuwse genrevoorstellingen," *Simiolus* 3 (1968–69): 22–74.

51. I am grateful to Elizabeth Johns for bringing this painting to my attention.

52. Edmonds, "Travel Diary," vol. 2, 3 July [1841].

53. Edmonds's 1846 offerings at the Academy are listed in Cowdrey, *National Academy Exhibition Record,* 1: 144.

54. "Editor's Table: The Fine Arts," *Knickerbocker* 27 (May 1846): 464.

55. See David B. Lawall, *Asher B. Durand, 1796–1886,* exh. cat. (Montclair, N.J.: Montclair Art Museum, 1971), pp. 14ff.

56. Lois Engelson, "The Influence of Dutch Landscape Painting on the American Landscape Tradition," M.A. thesis, Columbia University, 1966.

57. Edmonds, "Travel Diary," vol. 2, 29 June 1841.

58. The pertinent passage from Scott is quoted in *Catalogue of the Twenty-first*

Annual Exhibition of the National Academy of Design (New York: Israel Sackett, 1846), no. 167.

59. "National Academy of Design," *New-York Mirror and Literary Gazette*, 22 May 1846, p. 92.

60. "Fine Arts," *Knickerbocker*, May 1846, p. 464.

61. "National Academy of Design," *New-York Mirror and Literary Gazette*, 22 May 1846, p. 92.

62. "Fine Arts," *Knickerbocker*, May 1846, p. 464.

63. Cowdrey, *American Academy*, 2: 127.

64. Halleck, *Poetical Works*, p. 202.

65. "Halleck's Poetical Work," *Boston Transcript*, 8 November 1847, p. 2; "Editor's Table: Literary Notices," *Knickerbocker* 30 (November 1847): 449.

66. Cowdrey, *National Academy Exhibition Record*, 1: 144; and idem, *American Academy*, 2: 127.

67. "National Academy of Design," *New York Post*, 6 June 1848, n.p. Although the painting remains lost today, its early ownership is of interest. In 1853 *First Earnings* was exhibited in Philadelphia at the Pennsylvania Academy of the Fine Arts, lent by William J. Stillman (1828–1901) and John Durand. The latter was Asher B. Durand's son, and his close association with Edmonds was inspired, no doubt, by the feelings of his father toward this good friend. Stillman was an artist, journalist, and diplomat whose painting was profoundly influenced by the writings of John Ruskin and the art of the pre-Raphaelites. The shared ownership of *First Earnings* anticipated another joint venture undertaken by these two men. In 1855 they commenced publication of the *Crayon*, the first art magazine in America and for the next five years one of the most important. (Linda S. Ferber and William H. Gerdts, *The New Path: Ruskin and the Pre-Raphaelites*, exh. cat. [New York: Brooklyn Museum and Schocken Books, 1985], p. 277.) For the exhibition of *First Earnings* in Philadelphia, see Anna Wells Rutledge, *Cumulative Record of Exhibition Catalogues: The Pennsylvania Academy of the Fine Arts, 1807–1870* (Philadelphia: American Philosophical Society, 1955), p. 68.

68. "National Academy of Design," *New York Post*, 6 June 1848, n.p.

69. On the place of tidiness in the Dutch national ethos, see Huizinga, *Dutch Civilization*, p. 62. For its connection to American painting, see Clark, "Dutch and Flemish Genre Painting," pp. 27ff.

70. "Dutch Cleanliness and Female Influence," *Portfolio*, 4th ser., 3 (March 1814): 253–55.

71. See Donelson F. Hoopes, *American Narrative Painting*, exh. cat. (Los Angeles: Los Angeles County Museum of Art, 1974), pp. 126–27, for a discussion of Schussele; and see Celia Betsky, "American Musical Paintings, 1865–1910," in Celia Betsky et al., *The Art of Music: American Paintings and Musical Instruments, 1770–1910*, exh. cat. (Clinton, N.Y.: Emerson Gallery, Hamilton College, 1984), p. 60, for a discussion of Story.

72. Nathaniel Hawthorne, *American Notebooks*, p. 117.

73. Hawthorne, *The House of the Seven Gables* (1851) (New York: Heritage Press, 1935), pp. 210–11.

74. "The Fine Arts," *Town and Country*, 11 November 1848, p. 2; quoted in Mann, *Edmonds: Mammon and Art*, p. 110.

75. "Fine Arts," *New York Day Book*, 20 November 1848, n.p., in American Art-Union Press Book (New-York Historical Society).

76. "Fine Arts," *Town and Country*, 11 November 1848, p. 2. *The Strolling Musician* was won by James C. McGuire of Washington, D.C., in the American Art-Union lottery (Cowdrey, *American Academy*, 2: 127). This was fortuitous, since

McGuire had an extensive collection significant enough to be listed among the roll of prominent collectors in Henry Tuckerman's *Book of the Artists*. McGuire further obliged Edmonds's desire for broader exposure by lending the work the following year to the Second Annual Exhibition at the Maryland Historical Society in Baltimore, where it was known as *The Wandering Minstrel* (*Catalogue of Painting, Engraving, etc., etc. at the Picture Gallery of the Maryland Historical Society: Second Annual Exhibition, 1849* [Baltimore: John D. Toy, 1849], no. 170).

77. "Fine Art Intelligence," *Literary World*, 10 March 1849, p. 228. The pertinent text of the novel is reproduced in "Catalogue of the Exhibition," *Bulletin of the American Art-Union*, May 1849, p. 26.

78. Alain-René Lesage, *The Adventures of Gil Blas of Santillane* (1715–35), trans. Tobias Smollett, introduction by J. B. Priestly, and illustrations by John Austen, 2 vols. (Oxford: Oxford University Press, 1937).

79. Leonard L. Richards, *"Gentlemen of Property and Standing": Anti-Abolition Mobs in Jacksonian America* (New York: Oxford University Press, 1970), p. 18.

80. Cole, *Martin Van Buren*, p. 269.

81. Mann, *Edmonds: Mammon and Art*, pp. 112ff.

82. See Cowdrey, *American Academy*, 2: 127; "Our Private Collections: No. IV," *Crayon* 3 (June 1856): 186; and Callow, "Collection of Charles M. Leupp," p. 999. Distributed through the American Art-Union to Peter van Denberg of Coxsackie, New York, the painting had passed into the hands of Edmonds's close friend and erstwhile patron Charles M. Leupp by 1856. When Leupp's collection was auctioned after his death, the painting was purchased by another prominent New Yorker, John Taylor Johnston, who was the first president of the Metropolitan Museum of Art. With the sale of Johnston's collection in 1876, the painting passed into oblivion for almost a century.

83. Cowdrey, *National Academy Exhibition Record*, 1: 144.

84. "The Fine Arts: National Academy of Design," *Literary World*, 4 May 1850, p. 448.

85. See Washington Irving, "The Legend of Sleepy Hollow," pp. 253ff.; for Darley's illustrations, see Mann, *American Art-Union*, pp. 58–63.

86. Russell B. Nye, *Society and Culture in America, 1830–1860* (New York: Harper and Row, 1974), pp. 393ff.

87. See Nicolai Cikovsky, Jr., "Winslow Homer's *School Time*: 'A Picture Thoroughly National,'" in John Wilmerding, ed., *Essays in Honor of Paul Mellon, Collector and Benefactor* (Washington, D.C.: National Gallery of Art, 1986), pp. 53ff.

88. See James A. Welu, "Vermeer: His Cartographic Sources," *Art Bulletin* 57 (December 1975): 529ff.

89. "The Fine Arts," *Literary World*, 4 May 1850, p. 448.

90. Ibid.

91. Cowdrey, *National Academy Exhibition Record*, 1: 144.

92. *The Complete Poetical Works of Robert Burns* (Boston: Houghton Mifflin and Co., 1897), p. 233.

93. "The Fine Arts: National Academy of Design," *Literary World*, 19 April 1851, p. 321. The use of the key as a signal to deeper interpretation was a popular motif in seventeenth-century Dutch genre painting, most notably in Jan Steen's (c. 1626–79) *Topsy Turvy World* (Kunsthistorisches Museum, Vienna).

94. Cowdrey, *American Academy*, 2: 128. The successful bidder was listed as John Van Buren. This could have been Martin Van Buren's son, who was Edmonds's contemporary and undoubtedly would have known him through the friendship of the respective families, or possibly John Dash Van Buren (1811–85), who was a lawyer and financier in New York at roughly the same time ("John Dash Van Buren," *National Cyclopaedia*, 10: 236). The latter was an ardent Democrat, writing

financial editorials that advocated free trade and hard money for New York's *Evening Post* under the tenure of the equally zealous Democrat John Bigelow. (In 1850 this Van Buren moved to New Windsor [on the Hudson] because of his health, which may have precluded his interest in attending an auction in the city.) In either case, the purchaser was fiscally and politically sympathetic to the artist, as was often true for his paintings.

95. The description of *Preparing for Christmas* is from Cowdrey, *American Academy*, 2: 127–28.

96. Efforts to trace it through the Inventory of American Paintings (National Museum of American Art, Washington, D.C.), where it is listed and there is a photograph, have proved futile thus far.

97. Cowdrey, *National Academy Exhibition Record*, 1: 144.

98. Mann, *Edmonds: Mammon and Art*, pp. 116ff.

99. "Fine Arts: National Academy of Design," *Home Journal*, 8 May 1852, p. 2.

100. Ibid.

101. "The Fine Arts," *Literary World*, 1 May 1852, p. 316; "Fine Arts," *Home Journal*, 8 May 1852, p.2.

102. See Edmonds to Azariah C. Flagg, [after 7/before 19] October 1843 (Azariah C. Flagg Papers, NYPL).

103. Edmonds's portrait of the bull may have aesthetic implications as well. Although it is impossible to attribute a specific source for the depiction of this animal, Edmonds expressed a decided preference for certain cattle painters (not surprisingly Dutch) when he was in Europe, praising the work of Balthazar Ommeganck (1755–1826) and noting disappointment in that of Paulus Potter (1625–54); "Travel Diary," vol. 2, 9 June 1841.

104. Edmonds to Asher B. Durand, 19 July 1849 (Durand Correspondence, NYPL).

105. Cowdrey, *National Academy Exhibition Record*, 1: 144.

106. *Catalogue of the Twenty-eighth Annual Exhibition of the National Academy of Design* (New York: Sackett and Co., 1853), no. 154.

107. The poem appears on p. 212 of Robert Burns, *Poetical Works*.

108. The home still exists on the outskirts of Philadelphia, where much of the collection remains. I wish to express my gratitude to Jay Cantor for his assistance in pursuing this matter.

109. W. P. Eaton, "Edwin Forrest," *Dictionary of American Biography*, 22 vols. (New York: Charles Scribner's Sons, 1928–81), 6: 530–31.

110. Contemporary audiences easily recognized the role of knitting in affairs of the heart; the critic for the *New-York Mirror* dwelled on it at some length in his favorable review of Mount's painting: "Can anything be more beautifully correct than the graceful figure, arch (yet modest) expression of this American farmer's daughter? She has tasked her clownish admirer to hold the skein, while she *holds the ball in her own hands*, while winding up a courtship not suited to her taste. We may imagine that when the yarn is off, and he drops his hands, she may dismiss him by dropping a *curtsey*"("The Fine Arts: National Academy of Design," *New-York Mirror and Literary Gazette*, 17 June 1837, p. 407).

111. I wish to thank Betsy Kornhauser for her assistance in this matter.

112. Perkins and Gavin, *Boston Athenaeum Art Exhibition Index*, p. 53; Rutledge, *Pennsylvania Academy of the Fine Arts*, p. 68.

113. "James L. Claghorn," *Harper's Weekly*, 6 September 1884, p. 581. Further information is in George P. Lathrop, "State Celebrities: James L. Claghorn, Merchant, Banker, Art Connoisseur," *Philadelphia Press*, 8 April 1882, n.p.

114. Edmund M. Young to James L. Claghorn, 26 June 1853 (James L. Claghorn Papers, Philadelphia Maritime Museum).

115. Information on the death of Edmonds's son was obtained from a family tree in possession of descendants from Edmonds's daughter by his first marriage.

116. Cowdrey, *National Academy Exhibition Record*, 1: 144.

117. "National Academy of Design," *Home Journal*, 1 April 1854, p. 2.

118. *Twenty Censuses: Population and Housing Questions, 1790–1980* (Washington, D.C.: Government Printing Office, 1979), p. 14. See also Joseph A. Hill, "The Historical Value of Census Records," in *Report of the American Historical Association for the Year 1908*, 2 vols. (Washington, D.C.: Government Printing Office, 1909), 1: 202ff.

119. Hyman Alterman, *Counting People: The Census in History* (New York: Harcourt, Brace and World, 1969), pp. 210–11.

120. "Reflections on the Census," *Crayon* 5 (October 1858): 315–16.

121. *Twenty Censuses*, p. 14.

122. Since the picture constitutes such an anomaly in Edmonds's oeuvre, it is not necessary to present a detailed account here. Maybelle Mann has provided a thorough treatment of the painting and its genesis, demonstrating how the painting and its subject of unjust persecution related to the controversy over the trial in 1845 of Bishop Benjamin Tredwell Onderdonk, who was charged with immorality and impurity; see Mann, *Edmonds: Mammon and Art*, pp. 130ff.

123. Edmonds, "Diary 1854," 30 October and 7 November (AAA).

CHAPTER IV

The Years of Solace, 1855–63

1. Hammond, *Banks and Politics*, pp. 710ff.

2. Cowdrey, *National Academy Exhibition Record*, 1: 144.

3. Carl Bode, ed., *American Life in the 1840s* (New York: New York University Press, 1967), pp. 3–12.

4. "Domestic Art Gossip," *Crayon* 3 (March 1856): 91.

5. Bode, *American Life in the 1840s*, p. 14.

6. *The Poetical Works of John Greenleaf Whittier*, 4 vols. (Boston: Houghton Mifflin and Co., 1892), vol. 3, *Songs of Labor: The Drovers*, p. 306.

7. Ibid., p. 308.

8. Anita Brookner, *Greuze: The Rise and Fall of an Eighteenth-Century Phenomenon* (London: Elek, 1972), pp. 76–79, 138ff.

9. "Sketchings: National Academy of Design," *Crayon* 3 (May 1856): 147.

10. Ibid.

11. Frankenstein, *William Sidney Mount*, p. 269.

12. Hugh Morrison, *Early American Architecture from the First Colonial Settlements to the National Period* (New York: Oxford University Press, 1952), pp. 123ff.

13. Nye, *Society and Culture*, pp. 230ff.

14. Little is known about the early ownership of *All Talk and No Work*; it appeared at auction in 1875 in the sale of the Gandy-Olyphant Collection, but which of the two collectors possessed it is unclear. It sold to a W. R. Garrison for $250; more important than its disposition was the *Evening Post*'s statement that it was rare

to encounter Edmonds's painting and that consequently *All Talk and No Work* attracted considerable attention. Thus, twelve years after his death, Edmonds and his art still merited positive notice. ("City Intelligence: The Somerville Gallery, the Gandy-Olyphant Collection," *Evening Post*, 20 March 1875, p. 4.)

15. They weren't, however, exhibited as a pair; possibly Edmonds hadn't finished the second canvas in time for the spring exhibition at the National Academy. Further clues to his intentions are hard to find, since no reference to *The Scythe Grinder* has yet come to light in the contemporary literature.

16. Frankenstein, *William Sidney Mount*, p. 95. Edmonds would have known this painting well, since it was bought by his good friend, associate, and patron, Jonathan Sturges (ibid., p. 100). He may even have used it as a point of departure.

17. Mann, *Francis William Edmonds*, pp. 46–47.

18. "National Academy of Design," *New-York Mirror and Literary Gazette*, 9 May 1846, p. 58; "Art and Artists," *Home Journal*, 22 February 1851, p. 3.

19. Edward D. Nelson to Asher B. Durand, 1 September 1856 (Durand Correspondence, NYPL).

20. "Domestic Art Gossip," *Crayon*, March 1856, p. 91.

21. *Time to Go* seems to have been owned initially by Edmonds's sketching companion Edward Nelson, who was a pupil of Durand although he considered himself an amateur (Groce and Wallace, *Dictionary of Artists in America*, p. 468). The precise nature of the transaction remains unclear, since there is no evidence of Edmonds owning a work by Nelson. The latter lent the work to the Yonkers Sanitary Fair in February 1864, and put it on view the following December at the fifth annual Artists' Fund Society exhibition and auction. Nelson had disposed of the canvas by 1867, when it was lent to the Brooklyn Art Association by Henry Sanger. It was seen again in Brooklyn five years later, property of the same owner, and then passed into oblivion until the 1970s when it resurfaced and eventually entered the collection of Blount, Inc. (For references to the painting's history, see Cowdrey, *National Academy Exhibition Record*, 1: 144; *Yonkers Sanitary Fair: Catalogue of Paintings on Exhibition in National Guard Armory, Farrington Building, Commencing Monday, February 15th, 1864* [New York: Henry Spear, 1864], no. 135; *Artists' Fund Society of New York, Instituted 1859, Chartered 1861: Catalogue of the Fifth Annual Sale of Paintings* [New York: G. A. Whitehorne, 1864], no. 243; Clark S. Marlor, *A History of the Brooklyn Art Association with an Index of Exhibitions* [New York: James F. Carr, 1970], p. 181; and Claudia T. Esko et al., *Art Investments: Selections from Three Alabama Corporate Collections: Blount, Inc.; Weil Enterprises and Investments, Ltd.; Vulcan Materials Company*, exh. cat. [Birmingham, Ala.: Birmingham Museum of Art, 1984], p. 12.)

22. Dayton, *Knickerbocker Life*, pp. 198–99.

23. "Sketchings: National Academy of Design," *Crayon* 4 (July 1857): 223.

24. *Catalogue, Art Exhibition, Maryland State Fair, Baltimore, April 1864* (Baltimore: J. B. Rose and Co., 1864), no. 13. This canvas was owned by John F. Kensett's brother Thomas Kensett.

25. *Catalogue of the Entire Collection of Paintings Belonging to the Late Mr. A. M. Cozzens, to Be Sold by Auction, at the Clinton Hall Art Galleries and Book Sale Rooms, John H. Austen, Auctioneer, Friday Evening, May 22, 1868, Commencing at a Quarter before 8 O'clock* (New York: Leavitt, Strebeigh and Co., 1868), no. 65 (sold to a Mr. Burch [?] for $370). The two paintings were also written up in "Sketchings: Our Private Collections, No. III," *Crayon* 3 (April 1856): 123.

26. Peter C. Sutton, "Life and Culture in the Golden Age," in idem, *Masters of Seventeenth-Century Dutch Genre Painting*, exh. cat. (Philadelphia: Philadelphia Museum of Art, 1984), pp. lxxvff.

27. "Sketchings: The Artists' Reception," *Crayon* 5 (March 1858): 87. See also

Crayon 5 (April 1858): 115.

28. "Artists' Reception," *Crayon*, March 1858, p. 87. See also Mann, *Francis William Edmonds*, p. 58.

29. The Cozzens painting measures 10 by 12 inches, and *Reading the Scriptures* is 13½ by 17¼ inches.

30. Mann, *Edmonds: Mammon and Art*, p. 154.

31. Bode, *American Popular Culture*, pp. 132–48, esp. p. 141.

32. "Sketchings: Our Private Collections, No. II," *Crayon* 3 (February 1856): 57–58.

33. Peter C. Sutton, *Pieter de Hooch* (Oxford: Phaidon, 1980), pp. 88–89. Sutton titles the painting *A Woman Delousing a Child's Hair*. The provenance indicates that the work was in Amsterdam when Edmonds was in Europe and was not reproduced in engraved form until 1880.

34. Cowdrey, *National Academy Exhibition Record*, 1: 144.

35. Edmonds to John Durand, 14 April 1858 (Asher B. Durand Correspondence, NYPL).

36. Robert L. Stuart was a highly successful merchant who with his wife, Mary, devoted much of his fortune to philanthropic activities, ranging from supporting religious and medical organizations to aiding cultural institutions. Mrs. Stuart willed the extraordinary collection of statuary, paintings, and books to the Lenox Library (now part of the New York Public Library); much of the collection of art works is now on permanent loan to the New-York Historical Society. (See "Robert Leighton Stuart," *National Cyclopaedia*, 10: 24; and "Mary McCrea Stuart," *National Cyclopaedia*, 13: 150–51.)

37. *Catalogue of Paintings to Be Sold for the Benefit of the Ranney Fund* (New York: no publisher, 1858), no. 183. The annotated catalog indicates that someone named O'Brian purchased this work.

38. "Sketchings: National Academy of Design," *Crayon* 6 (May 1859): 153; and "Sketchings: National Academy of Design, Second Notice," *Crayon* 6 (June 1859): 192.

39. "The Fine Arts: National Academy of Design," *Home Journal*, 18 June 1859, p. 2.

40. Graham Reynolds, *Painters of the Victorian Scene* (London: B. T. Batsford, 1953), p. 73.

41. E. De Jonghe, "Vermommingen van Vrouw Wereld in de 17de eeuw," in *Album Amicorum J. G. Van Gelder* (The Hague: Martinus Nijhoff, 1973), pp. 198–206. See also Elizabeth B. Walton, "Netherlandish Maps: A Decorative Role in the History of Art," *Professional Geographer* 14 (March 1962): 32–33; and Welu, "Vermeer," pp. 529–47.

42. "The Fine Arts: Last Reception at Dodsworth's," *Home Journal*, 19 March 1859, p. 2; "The Fine Arts: The Sale of Native and Foreign Pictures," *Home Journal*, 19 March 1859, p. 2.

43. Frederick R. Selch, "The Musical Instruments: A Brief History," in Betsky et al., *Art of Music*, p. 21. I wish to express my gratitude to Doug Worthen of the Music Department of Phillips Exeter Academy for his insight into the technical aspects of this discussion.

44. Alexander Hamilton, *Itinerarium: Being a Narrative of a Journey from Annapolis, Maryland, through Delaware, Pennsylvania, New York, New Jersey, Connecticut, Rhode Island, Massachusetts, and New Hampshire from May to September 1744*, ed. Albert Bushnell Hart (Saint Louis, Mo.: private printing, 1907), p. 144.

45. H. Nichols B. Clark, "American Musical Paintings, 1770–1865," in Betsky et al., *Art of Music*, p. 35.

46. Frankenstein, *William Sidney Mount*, pp. 79ff. See also *Catching the Tune*, exh. cat. (Stony Brook, N.Y.: The Museums at Stony Brook, 1984).

47. See Patricia Hills, *The Painters' America: Rural and Urban Life, 1810–1910*, exh. cat. (New York: Whitney Museum of American Art, 1974), pp. 63ff., for further discussion.

48. A final point concerning the early ownership of *Dame in the Kitchen* is worth mentioning, since the issue seems somewhat clouded. Maybelle Mann suggests that the painting was owned by James L. Claghorn, basing her evidence on Henry Tuckerman's survey of private collections in *Book of the Artists* (Mann, *Francis William Edmonds*, p. 37). But Tuckerman cited the painting by Edmonds in Claghorn's collection as *Dance in the Kitchen*, and this title is consistent with its listing in two contemporary exhibitions (*Catalogue of the Exhibition of a Private Collection of Works of Art for the Benefit of the United States Christian Commission, at the Academy of the Fine Arts, Philadelphia* [Philadelphia: Caxton Press, 1864], no. 128. This exhibition was repeated in its original form the following year). It is highly unlikely that the same typographical error would go uncorrected three times. Furthermore, a painting Claghorn bought in 1853 was titled *The First Step*, and it is possible that the subject pertained to dancing, since the theme does appear in Edmonds's repertoire. Possibly the title was changed during the course of the ensuing decade, and this painting—and not fig. 100—is the *Dance in the Kitchen* cited by Tuckerman. Pending clarification, it is difficult to consider *Dame in the Kitchen* as part of Claghorn's collection.

49. The four titles are respectively documented in "Sketchings: New York," *Crayon* 7 (March 1860): 83; "Art Items," *New-York Daily Tribune*, 29 December 1860, p. 4; *Artists' Fund Society of New York, Instituted 1859, Chartered 1861: Catalogue of the Third Annual Exhibition at the Gallery of the Fine Art Institute, 625 Broadway, New York, 1862* (New York: G. A. Whitehorne, 1862), no. 15; and "The Fine Arts: Artists' Fund Exhibition," *Home Journal*, 14 December 1861, p. 2.

50. "Artists' Fund Exhibition," *Home Journal*, 14 December 1861, p. 2.

51. See Hills, *Painters' America*, pp. 80ff.

52. Lanman, *Letters from a Landscape Painter*, p. 240.

Checklist of the Exhibition

Plate and figure references in brackets refer to text illustrations herein.

Paintings

Sammy the Tailor, 1836
Oil on canvas, 9¾ × 11¾ in.
The Art Institute of Chicago;
Charles H. and Mary F. S.
Worcester Collection
[Figure 10]

The Skinner, 1837
Oil on canvas, 14 × 18¼ in.
Private collection
[Figure 11]

The Epicure, 1838
Oil on canvas, 26¾ × 33½ in.
Wadsworth Atheneum, Hartford,
Connecticut; The Ella Gallup
Sumner and Mary Catlin Sumner
Collection
[Plate 1]

The Epicure, c. 1838
Oil on canvas, 29¼ × 36⅛ in.
Private collection
[Figure 13]

*Commodore Trunnion and Jack
Hatchway*, 1839
Oil on canvas, 25½ × 22 in.
Vose Galleries of Boston, Inc.,
Boston, Massachusetts
[Plate 2]

Sparking, 1839
Oil on canvas, 20 × 24 in.
Sterling and Francine Clark Art
Institute, Williamstown,
Massachusetts
[Plate 3]

The City and the Country Beaux,
c. 1839
Oil on canvas, 20⅛ × 24¼ in.
Sterling and Francine Clark Art
Institute, Williamstown,
Massachusetts
[Plate 4]

First Aid, c. 1840–45
Oil on canvas, 17 × 14 in.
Collection of Henry Melville Fuller
[Figure 55]

The Bashful Cousin, c. 1842
Oil on canvas, 25 × 30 in.
National Gallery of Art,
Washington, D.C.;
Gift of Frederick Sturges, Jr.
[Plate 5]

The Image Pedlar, c. 1844
Oil on canvas, 33¼ × 42¼ in.
The New-York Historical Society;
Gift of the New-York Gallery of
Fine Arts
[Plate 6]

The New Scholar, 1845
Oil on canvas, 27 × 34 in.
Private collection
[Plate 7]

The Sleepy Student, 1846
Oil on canvas, 20 × 24 in.
Collection of Victor R.
Coudert, Jr.
[Figure 57]

The Organ Grinder, c. 1848
Oil on canvas, 31¾ × 42¼ in.
Private collection
[Plate 8]

Gil Blas and the Archbishop, c. 1849
Oil on canvas, 29½ × 24 in.
Private collection
[Plate 9]

The Speculator, 1852
Oil on canvas, 25⅛ × 30⅛ in.
National Museum of American
Art, Smithsonian Institution,
Washington, D.C.; Gift of
Ruth C. and Kevin McCann
in affectionate memory of Dwight
David Eisenhower, 34th President
of the United States
[Plate 10]

Taking the Census, 1854
Oil on canvas, 28 × 38 in.
Private collection
[Plate 11]

All Talk and No Work, 1855–56
Oil on canvas, 24 × 20⅛ in.
The Brooklyn Museum, Brooklyn,
New York; Carll H. De Silver
Fund
[Figure 77]

Waiting, c. 1855–60
Oil on panel, 14¾ × 11½ in.
Courtesy of Kennedy Galleries,
New York
[Figure 99]

The Scythe Grinder, 1856
Oil on canvas, 24⅛ × 20 in.
The New-York Historical Society;
Gift of Charles E. Dunlap
[Figure 83]

The Thirsty Drover, 1856
Oil on canvas, 27 × 36 in.
The Nelson-Atkins Museum of
Art, Kansas City, Missouri;
Nelson Fund
[Plate 12]

Reading the Scriptures, c. 1856
Oil on canvas, 13½ × 17¼ in.
Private collection
[Figure 90]

Devotion, 1857
Oil on canvas, 20¼ × 24 in.
Collection of Mr. and Mrs. E. G.
Nicholson
[Plate 13]

Time to Go, 1857
Oil on canvas, 25½ × 30 in.
Blount, Inc., Montgomery,
Alabama
[Figure 87]
(Amon Carter Museum only)

Bargaining (The Christmas Turkey),
1858
Oil on canvas, 16½ × 23⅜ in.
The New-York Historical Society;
The Robert L. Stuart Collection,
on permanent loan from the
New York Public Library, 1944
[Plate 14]

The New Bonnet, 1858
Oil on canvas, 25 × 30⅛ in.
The Metropolitan Museum of Art,
New York; Purchase, Erving
Wolf Foundation Gift and
Hanson K. Corning Gift by
exchange, 1975
[Plate 15]

The Wind Mill, c. 1858
Oil on canvas, 24 × 20⅛ in.
The New-York Historical Society;
The Robert L. Stuart Collection,
on permanent loan from the
New York Public Library, 1944
[Figure 94]

Dame in the Kitchen, c. 1859
Oil on panel, 10¾ × 13¾ in.
Private collection
[Figure 100]

The Flute, c. 1859
Oil on canvas, 13¼ × 17¼ in.
Amon Carter Museum, Fort
Worth, Texas;
Gift of Mr. and Mrs. Louis J.
Urdahl and Mitchell A. Wilder
Memorial Fund donors
[Plate 16]

*Hard Times (Out of Work and
Nothing to Do)*, 1861
Oil on canvas, 16 × 21 in.
Albrecht Art Museum, Saint
Joseph, Missouri;
The Enid and Crosby Kemper
Foundation Collection
[Figure 105]
(Amon Carter Museum only)

Drawings and Oil Studies

The Paper City, 1838
Wash on paper, 7 × 8¼ in.
The New-York Historical Society;
Bequest of Emily Ellison Post
[Figure 69]

*Sketchbook with graphite and wash
sketches*, c. 1839
6⅝ × 8¼ in.
The Metropolitan Museum of Art,
New York; Sheila and Richard J.
Schwartz Fund, 1987
[See figures 21, 60, 61]

Travel Diary, 1840–41
6⅛ × 4⅛ in.
The Columbia County Historical
Society, Kinderhook, New York
[See figure 29]

*Sketchbook with watercolor sketches,
from Edmonds's European journey*,
1841
4¼ × 5¾ in.
Courtesy of Kennedy Galleries,
New York
[See figures 32–35]

Perseverance, 1840–45
Brown and white wash over
graphite touched with white on tan
paper, 13¾ × 19¾ in.
Museum of Fine Arts, Boston;
Gift of Maxim Karolik
[Figure 4]

The Trying Hour, c. 1841
Brown wash over graphite touched
with white on light blue paper,
10¾ × 15⅝ in.
Museum of Fine Arts, Boston;
Gift of Maxim Karolik
[Figure 2]

Study for *Facing the Enemy*, 1845
Oil on board, 10½ × 9 in.
Private collection
[Figure 48]

Study for *Facing the Enemy*, c. 1845
Graphite on paper, 6⅞ × 6⅝ in.
The Metropolitan Museum of Art,
New York; Gift of
James C. McGuire, 1926
[Figure 47]

Study for *The New Scholar*, c. 1845
Oil on board, 4½ × 6 in.
Private collection
[Figure 54]

Just in Time, c. 1850–55
Graphite on paper, 9¹⁄₁₆ × 11⅝ in.
Munson-Williams-Proctor
Institute, Utica, New York
[Figure 68]

Crow's Nest, 1851
Watercolor, gouache, and graphite
on paper, 9 × 12 in.
Private collection
[Figure 9]

Study for *The Speculator*, c. 1852
Oil on board, 11¼ × 14 in.
Collection of Charles O. Coudert
[Figure 70]

Study for *Taking the Census*,
c. 1854
Oil on board, 4⅜ × 5⅞ in.
Collection of Jo Coudert
[Figure 75]

Stir the Mush Three Times,
c. 1855–60
Graphite and Chinese white on
brown paper, 8 × 10½ in.
Private collection
[Figure 89]

Study for *The Thirsty Drover*,
c. 1856
Oil on board, 9¼ × 13¼ in.
Collection of Rex Tatum, Jackson,
Mississippi
[Figure 78]

Study for *Devotion*, c. 1857
Oil on board, 4¾ × 6 in.
Collection of Mr. and Mrs. E. G.
Nicholson
[Figure 88]

Prints after Francis W. Edmonds

Alfred Jones (1819–1900)
Sparking, 1844
Engraving (hand colored),
12¾ × 16¹³⁄₁₆ in. (image)
Amon Carter Museum, Fort
Worth, Texas
[Figure 6]

Facing the Enemy, c. 1847
Engraving, 18¾ × 15¾ in.
(image)
Private collection
[Figure 49]

Alfred Jones (1819–1900)
The New Scholar, 1850
Engraving, 7⅜ × 9⅜ in. (image)
Private collection
[Figure 7]

Bibliography

Archival Materials

American Art-Union Press Book, 2 vols., New-York Historical Society, New York.

Bryant-Godwin Collection, New York Public Library, New York.

James L. Claghorn Papers, Philadelphia Maritime Museum, Philadelphia.

Thomas Cole Papers, Archives of American Art, Washington, D.C.

Asher B. Durand Correspondence, New York Public Library, New York.

Francis W. Edmonds, "Autobiography," Three manuscripts in possession of Mrs. Francis Edmonds Tyng, Clifton, New Jersey.

————. "Diary 1854," Archives of American Art, Washington, D.C.

————. "Technical Notebook," private collection.

————. "Travel Diary, 25 November 1840–17 July 1841," 2 vols., Columbia County Historical Society, Kinderhook, New York.

Edmonds Folder, Inventory of American Paintings, National Museum of American Art, Washington, D.C.

Edmonds File, Art Division, New York Public Library, New York.

Azariah C. Flagg Papers, New York Public Library, New York.

Charles Henry Hart Autograph Collection, Archives of American Art, Washington, D.C.

John F. Kensett, "Journal, 1 June 1840–31 May 1841," 2 vols., Frick Art Reference Library, New York.

Charles M. Leupp Papers, Alexander Library, Rutgers University, New Brunswick, New Jersey.

Edwin D. Morgan Papers, John F. Kensett Collection, New York State Library at Albany.

Minutes of the National Academy of Design, National Academy of Design, New York.

Archives of the New York Clearing House, New York.

Archives of the New York Public Library, New York.

Thomas Worth Olcott Papers, Columbia University, New York.

Sketch Club Minutes, Archives of the Century Association, New York.

Books and Dissertations

Alterman, Hyman. *Counting People: The Census in History*. New York: Harcourt, Brace and World, 1969.

Baker, Charles E. "The American Art-Union." In *American Academy of Fine Arts and American Art-Union*, by Mary Bartlett Cowdrey. 2 vols. New York: New-York Historical Society, 1953.

Bancroft, George. *A History of the United States, from the Discovery of the American Continent to the Declaration of Independence*. 10 vols. Boston: Little, Brown and Co., 1834–74.

Betsky, Celia, et al. *The Art of Music: American Paintings and Musical Instruments, 1770–1910*. Exhibition catalog. Clinton, N.Y.: Emerson Gallery, Hamilton College, 1984.

Bode, Carl. *The Anatomy of American Popular Culture, 1840–1861*. Berkeley: University of California Press, 1959.

————, ed. *American Life in the 1840s*. New York: New York University Press, 1967.

Brock, Lucien. *The Bench and Bar of New York*. 2 vols. New York: no publisher, 1870.

Brookner, Anita. *Greuze: The Rise and Fall of an Eighteenth-Century Phenomenon*. London: Elek, 1972.

Burnet, John. *A Treatise in Four Parts Consisting of an Essay on the Education of the Eye with Reference to Painting and Practical Hints on Compostion, Chiaroscuro, and Colour*. London: J. Carpenter and Son, 1827.

Burns, Robert. *The Complete Poetical Works of Robert Burns*. Boston: Houghton Mifflin and Co., 1897.

Callow, James T. *Kindred Spirits: Knickerbocker Writers and American Artists, 1807–1855*. Chapel Hill: University of North Carolina Press, 1967.

Catching the Tune. Exhibition catalog. Stony Brook, N.Y.: The Museums at Stony Brook, 1984.

Chambers, Bruce. *The World of David Gilmour Blythe (1815–1865)*. Exhibition catalog. Washington, D.C.: Smithsonian Institution Press for National Collection of Fine Arts, 1980.

Clark, H. Nichols B. "The Impact of Seventeenth-Century Dutch and Flemish Genre Painting on American Genre Painting, 1800–1865." Ph.D. dissertation, University of Delaware, 1982.

Cole, Donald B. *Martin Van Buren and the American Political System*. Princeton, N.J.: Princeton University Press, 1984.

Cooper, James Fenimore. *The Spy*. 1821. New York: G. P. Putnam's Sons, n.d.

Cowdrey, Mary Bartlett. *American Academy of Fine Arts and American Art-Union*. 2 vols. New York: New-York Historical Society, 1953.

————. *National Academy of Design Exhibition Record, 1826–1860*. 2 vols. New York: New-York Historical Society, 1943.

Cummings, Thomas S. *Historic Annals of the National Academy of Design, New-York Drawing Association, Etc., with Occasional Dotings by the Way-Side from 1825 to the Present Time*. Philadelphia: George W. Childs, 1865.

Dayton, Abram C. *Last Days of Knickerbocker Life in New York*. 1882. New York: G. P. Putnam's Sons, 1897.

Dickens, Charles. *The Posthumous Papers of the Pickwick Club*. 1836. London: Oxford University Press, 1947.

Dickson, Harold E., ed. *Observations on American Art: Selections from the Writings of John Neal (1793–1876)*. State College: Pennsylvania State College Studies No. 12, 1943.

Dictionary of American Biography. 22 vols. New York: Charles Scribner's Sons, 1928–81.

Dunlap, William. *History of the Rise and Progress of the Arts of Design in the United States.* 1834. Edited and with an introduction by James T. Flexner. 2 vols. New York: Dover Publications, 1969.

Edmonds, Francis W. *Defence of Francis W. Edmonds, Late Cashier of the Mechanics' Bank, against the Charges Preferred against Him by Its President and Cashier.* New York: no publisher, 1855.

Emerson, Ralph Waldo. *The Works of Ralph Waldo Emerson.* Edited by J. E. Cabot. 12 vols. Boston and New York: Houghton Mifflin and Co., 1883–93.

Engelson, Lois. "The Influence of Dutch Landscape Painting on the American Landscape Tradition." M.A. thesis, Columbia University, 1966.

Esko, Claudia T., et al. *Art Investments: Selections from Three Alabama Corporate Collections: Blount, Inc.; Weil Enterprises and Investments, Ltd.; Vulcan Materials Company.* Exhibition catalog. Birmingham, Ala.: Birmingham Museum of Art, 1984.

Ferber, Linda S., and William H. Gerdts. *The New Path: Ruskin and the Pre-Raphaelites.* Exhibition catalog. New York: Brooklyn Museum and Schocken Books, 1985.

Fink, Lois, et al. *Academy: The Academic Tradition in American Art.* Exhibition catalog. Washington, D.C.: Smithsonian Institution Press for National Collection of Fine Arts, 1975.

Frankenstein, Alfred. *William Sidney Mount.* New York: Harry N. Abrams, 1975.

Gourlie, John H. *A Tribute to the Memory of Charles M. Leupp: An Address Delivered before the Column, February 10, 1860.* New York: Wm. C. Bryant and Co., 1860.

Griffiths, William. *The Story of the American Bank Note Company.* New York: no publisher, 1959.

Groce, George, and David Wallace. *The New-York Historical Society's Dictionary of Artists in America, 1564–1860.* New Haven, Conn.: Yale University Press, 1957.

Haley, K. H. D. *The Dutch in the Seventeenth Century.* London: Thames and Hudson, 1972.

Halleck, Fitz-Greene. *The Poetical Works of Fitz-Greene Halleck.* New York: D. Appleton and Co., 1847.

Hamilton, Alexander. *Itinerarium: Being a Narrative of a Journey from Annapolis, Maryland, through Delaware, Pennsylvania, New York, New Jersey, Connecticut, Rhode Island, Massachusetts, and New Hampshire from May to September 1744.* Edited by Albert Bushnell Hart. Saint Louis, Mo.: private printing, 1907.

Hammond, Bray. *Banks and Politics in America from the Revolution to the Civil War.* Princeton, N.J.: Princeton University Press, 1957.

Harris, Neil. *The Artist in American Society: The Formative Years, 1790–1860.* New York: George Braziller, 1966.

Hawthorne, Nathaniel. *The House of the Seven Gables.* 1851. New York: Heritage Press, 1935.

———. *Nathaniel Hawthorne: The American Notebooks.* Edited by Randall Stewart. New Haven, Conn.: Yale University Press, 1932.

Hills, Patricia. *The Painters' America: Rural and Urban Life, 1810–1910.* Exhibition catalog. New York: Whitney Museum of American Art, 1974.

Holmes, Oliver Wendell. *Ralph Waldo Emerson.* Boston: Houghton Mifflin and Co., 1885.

Hone, Philip. *The Diary of Philip Hone, 1828–1851.* Edited and with an introduction by Bayard Tuckerman. 2 vols. New York: Dodd, Mead and Co., 1889.

Hoopes, Donelson F. *American Narrative Painting.* Exhibition catalog. Los Angeles: Los Angeles County Museum of Art, 1974.

Huizinga, Johan H. *Dutch Civilization in the Seventeenth Century and Other Essays.* London: Collins, 1968.

Irving, Washington. *The Sketchbook of Geoffrey Crayon Gent.* 1819. New York: G. P. Putnam's Sons, 1894.

King, Moses, ed. *The Clearing House of New York City.* New York: no publisher, 1898.

Lanman, Charles. *Letters from a Landscape Painter.* Boston: James Monroe and Co., 1845.

Larkin, Oliver W. *Art and Life in America.* New York: Rinehart and Co., 1949.

Lawall, David B. *Asher B. Durand, 1796–1886.* Exhibition catalog. Montclair, N.J.: Montclair Art Museum, 1971.

Lesage, Alain-René. *The Adventures of Gil Blas of Santillane.* 1715–35. Translated by Tobias Smollett, introduction by J. B. Priestly, and illustrations by John Austen. 2 vols. Oxford: Oxford University Press, 1937.

M. & M. Karolik Collection of American Watercolors and Drawings, 1800–1875. 2 vols. Boston: Museum of Fine Arts, 1962.

Mann, Maybelle. *The American Art-Union.* Otisville, N.Y.: A.L.M. Associates, 1977.

———. *Francis William Edmonds.* Exhibition catalog. Washington, D.C.: International Exhibitions Foundation, 1975.

———. *Francis W. Edmonds: Mammon and Art.* New York: Garland Publishing, 1977.

Marks, Arthur S. "Wilkie to 1825." Ph.D. dissertation, University of London, 1968.

Marlor, Clark S. *A History of the Brooklyn Art Association with an Index of Exhibitions.* New York: James F. Carr, 1970.

Miller, Lillian B. *Patrons and Patriotism: The Encouragement of the Fine Arts in the United States, 1790–1860.* Chicago: University of Chicago Press, 1966.

Morrison, Hugh. *Early American Architecture from the First Colonial Settlements to the National Period.* New York: Oxford University Press, 1952.

The National Cyclopaedia of American Biography. 76 vols. New York: James T. White and Co., 1891–1984.

Nevins, Allan, et al. *The Century, 1847–1946.* New York: Century Association, 1947.

Nye, Russell B. *Society and Culture in America, 1830–1860.* New York: Harper and Row, 1974.

Paulding, James Kirke. *The Dutchman's Fireside.* Edited by Thomas F. O'Donnell. New Haven, Conn.: College and University Press, 1966.

Paulson, Ronald. *Hogarth: His Life, Art, and Times.* 2 vols. New Haven, Conn.: Yale University Press, 1971.

Perkins, Robert F., Jr., and William J. Gavin III. *The Boston Athenaeum Art Exhibition Index, 1827–1874.* Boston: Library of Boston Athenaeum, 1980.

Putnam, George P. *American Facts.* London: Wiley and Putnam, 1845.

Redlich, Fritz. *History of American Business Leaders: A Series of Studies.* 2 vols. Ann Arbor, Mich.: no publisher, 1940.

Report of the American Historical Association for the Year 1908. 2 vols. Washington, D.C.: Government Printing Office, 1909.

Reynolds, Graham. *Painters of the Victorian Scene.* London: B. T. Batsford, 1953.

Richards, Caroline Cowles. *Village Life in America.* New York: Henry Holt and Co., 1913.

Richards, Leonard L. *"Gentlemen of Property and Standing": Anti-Abolition Mobs in Jacksonian America.* New York: Oxford University Press, 1970.

Rutledge, Anna Wells. *Cumulative Record of Exhibition Catalogues: The Pennsylvania*

Academy of the Fine Arts, 1807–1870. Philadelphia: American Philosophical Society, 1955.

Scott, Sir Walter. *Guy Mannering.* 1815. Edinburgh: Adam and Charles Black, 1852.

Smollett, Tobias. *The Adventures of Peregrine Pickle.* 1751. New York: Tudor Publishing Co., 1935.

Strong, George Templeton. *The Diary of George Templeton Strong.* Edited by Allan Nevins and Milton Halsey Thomas. 4 vols. New York: Macmillan Co., 1952.

Sutton, Peter C. *Masters of Seventeenth-Century Dutch Genre Painting.* Exhibition catalog. Philadelphia: Philadelphia Museum of Art, 1984.

————. *Pieter de Hooch.* Oxford: Phaidon, 1980.

Tocqueville, Alexis de. *Democracy in America.* 1835–40. Translated by Henry Reeve. 2 vols. New Rochelle, N.Y.: Arlington House, 1966.

Trollope, Frances. *Domestic Manners of the Americans.* Edited by Donald Smalley. New York: Alfred A. Knopf, 1949.

Tuckerman, Henry T. *Book of the Artists: American Artist Life Comprising Biographical and Critical Sketches of American Artists Preceded by an Historical Account of the Rise and Progress of Art in America.* New York: G. P. Putnam and Son, 1867.

Twenty Censuses: Population and Housing Questions, 1790–1980. Washington, D.C.: Government Printing Office, 1979.

Tyrrell, Ian R. *Sobering Up: From Temperance to Prohibition in Antebellum America, 1800–1860.* Westport, Conn.: Greenwood Press, 1979.

Whittier, John Greenleaf. *The Poetical Works of John Greenleaf Whittier.* 4 vols. Boston: Houghton Mifflin and Co., 1892.

Williams, Hermann Warner, Jr. *Mirror to the American Past: A Survey of American Genre Painting, 1750–1900.* Greenwich, Conn.: New York Graphic Society, 1973.

Wilmerding, John, ed. *Essays in Honor of Paul Mellon, Collector and Benefactor.* Washington, D.C.: National Gallery of Art, 1986.

Yarmolinsky, Avrahm. *Picturesque United States of America, 1811, 1812, 1813, Being "A Memoir on Paul Svinin."* New York: William Edwin Rudge, 1930.

Periodicals and Short Essays

Anonymous articles are listed first, in chronological order.

"Dutch Cleanliness and Female Influence." *Portfolio,* 4th ser., 3 (March 1814): 253–55.

"The Editor's Table: The National Academy of Design, Eleventh Annual Exhibition." *Knickerbocker, New-York Monthly Magazine* 8 (July 1836): 115.

"National Academy of Design: Seventh Notice." *New-York Mirror and Literary Gazette,* 10 June 1837, p. 399.

"The Fine Arts: National Academy of Design." *New-York Mirror and Literary Gazette,* 17 June 1837, p. 407.

"The Fine Arts: National Academy of Design." *New-York Mirror and Literary Gazette,* 30 June 1838, p. 6.

"National Academy of Design." *Commercial Advertiser,* 24 April 1839, n.p.

"National Academy of Design: Review of the Exhibition." *American Repository of Art, Science, and Manufacturing* 1 (June 1840): 365.

"Editor's Table: The Fine Arts." *Knickerbocker* 16 (July 1840): 82–83.

"Editor's Table: The Fine Arts." *Knickerbocker* 19 (June 1842): 591.

"Editor's Table: The Fine Arts." *Knickerbocker* 21 (June 1843): 581.

"Editor's Table: The Fine Arts." *Knickerbocker* 23 (June 1844): 597.

"The New-York Gallery of the Fine Arts." *Broadway Journal*, 1 March 1845, pp. 134–35.

"National Academy of Design." *Broadway Journal*, 10 May 1845, p. 306.

"Editor's Table: The Fine Arts." *Knickerbocker* 27 (May 1846): 464.

"National Academy of Design." *New-York Mirror and Literary Gazette*, 9 May 1846, p. 58.

"National Academy of Design." *New-York Mirror and Literary Gazette*, 22 May 1846, p. 92.

"The Fine Arts." *Anglo-American*, 13 February 1847, p. 405.

"Halleck's Poetical Work." *Boston Transcript*, 8 November 1847, p. 2.

"Editor's Table: Literary Notices." *Knickerbocker* 30 (November 1847): 449.

"Proposed Exhibition of the Works of Cole." *Evening Post*, 19 February 1848, p. 2.

"National Academy of Design." *New York Post*, 6 June 1848, n.p.

"The Fine Arts." *Town and Country*, 11 November 1848, p. 2.

"Fine Art Intelligence." *Literary World*, 10 March 1849, p. 228.

"Catalogue of the Exhibition." *Bulletin of the American Art-Union*, May 1849, p. 26.

"The Fine Arts: National Academy of Design." *Literary World*, 4 May 1850, p. 448.

"Art and Artists." *Home Journal*, 22 February 1851, p. 3.

"The Fine Arts: National Academy of Design." *Literary World*, 19 April 1851, p. 321.

"The Fine Arts." *Literary World*, 10 May 1851, p. 380.

Bulletin of the American Art-Union, December 1851, p. 141.

"The Fine Arts." *Literary World*, 1 May 1852, p. 316.

"Fine Arts: National Academy of Design." *Home Journal*, 8 May 1852, p. 2.

"The Fine Arts." *Literary World*, 25 December 1852, p. 406.

"Dinner to Fitz-Greene Halleck." *Home Journal*, 28 January 1854, p. 2.

"National Academy of Design." *Home Journal*, 1 April 1854, p. 2.

"Sketchings: Our Private Collections, No. II." *Crayon* 3 (February 1856): 57–58.

"Domestic Art Gossip." *Crayon* 3 (March 1856): 91.

"Sketchings: Our Private Collections, No. III." *Crayon* 3 (April 1856): 123.

"Sketchings: National Academy of Design." *Crayon* 3 (May 1856): 147.

"Our Private Collections: No. IV." *Crayon* 3 (June 1856): 186.

"Sketchings: National Academy of Design." *Crayon* 4 (July 1857): 223.

"Domestic Art Gossip." *Crayon* 4 (September 1857): 287.

"Domestic Art Gossip." *Crayon* 4 (December 1857): 376–77.

"Sketchings: The Artists' Reception." *Crayon* 5 (March 1858): 87.

"Sketchings: The Artists' Reception." *Crayon* 5 (April 1858): 115.

"Reflections on the Census." *Crayon* 5 (October 1858): 315–17.

"The Fine Arts: Last Reception at Dodsworth's." *Home Journal*, 19 March 1859, p. 2.

"The Fine Arts: The Sale of Native and Foreign Pictures." *Home Journal*, 19 March 1859, p. 2.

"Sketchings: National Academy of Design." *Crayon* 6 (May 1859): 153.

"The Fine Arts: National Academy of Design." *Home Journal*, 18 June 1859, p. 2.

"Sketchings: National Academy of Design, Second Notice." *Crayon* 6 (June 1859): 192.

"Sketchings: New York." *Crayon* 7 (March 1860): 83.

"Leupp Sale." *New-York Daily Tribune*, 14 November 1860, p. 8.

"Art Items." *New-York Daily Tribune*, 29 December 1860, p. 4.

"Domestic Art Gossip." *Crayon* 7 (December 1860): 354.

"The Fine Arts: Artists' Fund Exhibition." *Home Journal*, 14 December 1861, p. 2.

"Making Money: The American Banknote Company." *Harper's New Monthly Magazine* 24 (February 1862): 308.

"Deaths." *New York Times*, 9 February 1863, p. 5.

"City Intelligence: The Somerville Gallery, the Gandy-Olyphant Collection." *Evening Post*, 20 March 1875, p. 4.

"James L. Claghorn." *Harper's Weekly*, 6 September 1884, p. 581.

Burnet, John. "Autobiography of John Burnet." *Art Journal* 12 (1850): 275–77.

Burns, Sarah. "Yankee Romance: The Comic Courtship Scene in Nineteenth-Century American Art." *American Art Journal* 18 (1986): 51–76.

Callow, James T. "American Art in the Collection of Charles M. Leupp." *Antiques* 118 (November 1980): 998–1009.

Clark, H. Nichols B. "A Fresh Look at the Art of Francis W. Edmonds: Dutch Sources and American Meanings." *American Art Journal* 14 (Summer 1982): 73–94.

Craven, Wayne. "Luman Reed, Patron: His Collection and Gallery." *American Art Journal* 12 (Spring 1980): 40–59.

Eitner, Lorenz. "The Open Window and the Storm-Tossed Boat: An Essay in the Iconography of Romanticism." *Art Bulletin* 37 (December 1957): 279–90.

Hoover, Catherine. "The Influence of David Wilkie's Prints on the Genre Paintings of William Sidney Mount." *American Art Journal* 13 (Summer 1981): 4–33.

Johns, Elizabeth. "This New Man: National Identity in American Genre Painting, 1835–1851." Paper delivered at Woodrow Wilson International Center for Scholars, Washington, D.C., 22 April 1986.

Jonghe, E. De. "Erotica in Vogelperspectief: De dubbelzinnigheid van een reeks 17de eeuwse genrevoorstellingen." *Simiolus* 3 (1968–69): 22–74.

———. "Vermommingen van Vrouw Wereld in de 17de eeuw." In *Album Amicorum J. G. Van Gelder*. The Hague: Martinus Nijhoff, 1973. Pp. 198–206.

Klitzke, Theodore E. "Alexis de Tocqueville and the Arts in America." In *Festschrift Ulrich Middeldorf*, edited by Antje Kosegarten and Peter Tigler. 2 vols. Berlin: De Gruyter, 1968. 2: 553–58.

Lanman, Charles. "Artist's Recollections." *Art-Union* 1 (August–September 1884): 158.

Lathrop, George P. "State Celebrities: James L. Claghorn, Merchant, Banker, Art Connoisseur." *Philadelphia Press*, 8 April 1882, n.p.

Mann, Maybelle. "The New-York Gallery of Fine Arts: 'A Source of Refinement.'" *American Art Journal* 11 (January 1979): 76–86.

Murray, George. "Notice of the Fourth Annual Exhibition in the Academy of the Fine Arts." *Portfolio*, 4th ser., 3 (June 1814): 566–70.

Osgood, Samuel. "Art in Relation to American Life." *Crayon* 2 (July 1855): 54.

Walton, Elizabeth B. "Netherlandish Maps: A Decorative Role in the History of Art." *Professional Geographer* 14 (March 1962): 32–33.

Welu, James A. "Vermeer: His Cartographic Sources." *Art Bulletin* 57 (December 1975): 529–47.

Nineteenth-Century Exhibition Catalogs

The catalogs are arranged chronologically.

Catalogue of the Eleventh Annual Exhibition of the National Academy of Design, 1836. New York: Sackett and Co., 1836.

Explication des ouvrages de peinture, sculpture, architecture, gravure, et lithographie des artists vivants, exposés au Musée Royal le 15 Mars 1841. Paris: Vinchon Fils, 1841.

Catalogue des tableaux composant la galerie de feu son eminence le Cardinal Fesch. Rome: Joseph Salviucci et Fils, 1841.

Catalogue of the Exhibition of the New-York Gallery of the Fine Arts. New York: James van Norden and Co., 1844.

Catalogue of Paintings of the Third Exhibition of the Boston Artists' Association, 1844. Boston: Clapp and Son's Press, 1844.

Fourth Annual Exhibition of the Brooklyn Institute. Brooklyn, N.Y.: no publisher, 1845.

Catalogue of the Exhibition of the New-York Gallery of the Fine Arts. New York: E. B. Clayton, 1846.

Catalogue of the Twenty-first Annual Exhibition of the National Academy of Design. New York: Israel Sackett, 1846.

Catalogue of Painting, Engraving, etc., etc. at the Picture Gallery of the Maryland Historical Society: Second Annual Exhibition, 1849. Baltimore: John D. Toy, 1849.

Catalogue of the Twenty-eighth Annual Exhibition of the National Academy of Design. New York: Sackett and Co., 1853.

The Washington Exhibition in Aid of the New-York Gallery of the Fine Arts. New York: John F. Trow, 1853.

Artists' Fund Society of New York, Instituted 1859, Chartered 1861: Catalogue of the Third Annual Exhibition at the Gallery of the Fine Art Institute, 625 Broadway, New York, 1862. New York: G. A. Whitehorne, 1862.

Catalogue, Art Exhibition, Maryland State Fair, Baltimore, April 1864. Baltimore: J. B. Rose and Co., 1864.

Yonkers Sanitary Fair: Catalogue of Paintings on Exhibition in National Guard Armory, Farrington Building, Commencing Monday, February 15th, 1864. New York: Henry Spear, 1864.

Catalogue of the Exhibition of a Private Collection of Works of Art for the Benefit of the United States Christian Commission, at the Academy of the Fine Arts, Philadelphia. Philadelphia: Caxton Press, 1864.

Sale Catalogs

The catalogs are arranged chronologically.

Catalogue of Paintings to Be Sold for the Benefit of the Ranney Fund. New York: no publisher, 1858.

E. H. Ludlow, Auctioneer, Catalogue of Valuable Paintings and Engravings, Being the Entire Gallery of the Late Charles M. Leupp, Esq. . . . to be sold at auction on Tuesday, November 13, 1860. New York: Hall, Clayton and Co., 1860.

Artists' Fund Society of New York, Instituted 1859, Chartered 1861: Catalogue of the Fifth Annual Sale of Paintings. New York: G. A. Whitehorne, 1864.

Catalogue of the Entire Collection of Paintings Belonging to the Late Mr. A. M. Cozzens, to Be Sold by Auction, at the Clinton Hall Art Galleries and Book Sale Rooms, John H. Austen, Auctioneer, Friday Evening, May 22, 1868, Commencing at a Quarter before 8 O'clock. New York: Leavitt, Strebeigh and Co., 1868.

Sale Catalogue Number 1025, Parke-Bernet Galleries, Inc., January 6, 7, 8, 1949. New York: Parke-Bernet, 1949.

Index